CW01238245

Threads of labour

Manchester University Press

Threads of labour

Tapestry of an ex-industrial community

Lisa Taylor

MANCHESTER UNIVERSITY PRESS

Copyright © Lisa Taylor 2025

The right of Lisa Taylor to be identified as the author of this work has been asserted in accordance with the Copyright, Designs and Patents Act 1988.

An electronic version of this book has been made freely available under a Creative Commons (CC BY-NC-ND) licence, thanks to the support of Leeds Beckett University, which permits non-commercial use, distribution and reproduction provided the author(s) and Manchester University Press are fully cited and no modifications or adaptations are made. Details of the licence can be viewed at https://creativecommons.org/licenses/by-nc-nd/4.0/

Published by Manchester University Press
Oxford Road, Manchester, M13 9PL

www.manchesteruniversitypress.co.uk

British Library Cataloguing-in-Publication Data
A catalogue record for this book is available from the British Library

ISBN 978 1 5261 6641 8 hardback

First published 2025

The publisher has no responsibility for the persistence or accuracy of URLs for any external or third-party internet websites referred to in this book, and does not guarantee that any content on such websites is, or will remain, accurate or appropriate.

EU authorised representative for GPSR:
Easy Access System Europe, Mustamäe tee 50, 10621 Tallinn, Estonia
gpsr.requests@easproject.com

Typeset by New Best-set Typesetters Ltd

Contents

List of figures	*page* vi
Acknowledgements	xi
Introduction: a drive up Birkby Lane	1
1 Histories	43
2 Nostalgia: a response to loss	123
3 'History gone': community after carpet	151
4 Hopeful re-making and the power of art	181
Conclusion: a journey back to Bailiff Bridge	212
Index	228

Figures

0.1	My mother at work in the setting, circa 1962. Author's photograph.	*page* 4
0.2	The tract of land where Clifton Mill once stood, 2016. Author's photograph.	13
0.3	Commissioned map of Firth Carpets Limited in Bailiff Bridge, by Eva Jew, 2024. Reproduced with permission from the artist.	25
0.4	*Emperor Abstract* Axminster broadloom leaflet. This highly patterned wall-to-wall carpet typically featured in the living rooms of my 1970s childhood. Reproduced with permission from Firth Carpets Archive, Bankfield Museum, Halifax, Box B.4.8, ref. 2005.46.	26
0.5	Aerial shot Firth Carpets Limited in Bailiff Bridge, circa 1985. Reproduced with permission from Michael Rooney.	26
0.6	Worker counts the tufts from the design so loom cards can be made, circa 1930s. Reproduced with permission from John Waddington.	31
0.7	The extra fine Wilton Carpet, *The Furnishing Trades' Organiser*, 1924. Reproduced with permission from Firth Carpets Archive, Bankfield Museum, Halifax, Box B.4.8, ref.2005.43.	33
1.1	*The Furnishing Trades' Organiser*, June 1924. Reproduced with permission from Firth Carpets Archive, Bankfield Museum, Halifax, Box B.4.8, ref. 2005.43.	58

Figures vii

1.2 Invitation to Firths' new London Showroom, 1934. Reproduced with permission from West Yorkshire Archive Service, Calderdale, WYC: 1538/11/1. 59
1.3 *Journal of Commerce*, 1931. Reproduced with permission from Firth Carpets Archive, Bankfield Museum, Halifax, Box B.4.8, ref. 2005.43. 61
1.4 Firths capitalised on cinema growth with *Firmoda*. Reproduced with permission from Firth Carpets Archive, Bankfield Museum, Halifax, Box B.4.8, ref. 2005.43. 65
1.5 The textile worker body as featured fitting 1930s *Firmoda*. Reproduced with permission from Firth Carpets Archive, Bankfield Museum, Halifax, Box B.4.8, ref. 2005.43. 66
1.6 Firths featured at the Hall of Production at the Festival of Britain, 1951. Firth Festival of Britain catalogue. Reproduced with permission from West Yorkshire Archive Service, Calderdale, WYC:1538/11/4. 72
1.7 Firths encouraged tourism across the UK. Firth Festival of Britain catalogue. Reproduced with permission from West Yorkshire Archive Service, Calderdale, WYC: 1538/11/4. 73
1.8 Firths catered for traditional and modern. *The Ambassador*, 1955. Reproduced with permission from Firth Carpets Archive, Bankfield Museum, Halifax, Box B.4.8, ref. 2005.43. 76
1.9 Firths extended its repertoire to cater to new markets. Reproduced with permission from Firth Carpets Archive, Bankfield Museum, Halifax, Box B.4.8, ref. 2005.182. 77
1.10 'Wilton by Firth' catalogue, 1976. Reproduced with permission from Firth Carpets Archive, Bankfield Museum, Halifax, Box B.4.8, uncatalogued. 90
1.11 Firth Carpets Limited manager's report, 1982. Reproduced with permission from Firth Carpets

	Archive, Bankfield Museum, Halifax, Box B.5, ref. 2005.106.7.	92
1.12	The abstract design of *Cabana*. Reproduced with permission from Firth Carpets Archive, Bankfield Museum, Halifax, Box B.5, ref. 2005.133.2.	93
1.13	Key brand symbol of the 1970s: the Firth twins. Reproduced with permission from Firth Carpets Archive, Bankfield Museum, Halifax, Box B.5, ref. 2005.16.	94
1.14	Investigating improvement; Just Jane in *Trim Lines*. Reproduced with permission from John Waddington.	100
1.15	Tufting machine workers at their looms in *Trim Lines*. Reproduced with permission from John Waddington.	106
1.16	Local press report the demolition of Clifton Mill, 2002. Author's newspaper cutting.	109
2.1	Weaver working at an Axminster gripper loom, circa 1965. Reproduced with permission from John Waddington.	128
2.2	Two menders pose for the camera. Reproduced with permission from John Waddington.	128
2.3	The whole body was used in mending, circa 1970s. Reproduced with permission from John Waddington.	129
2.4	Working together in winding. Reproduced with permission from John Waddington.	130
2.5	The secretary to the managing director in the reception in Clifton House. Reproduced with permission from John Waddington.	131
2.6	Sewing and mending department. Reproduced with permission from John Waddington.	132
2.7	Personalised workstation in the sewing and mending department. Reproduced with permission from John Waddington.	133
2.8	Bullseye at Firths Archery Club, circa 1968. Reproduced with permission from John Waddington.	134

Figures ix

2.9	Firth Carpets float for the local Brighouse Gala. Reproduced with permission from John Waddington.	135
3.1	Looking across demolition to new-build housing on a walk-and-talk tour. Author's photograph.	153
3.2	Bailiff Bridge flood, 1968. Reproduced with permission from Firth Carpets Archive, Bankfield Museum, Halifax, Box C.2.2, ref. 2007.23.7.5.	160
3.3	Firths organised prestigious work events: space hoppers at the Hawaiian evening, 1960s. Reproduced with permission from John Waddington.	162
3.4	Ex-workers documented demolition which left wide, open spaces. Photograph by Michael Halliwell. Reproduced with permission from the photographer.	165
4.1	Workshop 2: an ex-worker passes on the knowledge of tying the weaver's knot to newcomers, 2021. Author's photograph.	193
4.2	'Passing on' is captured in photography, 2021. Author's photograph.	194
4.3	The series 'Intertwining Threads: Valuing Labour, Re-Making Community' was displayed in the Boardroom at Clifton House. Artist: Catherine Bertola. Workshop photography: Simon Warner. Exhibition photograph: Nick Singleton. Reproduced with permission from Nick Singleton Photography.	195
4.4	Intertwining Threads – Angela and Rebecca, 2021, digital prints, 24 × 16". Centre: Angela (ex-winder) passes on the skill of the weaver's knot to newcomer Rebecca. Artist: Catherine Bertola. Workshop photography: Simon Warner. Exhibition photograph: Nick Singleton. Reproduced with permission from Nick Singleton Photography.	196
4.5	Intertwining Threads – Karen, 2021, digital prints, 24 × 16". Artist: Catherine Bertola. Workshop photography: Simon Warner.	

Exhibition photograph: Nick Singleton Reproduced with permission from Nick Singleton Photography. 197

5.1 Place attachment in the art of the local: *Buckingham Leaf*. Reproduced with permission from Firth Carpets Archive, Bankfield Museum, Halifax, Box B.4.8, ref. 2005.130.21. 218

Acknowledgements

Researching and writing a book takes many hours of labour, some of it from the solitary space of the study. But it is also in many ways a shared endeavour. My thanks first and foremost to ex-workers from Firth Carpets Limited and local Bailiff Bridge residents. Employees from across the company generously gave their time to share memories of industrial life and culture. They attended focus groups at the community centre and led me on walking tours of the village. In some cases they kindly gave permission for me to reproduce their personal photographs and editions of the Firth staff magazines which offer a wonderful visualisation of work and life in what became from the mid-nineteenth century a company village. This book would not have been possible without their lived experience and knowledge. I also drew on a rich bank of material about Firth Carpets Limited from local archives. Thanks to Jenny Wood and Ruth Cummins at the West Yorkshire Archive Service and Eli Dawson at Bankfield Museum for help to obtain image permissions. Thanks also to the volunteers at the Carpet Museum Archive, Kidderminster. Short excerpts in chapter 3 were previously published as L. Taylor, 'Landscapes of Loss: Responses to Altered Landscape in an Ex-industrial Textile Community', *Sociological Research Online*, 25:1 (2020), 46–65. I am grateful to my editors at MUP – Tom Dark for originally commissioning the book and Shannon Kneis for seeing it through to publication. Thanks must also go to Laura Swift for her helpful advice and patience during the various stages of publication.

My fellowship from the Independent Research Foundation (ISRF) in 2021 gave me time to work on the *Intertwining Threads* project with the Bailiff Bridge community and artist Catherine Bertola.

Special thanks to Catherine, with whom it was a pleasure to work; her creative ideas were intertwined with her lived knowledge of the village's sense of place. Thanks also to photographer and filmmaker Nick Singleton, who managed to capture the essence of our work with the community of Bailiff Bridge in his short film *Intertwining Threads*.[1] I am grateful to Lars Cornelissen, Christopher Newfield and Stuart Wilson at the ISRF for their interest in the project and the opportunity to share my work at conferences and workshops. Thank you, Kevin Hetherington, for your support for my fellowship at the ISRF. Thanks to my old friends and BCCCS colleagues from Wolverhampton University – in particular Dorothy Hobson, Paul Willis and Helen Wood; I learned a good deal from the 'Ethnography' seminar series. Thanks to my colleagues in Media at Leeds Beckett University for covering my role during the fellowship. I have been lucky to enjoy a rich intellectual life in the School of Cultural Studies and Humanities. Thanks for critical conversations and comments on the manuscript at various stages, especially Katherine Harrison, Nasser Hussain, Simon Morgan, Ruth Robbins, Dave Russell, Heather Shore, Ali Taft and Zoe Tew-Thompson. Thanks to Laura Ettenfield and Zoe Moreton for being more than research assistants on the project. Others gave sage advice, encouragement or helped me over small hurdles in the research process: gratitude to Chris Bradley, Marci Green and Paul Lewis. Special thanks must go to Jayne Raisborough for unstinting support and bespoke advice throughout the journey.

I have enjoyed support as an affiliate at the international association DePOT (Deindustrialisation and the Politics of our Time). It was a pleasure to deliver papers at the annual conferences at the Ruhr, Germany and Cape Breton, Nova Scotia. I have given presentations about this research at various other universities, including Berkeley, California, Bologna, Strathclyde, Stirling, Glasgow, Newcastle, Kent and at Elefsina town hall, Athens. I am grateful to those who gave comments at these events that have helped along the way.

I owe a particular debt of gratitude to those who have given this project the kind of close attention which has been especially helpful. Tim Strangleman was particularly generous with his time and gave a good deal of support and encouragement. He helped me to underscore my familial connection to Firth Carpets and sharpened my thinking about the craft of writing through storytelling. Thanks to Nick Cox, whose historical knowledge and sharp critical eye

helped me to circumvent the temptation to idealise the industrial past. Special thanks to Sarah Doonican, whose endless encouragement and creative insights kept me going.

The support, patience and good humour of family and friends were highly appreciated. Particular credit must be given to Rauf Khan, the Khan family and Jane Shaw for maintaining good humour when it seemed like the act of writing would never end! Last but not least, my thanks to Jim and Nancie Taylor for all your stories about working at Firths. Witnessing your experience of thriving industrial life and its demise was inspirational. I only wish you were still here to see it to completion. Thanks, of course, to Alice and Freddie: this book is for you.

Note

1 Available to view on YouTube at: www.youtube.com/watch?v=DkvYaEgSb-4 (accessed 14 February 2025).

Introduction: a drive up Birkby Lane

My mother's story ...

It was Ella, my mother's older sister, who told her she had to find work in the mills at Firths. It was 1951 and my mother was 15. Ella, supervisor in the 'setting' where bobbins were prepared for looms, arranged the interview and they took Mum on. You could usually get a job at Firths if you already had family there. Her most vivid memories were of her time as a young woman in the early 1960s. She would walk down in her coat and headscarf to do her shift. Getting on well with your co-worker in the setting was important. Practically all the work in that department was done by women. There was a good deal of female camaraderie, and everybody was on first-name terms. Her job in the setting was to count the wool bobbins and set them on the frame, with all their vibrant colours, in readiness for the loom. 'Some designs, especially in Axminster, had colours you wouldn't believe, one had 56 colours!' she told me, adding while turning to look at me, 'we made beautiful carpets you know'. It was noisy in the shed – there would be 60 women there working at 30-odd frames and there were carts trundling up and down with yarn. And there was more beside just the work at Firths: the 'dos' were good. They'd book out big ballrooms in places like Halifax, Bradford or Huddersfield, and hire a big band, like Ted Heath and His Orchestra. You could dress up, have a laugh, dance to a number like *Mood Indigo*. It was packed with Firths workers and the people they were courting. It was something to talk about the next day at work: who was there, what they wore and what happened. ...

She was expected to resign from her job when she became pregnant in 1965. After I was born, she found low-paid interim work for the

local council as a 'home help' for the elderly, and she would take me with her. It wasn't until I went into reception at the local junior school in 1971 that she went back full time and moved into a new department. She worked as a design clerk calculating the amount of yarn required for the loom with a 'clicker device' as she counted the squares on the patterned design. It was a move up, an office job in 'Design'. It meant she could afford the odd treat to take home, usually from Waddingtons the drapers across the road from Clifton Mill where 'seconds' carpet offcuts that workers could afford were sold off. She bought a purple Berber shag-pile rug for the bedroom we shared. In the late 1970s she married my stepfather, quality control manager at Firths. We moved away from Bentley Avenue on Stoney Lane council estate, and she gave in her notice at Firths. Would she want to go back to those days? 'Not really', she told me. But she never experienced that feeling of community at work and at home in quite the same way again.

My story ...

Bailiff Bridge has altered beyond recognition. There must be 600 new-build pale-brick flats and houses sited over where the vast weaving sheds were when I was a pupil at Bailiff Bridge Junior and Infants' school. As I walk up Victoria Road now, despite the houses I can see, in my mind's eye I'm hurtled back to the excitement and apprehension of entering through a weaving shed doorway, one cold late December Saturday afternoon in 1973. Long tables decked with Christmas trimmings offered juice and sandwiches and music blared in the background as children, shouting with laughter, circled the floor playing chase at the Firth Carpets' Christmas Party. It felt like a privilege to be taken into out-of-bounds spaces where our parents disappeared daily behind the shed doors; to see inside, to inhale the stubborn smell of carpets that hung in the village air, only to experience it more intensely inside the works. Most of the children were classmates; three-quarters of the pupils at school had parents who worked at Firths. The highlight was the individually labelled gifts given out by Santa, of decent quality and carefully wrapped. The children of Firths workers, we were made to feel special as we and others climbed the platform in a performed display

to collect them. We lived in a company village where the worker's whole family felt the embrace of Firths' paternalism. We felt it together, we were part of the Firths club. What we didn't know then was that the memory of those parties – woven into our identities as children of the carpet industry – would stay strong through the collective spirit of interconnecting.

Dad's story ...

Dad retired as quality control manager in 1990. Thirteen years later in 2003 we took a drive through the crossroads of Bailiff Bridge, through and past the bricolage of old and new buildings, past the tract of churned-up, neglected brownfield land where Clifton Mill once stood at the crossroads before demolition in 2002. We drove up Birkby Lane, past the new residential blocks over the once-dye house to my left. The air in the car, with Dad driving to my right, felt heavy. Its silent atmosphere carried an emotional density. I could sense Dad bristle. As we reached the brow of the hill, I imagined the works back into the air and thought of him brushing past fellow workers in its corridors as he sought to solve a technical problem with a loom. I spent the next few moments in recognition that Dad must have felt terribly low seeing the radically altered space with no trace of the buildings he had spent the last 35 years of his working life navigating.

Illustrating an arc from a thriving industrial locale to a denuded, deindustrialised site, these stories chart half a century of the rapid process of industrial change. The first shows that women and men could secure an employment contract in the early 1950s when my mother could easily get a local job by word of mouth, where there was 'work for everyone who wanted it' in Britain.[1] Being able to acquire work through a family member and trusted employee was an entirely acceptable social more in industrial culture at this time. The post-war settlement offered a decent standard of living, while the functioning welfare state addressed inequalities through its social and economic safeguards.[2] My mother's story details the ecology of local industrial life and how it was experienced. She tells of the importance of partnership and mutual trust; of the rhythm of physical

Figure 0.1 My mother at work in the setting, circa 1962. Author's photograph.

work involving specialist skill using hands and bodies in groups of other female workers; the sense of importance and pride in making vibrant, high-quality carpets together (see Figure 0.1). Her story shows the convenience of company village life: living at walking distance to the mills. The benefits of local services – the school, the local pub – amenities that had clustered around what the place had become since its beginnings in the mid-nineteenth century: Firth Carpets Limited – the *raison d'être* of the village. It tells us that Firths provided the social glue that could bond affective ties through its extensive programme of paternalism: the days out, sports clubs, worker games of tombola and the nighttime 'dos'. While working together sometimes led to friendship, the social programme provided workers with opportunities to meet at impressive, fashionable events which created convivial spaces, conducive to play, courtship, love and marriage. It offers an insight into how life was lived in a company village assured of its traditional and historic standing as a proud manufacturer of woven carpet. While my mother had no desire to go back, her account is tinged with nostalgia for an authentic way of life rooted around industrial work in mid-century Britain.

But it is also, importantly, a gendered story about the realities of a working-class woman's life in a textile mill. My mother's work was pre-decided by her family's economic circumstances and by the cultural expectations that living among mills produced: there were no choices. Her employment journey was to join a tranche of other local female textile workers whose employment destinies were also likely to be pre-decided. When she became pregnant, and in line with manufacturing legislation at the time, Firths' 'family' generosity evaporated.[3] She had no choice but to leave and seek employment that paid less than work in the setting. She had to 'manage' and negotiate how to care for her child as a single mother and re-start her life as a textile worker when it suited Firths to re-open its doors to her. Luckily, she could carry on living with her ageing parents on the council estate. But like Carolyn Steedman in *Landscape for a Good Woman* (1986), who writes of a working-class childhood in which her father was 'barely around', our stories, both mine and my mother's, mark an important intervention.[4] They lie outside twentieth-century working-class histories of community in which the 'family' is 'headed' by the male figure of the father. Set against 'countless streets' in Leeds and Northampton, Richard Hoggart and Jeremy Seabrooks' accounts assume fathers worked to support the family and the mother stayed at home.[5] Our experience sits outside their idea of the group-bound homogeneous working-class family. There are compelling accounts of sons witnessing their father's experience of industrial life;[6] here I speak as a daughter of watching a working-class mother who held down a job in a carpet factory to single-handedly support her family.

A good deal of literature about deindustrialisation explores the 'heroic' masculine labour of heavy and dirty work in industries such as coal mining and steel.[7] Nick Hedges' spectacular photographs of male steelworkers doused in soot, manoeuvring their gait to balance a piece of red-hot molten steel in *Born to Work* (1982), about the emerging precarity of the Midlands steelworks, offer an example.[8] *Threads of Labour* counters the celebration of uber-masculine labour. By focusing on Firth Carpets, it shifts the focus to the relative invisibility of the bodily skills required for textiles. Work in woollen textiles factories – which included the production of carpet and worsted cloth – was characterised by the large number of varied worker roles within the factory setting, required to keep the 'number

of cogs' or wheels of the textile factory turning.[9] In some cases, there would be upwards of 30 different jobs within a typical factory. This work was gender segregated, with a more or less 50/50 split between male and female workers.[10] Weaving, classed as semi-skilled, is perhaps the best known, where the body and hands were used to operate highly complex technical loom machinery. Part of the weaver's job was to supervise its smooth operation – this required careful visual monitoring and the weaver to stand by with hand tools such as pliers for intervention. Carpets were finished, predominantly by female workers, through close inspection, which might require sewing at machines or hand mending of faults as well as 'leaning in' the body to get close to the carpet. It was also the case that gendered labour meant differential pay. Women's wages were on average £12 a week lower than men's in 1971 – a significant difference.[11] Men did work which drew on technical expertise for handling looms; women worked largely on the more filigree tasks using fine-motor hand skills required to produce the finish for the quality that a company like Firths used as its selling point.

The renowned photographer Martin Parr visualised these roles when he was commissioned to take photographs in Hebden Bridge in the Calder Valley in the 1970s. He produced a collection titled *The Non-Conformists*, including the series *Firths Mill* in Bailiff Bridge between 1975 and 1980. This black and white collection, shown at an exhibition at Bankfield Museum in 2020, opens Firths' doors to reveal the intrigue of the largely hidden and highly varied roles of carpet workers at their machinery.[12] Men are shown working at broadlooms, tying in an Axminster gripper creel, operating a beaming machine and preparing hanks of wool in the dye house. But importantly, 10 of the 16 photographic plates show the extent of the contribution of women's work at the factory. Contrary to popular belief, some women did have the technical skills to operate looms, though when they worked in weaving they were in the minority. In this collection, they are shown spool setting an Axminster loom, as my mother had in the 1960s, rectifying weaving faults on a narrow loom carpet, sewing a fringe onto a rug and winding in Wilton. What they amply demonstrate is that work in the setting, winding and mending was performed almost exclusively by women. Essentially this gendered segregation was part of the economic rationale of Firths' factory departments; men were better paid for

what was considered higher, technical and more autonomous work. Parr's photographs offer a snapshot, a slice of Firths in the 1970s. This book opens the door to a wonderful cache of photographs which tell a much wider story of the firm across the twentieth century, in the hope of deepening our knowledge of how workers contributed to Firths' standing as part of the industrial heritage of carpet making.

Publishing in deindustrialisation studies has burgeoned into a varied and vibrant topic, as I illustrate later in this introduction. Undoubtedly, given the emphasis on the male worker in accounts of labour history, the wool textile industries have been overlooked in deindustrialisation literature because of the preponderance of women workers involved in textile production. Moreover, as a consumer industry the carpet industry, with its female-centred associations, has received scant attention. Carpet is a decorative art. It has long been thought of as a 'craft', traditionally associated with being a women's practice. While carpets have been used as wall hangings, in the British colder climate they usually clothe the floor. Made so that wool or other fibre stands upright as a pile, they are pleasantly sensuous to the touch underfoot or the hand. Bertram Jacobs describes them purposefully as 'lustrous and comforting, decorative in colouring, ... protective against a floor that would otherwise be cold and unfriendly'.[13] Carpets and rugs offer a way to bring appealing aesthetic design principles to domestic spaces. In a lecture delivered at the Wool Secretariat, Thomas Marchetti, chief designer at Crossley's Carpets in Halifax, describes the fascinating design-to-production process of a floral Chintz in the mid-1940s. He shows a clear understanding that the key household decision maker was the 'British housewife' who, because of household economy, will 'more often play safe'.[14] Firths supplied an array of goods to meet the demand required to cater to the feminine competence of homemaking from the mid-nineteenth century. The Victorian woman's drawing room ensemble included Georgian-style features, including expensive 'red turkey carpets', to indicate taste, wealth and status.[15] The company moved to mechanise Chenille carpets in the 1860s, making them accessible to middle-class domestic consumers. When house buying increased, it took the shrewd decision to continue traditional designs when housewives longed for the fashion for 'modern' but had to make their existing furnishings go

further in post-war 1930s Britain. Firths made use of cultural intermediaries to reach female consumers, advertising its goods in trade design journals such as the *Furnishing Trades Organiser* and women's magazines of the 1950s. Its branding drew on the feminine appeal of blonde identical twins, shown lying or sitting on its ranges in advertising leaflets. But as a consumer industry, it faced very tough challenges. It had to balance its production with supply and demand, which depended on a nexus of factors. Throughout its illustrious history it had to ride the ebbs and flows of international economic inflation and recession. It dealt with fierce global competition and was heavily dependent on the housing market. From the start of the post-Fordist years in the 1960s, cultural bids for personal expression began to be met by yet more demands for increasingly specialised tastes in home goods. The industry had to cater for a wide range of designs in an increasing range of materials as scientific developments meant wool could be blended with synthetic fibres. It encountered a major challenge when wood and laminate flooring became fashionable in the 1990s. The latest developments in technical textiles, such as medical technology, sportswear and protective clothing, have given new buoyancy to the industry, but conditions are no less challenging today.

Moreover, given the strand of labour history in deindustrialisation studies,[16] wool textiles in West Yorkshire have probably been occluded because of the historically low level of trade union membership since the post-war period. Trade unionism was conspicuously absent across the research journey. I found a silence around union membership and strike activity in the Firth Carpets Archives, aside from an appreciative management bulletin thanking workers in the mid-1970s for not resorting to strike action. Why was this the case? Laura Price argues that trade unionism was historically weak in wool textiles for several reasons.[17] First, the environment of mills was not conducive: workers across segmented roles in spatially separated departments across factories had few opportunities to collectively organise. The deafening noise of mills, so damaging to the hearing of the Firths weavers and creelers I interviewed, made it hard to interpersonally communicate about unfair conditions. Secondly, unlike coal workers who were aligned to trade union affiliation rooted in local communities, which combined to generate a clear sense of occupational standing, textile workers lacked a strong

industrial identity. T. F. Firth and Sons originated in 1822 in Heckmondwike and became split across two sites in 1897. The carpet-making division was sited at Bailiff Bridge – the main focus of this book – which employed predominantly white workers. Immigrant labour, particularly South-Asian workers, was employed at the Flush Mills site in Heckmondwike which specialised in textiles and mouldings for car interiors. These constitutions are germane to her argument about membership motivation. Price draws on oral history interviews to argue that gendered or ethnic worker identities figured more powerfully than being a textile worker. The logic of this argument is that female workers were more likely to prioritise activities such as domestic housework associated with their gendered identities as wives and mothers – as my mother did – above attendance at union meetings. Moreover, the main wool union, the National Union of Dyers, Bleachers and Textile Workers (NUBTW), founded in 1939, appealed to white, male skilled workers and made little attempt to recruit either women or immigrant workers. Given the size of women's contribution and that in the late 1960s a third of all woollen textile workers in West Yorkshire were immigrants,[18] this seriously undermined the political power of the NUBTW. An important additional factor in the case of Firth Carpets was its largesse. As a big player in the carpet industry, it understood the instrumental power of paternalism to circumvent trade unionism. The 'dos' and sports clubs coupled with staff magazines did much to encourage loyalty among workers to the Firths 'family'.

From this angle, the story of Firth Carpets' deindustrialisation and closure seems like a non-event by comparison to accounts of the bitter coal-mining strikes in 1984–1985. Beyond periodic local press accounts of dwindling jobs across the 1980s and 1990s, I found no evidence of collective worker resistance or fights against closure. It was a slow-motion, mundane story of gradual job loss and takeover.[19] But this book insists that non-spectacular stories, affecting the lives of carpet workers – often female or immigrant workers – at times rendered invisible in the archive materials, need to rise to the top of the pile and be told.

Two decades on, my story shows how adept Firths was at conferring value across the worker life course on the children of its workers as a way of creating a sense of industrial identity. These yearly

Christmas parties took place in the wake of the carpet industry's peak in 1966, within the purview of Firths' budget. Exciting and highly memorable events, the fact they were staged in the works buildings was significant. It piqued our intrigue as it pulled us into the spaces of industrial culture that, as children, we had never been allowed to see. This guarded approach was not uncommon; many firms acted to protect the formula that underpinned the quality or selling points of their products. We felt being let in placed value upon us; we felt special. It underscored Firth Carpets legacy as a generous family employer, to make way for what must have seemed unproblematically feasible from its vantage point in the early 1970s: the next generation of Firth Carpets workers. In this way, it extended its vertically integrated, self-sufficient 'way of life' in the expectation it would be reproduced. My aspirations to study at university outside the region meant that working at Firths was confined to the summer holidays in the mid-1980s, when Dad would urge me to apply for a summer office job. But I did suffer the intergenerational hurt of witnessing Dad's affective pain on that drive up the hill, an emotion too difficult for him to talk about. I watched the effects on his health during a retirement lived at such close quarters to a company in slow decline. I too suffered loss and longing for a place that had once defined my family's purpose and acted as the safe place of home on those drives through the village as it crumbled through demolition. Firths' Christmas parties are a fragment which formed part of the larger impetus to return to Bailiff Bridge and unfold hitherto untold stories about a textiles company village through this book.

My stepfather's story comes 13 years after his retirement event in the showroom at Clifton House. It unfolds the affective pain of witnessing the loss of works buildings after Firths was acquired by the US textiles giant Interface in 2000 and the decision was taken to close the company premises in Bailiff Bridge as a manufacturing base. It shows that within the space of one generation, the good way of life that my mother's story illustrates in the 1960s had largely evaporated. Of course, the drive up the hill of Birkby Lane did not come as a complete shock. Dad worked at Firths during the late 1970s and the recession of the early 1980s. High interest and exchange rates meant that manufacturing fell sharply and unemployment

followed. As John Hargreaves shows in *A History of Halifax*, textiles took a dramatic hit and job losses accelerated sharply between 1976 and 1981.[20] As textiles declined, the service sector became dominant in Halifax and the Calder Valley, as women left their jobs in the mills to work in banking, catering and personal services.[21] This blow was compounded by another recession just after Dad retired in 1990. The local *Evening Courier* reported 70 job losses in April 1991 and subsequently that year a 35% profit slump.[22] But while the recession ended in March 1991, its effects reverberated through the early 1990s. In February 1992 the paper reported on a visit by Labour MP Roy Hattersley in the feature 'Where Are All the Workers?'[23] It contrasts an earlier visit at the start of the 1970s when there were 1,400 workers with a figure of 650 after jobs had further dwindled. Hattersley toured what the paper describes as a 'fighting carpet firm' accompanied by the Transport and General Workers Union convenor. But in September 1992, the paper reported 'talk of redundancy in one of Calderdale's biggest employers' and rumours of yet more workers threatened with lay-off.[24] The company did fight back the following year by ploughing £1.5 million into brand-new high-speed machines for making tufted carpet and a shed refurbishment to house them.[25] The move to open its new 'tufted division' was marked as an auspicious occasion at its opening in 1994 by Prime Minister John Major. But the firm's long-standing pride and concern to protect its reputation as a maker of luxury carpets meant it was slow to manufacture what it believed were lower-quality carpets. It was an important move, but one that came too late. And while the national economy grew in its aftermath by 15%, manufacturing employment in the UK continued its downward trajectory.[26] Dad could only watch Firths struggle to carry on against inclement political weather in the mid-stage of his retirement. Reading Christine J. Whalley's account of her father's lay-off at Wisconsin Steel, a firm which abruptly ended his pay, health care and retirement benefits in 1980, I realise that my father suffered relatively lightly.[27] The stigma of work loss meant that Whalley's father fell into depression, agoraphobia and a lack of self-care, and some of his fellow workers took to alcoholism and even suicide. My dad retired early enough not to face redundancy and the stigma of losing his job at Firths. But I know that watching the struggle of the 1990s and eventual closure of the company in the early 2000s from close

quarters produced low mood and added to his sense of purposelessness. Of course, these feelings of witnessing what one ex-Firths participant later called 'Firths and Bailiff Bridge go down and down and down' was a process I had returned to in my mind ever since I had reached the brow of the hill on that drive up Birkby Lane in 2003. From the heavy atmosphere of the car my thoughts expanded out to the remaining community of ex-Firths workers. How had they come to terms with the closure of Firth Carpets? How did they feel about the erasure of its landmark industrial buildings and features – the clock, the works canteen, the mix of tall and expansive mills? How did they speak and relate to each other about such significant place changes? These questions are pivotal themes of this book.

The seed of the drive I had taken with Dad up Birkby Lane continued to germinate. As a cultural studies academic, in around 2015 I had begun to develop an interest in the idea of landscape and how cultures of meaning accrete around how people think and feel about places. I researched how people from the North used Yorkshire artist David Hockney's East Wolds landscape paintings from *A Bigger Picture* to counter pejorative ideas of the North as a grimy, ugly, culturally barren locale.[28] Living just two miles away from Bailiff Bridge, I was also at this time making repeated journeys through the crossroads where the central buildings of Firths had stood at the heart of the village. As I did so I became highly conscious of a set of memories and feelings that moving through the landscape of my childhood evoked. I thought back to playing with friends on summer afternoons in the soft-water 'beck' – essential to carpet making – which ran through the village, fishing for tadpoles and newts, finding occasionally that the small stream would be vibrantly coloured by dye from the works. I thought back to how dangerous it was to be on the pavements of the village as a child in the early 1970s when hundreds of workers with their frenetic energy spilled on to small streets when the sirens called out at 5pm. I recalled being almost knocked over as they hurried to catch the buses that Firths laid on to carry them home to local villages and towns. I remembered summer evenings when my friends' mothers would walk down from the estate in light overalls to the works to start their nightshift work at 6pm in the mending or setting. What I saw on those drives in 2015 was a radically altered place. What remained was a fenced-off tract of land. Living in the adjacent small town of

Figure 0.2 The tract of land where Clifton Mill once stood, 2016. Author's photograph.

Cleckheaton, I often pass through Bailiff Bridge. For the last 22 years I have watched the shifting ecology of this churned-up space of bricks and rubble: weeds and plant life surge and die back with the seasons and advertising hoardings have sometimes faced out to the passing public (Figure 0.2).

In 2016, I returned to the village to research the questions that the drive up Birkby Lane with my stepfather back in 2003 had provoked. Studying the community involved working as an ethnographer, using ways of researching people's experience of witnessing and living alongside the fall of Firth Carpets and its impact on the village of Bailiff Bridge. My approach is underpinned by the culturalist strand of the field with its commitment to understanding lived culture by listening to voices 'from below'. But in returning to this space, I need to acknowledge where I am located in the book. When I look at the space where Clifton Mill once stood I recognise it as a contested space – open to be understood differently according to one's interests. For me, it is emotionally charged; I am personally

invested in this book. Raised in the village, as a pupil at Bailiff Bridge Junior and Infants' School, like many of those children, most of my family worked at Firth Carpets Limited. While my mother and stepfather worked there, so had my grandmother and maternal aunts.[29] I am the author, but in a partial sense also a subject within the story. I too have witnessed and experienced the decline and eventual removal of the works, and these factors make this book auto-ethnographic in orientation. I recognise that emotions form the subject matter and that my investment in Firth Carpets and Bailiff Bridge is embedded in this book. In this I join a generation of scholars who have also witnessed and experienced the compulsion to write about industrial decline.

Deindustrialisation is a vibrant topic of enquiry with a burgeoning literature, much of which emanates from studies in North America and Western Europe. It is also a process running parallel with neoliberalism across the global North. Couching an understanding of its features within global neoliberal capitalism, it is possible to trace similarities of experience across deindustrialised places. As the intergenerational familial stories at this chapter's opening reveal, communities felt loss of pride and respectability in making tangible and desirable goods,[30] the evisceration of work which gave economic stability[31] and a halt on the affective working rhythms which once characterised industrial identity and culture.[32] Sherry Lee Linkon's phrase 'the half-life of deindustrialisation' captures the simmering and enduring toxicity of the effects of industrial retrenchment years after closure.[33] Writers ascertain unemployment, poverty, difficulty embedding into service industry work, and physical and mental ill-health.[34] Ruination in old industrial Britain has left town and village high streets bereft of amenities – leading to yet more loss in pride of place. Writing some 30 years after plant closure, writers have highlighted the problems ex-industrial communities encounter when newcomers settle in deindustrialised places, often feeling an aching nostalgia for industrial paternalism which made physical, tight-knit community relations affording high levels of sociability and security to workers. Previously industrial towns become commuter centres or dormitory villages, shifting the identity of place in ways which in Bailiff Bridge feels disorientating for ageing ex-workers.[35] Yet commemoration in deindustrialised locales – of disasters, past struggles or the valorisation of lost labour – is never

straightforward. Speaking of Lowell in Massachusetts, Cathy Stanton argues that high tension is an inherent feature of heritage projects which attempt to mix celebratory occasion and post-industrial regeneration because stakeholders have such widely competing interests.[36]

Thus, when I returned as a researcher to Bailiff Bridge in 2016, I came with an interest in thinking about the village as an emotional landscape of loss. But the socio-political circumstances which formed the backcloth to the run-down village of 2015 meant that a good deal had changed since our drive up Birkby Lane in 2003. The recession triggered by the financial crash of 2008 prompted a re-evaluation of Britain's polarised labour market trends between the North and South and between city regions. What emerged was an awareness that locales known as 'old industrial Britain', what Christine Beatty and Steve Fothergill describe as the 'smaller places beyond the big cities', formed as vertically integrated business centres in the nineteenth century, were failing to recover.[37] It is these places 'where the loss of industrial jobs is most likely to have been most keenly felt and where we might expect to observe lasting impacts'.[38] The global financial crisis, with its swinging austerity measures aimed in the main at the public sector, acted to deplete financial resources at local authority level.[39] This led to the closure of many public services in what were described as 'the deepest and most precipitate cuts ever made in social provision' in Britain.[40] It signalled what some described as a 'radical contraction of the welfare state'.[41] It meant that vulnerable people at the less fortunate end of Britain's class society – from disabled people and working-class children to those beset by unemployment in deindustrialised communities – were set to lose. The welfare reforms of 2010 deepened the crisis by increasing poverty rates, increasing precarity, pulling down living standards and widening inequalities. For deindustrialised communities who already felt depleted from the loss of their industrial livelihoods, the cuts must have felt like a double punishment.

The austerity years fermented a deep sense of disillusionment for deindustrialised communities. Disaffection led to a sense of marginalisation – the feeling now widely accepted in political debates of being 'left behind' – a state of being now widely read as a major contributing factor to the geographic distribution across older industrial Britain of votes to 'Leave' the EU in the Referendum of

2016. Some argued that the Leave vote emanated from a particularly British sentiment: the painful knowledge that the once 'global hegemon of the capitalist world economy' now felt a 'deep sense of the loss of global prestige'.[42] Actually, if the Firths community did feel this way, it perhaps shouldn't surprise us. Throughout the twentieth century, Firths held global reach and employed 39 international agents across the British Empire to export and deliver carpets and rugs to markets overseas. It maintained production throughout the dour and hungry 1930s with a workforce of 3,000 workers and managed to become one of the big six carpet manufacturers in the UK. It exported to 'every carpet consuming country', shipping to 40 global markets beyond the mid-1960s.[43] Firths' prestige must have loomed large in worker mentalities: how could the loss of that prestige not come as a heavy blow? No wonder that increased international competition from other carpet-making countries during the deindustrialising years led some of the ex-workers I interviewed to believe that globalisation was a causal factor in the company's demise. Indeed, some commentators argued that the EU Referendum result was more of a barometer on how communities felt about globalisation than their experience of the EU. Alan Finlayson, for example, argued that the more resentment people felt about losing out both economically and culturally to processes of globalisation, the more likely they were to vote Leave.[44]

In deindustrialised regions such as Teesside, traditionally a working-class socialist heartland, the Leave vote marked 'one of the most unexpected election results of the modern era'.[45] It represented a deep sense of political alienation and a firm step away from the Labour Party. The result was that the Labour Party lost 20% of its seats in the subsequent general election of 2017. Brexit also played a central role in the breakdown of the Red Wall in 2019, the corridor of constituencies running from Northeast Wales to Northeast England, which for the first time in their electoral history casted a Conservative vote. Calderdale's ward has returned a Conservative MP since 2010, indicating the region's longer-standing disillusionment with Labour, but its 55.7% Leave vote was not incompatible with regions in the UK's deindustrialised locales. The reasons can be read as twofold: the Labour Party failed to devise a robust industrial policy and years of neoliberal policies across both Conservative and Labour governance – the privatisation of public services, poor wages, and growing

inequality and deregulation had a deleterious effect on national life. What the Referendum provided was an opportunity for people in broken down industrial Britain to voice their sense of injustice after all they had been through.

Britain is arguably the most regionally unbalanced country in the global North. There are many 'left behind' places which, in terms of living standards, lag far behind London and the Southeast of England. Consecutive governments in the UK have attempted to harness regional inequality within 'tolerable limits',[46] but critics argue that the logic of neoliberalism's spatial growth led to deindustrialisation across pockets of the Midlands and the North, denuding them of their industrial livelihoods. Simultaneously, the Southeast and London – known as the world's most prestigious financial centre – powered ahead in the UK, deepening an already long-standing North–South divide. Regional inequalities were severely worsened by the 2008 financial crash, subsequent austerity cuts and by the C-19 pandemic. Politicians had to act in response to gross regional inequality and to the damage being reported in post-industrial places: increasing poverty, low educational attainment and deleterious health effects. In 2019 the UK government announced its 'Levelling Up' strategy, expressed in its 2022 White Paper. Drawing on vibrant historical moments of industrious economic and cultural success, such as Renaissance Italy and Britain's first Industrial Revolution, the tone of the White Paper is aspirational, arguing that all citizens hold the right to flourish – no matter where they are placed across the UK.[47]

The socio-economic geography of Britain is uneven, and each depleted deindustrialised region is highly specific in terms of needs. Stoke-on-Trent for example, which has already been granted funding through the Levelling Up programme, has virtually lost its Ceramics industry. But Calderdale is also identified as a priority area. In a report detailing priority zones by the Institute for Community Studies, the authors discuss two categories for Levelling Up: regions with the greatest need and those which worsened significantly between 2015 and 2019.[48] Calderdale meets both of these criteria but Bailiff Bridge as a deindustrialised locale carries its own specific issues which should be addressed by Levelling Up. This book draws on the ageing Firths ex-workers who were laid off or retired a generation ago and were mostly of pension age when I returned as a researcher

to Bailiff Bridge in 2016. It might be tempting, as Beatty and Fothergill argue, 'to assume that the problems arising from deindustrialisation have passed into history', especially for this group of ex-workers.[49] But they too carry the consequences of deindustrialisation; it is just that their problems are less exposed in both popular media narratives and academic enclaves. In the early phase of my research, I found that Firths ex-workers acutely felt the loss of the culture and rhythm of industrial work. They felt robbed of the works buildings which offered them a sense of industrial heritage and faced difficulties navigating a landscape which was both scarred by demolition and extensively rebuilt. They sorely missed a physical community, which industrial life and work had secured around them. Accustomed to living in a place which was once a self-sufficient working business centre, they struggled to live in what has become a 'dormitory village' where people live but out-commute to work elsewhere. And as a generation who still believes in the values of industrial culture, they found it hard to build social ties with newcomers who had little connection in a place which once had a strong identity as a centre of industrial heritage.[50]

So what is the focus of the Levelling Up agenda? How relevant is it for the issues still festering in Bailiff Bridge? The *Levelling Up* White Paper's 12 'medium term missions' set for completion by 2030 focus down on place-based problems in recognition of the need for all citizens to enjoy, 'longer fulfilling lives … from sustained rises in living standards and well-being'. It advises attention to the geographic scarring of deindustrialised places: the 'visible effects on the high street' and the need to 'remediate brownfield land'. Attention to these deficits, it implies, will 'restore a sense of community' and build 'pride in place, health and well-being'.[51] On the face of it, these recognitions are welcome. But the White Paper has been virulently attacked: for high ambition but poor financial planning and resources; and for maintaining belief in the regeneration of innovation within the market capitalist system that was the root cause of regional inequality in the first place.[52] According to the Public Accounts Committee, only a small percentage of the money has been spent, projects are subject to delays described as 'astonishing' and the Department for Levelling Up, Housing and Communities has struggled to provide examples of completed work.[53] Notwithstanding these criticisms, West Yorkshire Combined Authority announced a fund

of £89 million from the Department of Levelling Up, Housing and Communities, pledging 5,400 new homes by March 2025 to grant 'improved housing delivery on Brownfield sites'. But at the time of writing, the five projects set to benefit are located not in 'hinterland towns and villages' such as Bailiff Bridge, but near to the cities of Pontefract, Wakefield and Leeds.[54]

Moreover, the roll-out of Levelling Up incentives has, according to critics, proved problematic. A key driver is the tension which has arisen between a highly centralised Westminster government, one of the most centralised liberal democracies in the world, and the aim that Levelling Up incentives be delivered through local actors. Devised from centralised control, ad-hoc policy-making failed to respect the local knowledge and sub-national funding arrangements that were required to achieve genuine place-sensitive policy development.[55] Indeed, the report by the Institute for Community Studies, titled 'Why Don't They Ask Us?' (2021), argues that community participation in Levelling Up economic intervention has been 'seriously undervalued'.[56] Despite the funding for capacity building of deprived local economies over the last 20 years, over half show the non-existence of community-engaged incentives. This emanates from a lack of trust higher up in political and administrative circles; a belief it is naïve to assume that communities possess expertise, can agenda set or identify relevant actions. This, the report argues, has solidified into a 'lack of tradition in this country of genuine co-creation and community engagement in local public service delivery'.[57] But while community members in places like Bailiff Bridge are tired because they have been persistently left behind, they do have the capabilities to voice the issues which matter to them from their vantage point.

This book is about an arts-based attempt to tackle the place-based community problems acknowledged in the *Levelling Up* White Paper. Designed with a clear sense of trying to achieve a grassroots social outcome, in 2021 local artist Catherine Bertola[58] and I set out to specifically address what the voices I had listened to in the early phases of my research said about the experience of place. We understood Bailiff Bridge to be a community eroded by demolition, its old sites covered over by unfamiliar and architecturally out-of-place new-build houses. It was also, from the vantage point of ex-workers I had been working with since 2016, a divided community with an

influx of newcomers who remained, at least a decade on, relative strangers. With funding from a research grant we put a call-out to both sides of the community for their participation in a project, based on artmaking workshops.[59] Our aim was to bring healing and care opportunities, because from what we had been told through 'deep listening', nobody had bothered to ask what the process of deindustrialisation had wrought upon the community.

We set up two workshops in the summer of 2021. To reach newcomers we leafleted the new builds and to attract interest we badged it as an opportunity to learn about the industrial history of the village and meet new people. We wanted the workshops to be loose and improvisatory and led from what Catherine called 'the living, breathing archive' of ex-workers. Sure enough, with village newcomers in attendance, setters and weavers socialised with an affection which demonstrated how workers had made their own culture within the walls of the mills. The atmosphere was highly convivial and there were gentle jibes made about one weaver who worked in the tufting division – which drew on the widely held view at Firths of tufted as lesser-quality carpet, but a product which was equally respectfully understood as a best seller which extended the life of the firm. There was a common textile vernacular and a subtle but visibly shared understanding of the values of the times they had shared: decent wages, particular forms of interaction, company socials and physical recognition in the village and adjacent towns – set within an understanding of the standard employment contract and the rootedness this had afforded their lives. As they spoke they re-acted memories of their specific roles using bodily movements which they knew would be understood by other ex-workers. What came through was the rhythm of textile work conducted to the sound of the looms and often borne out in the rhythm of repeated pattern on the surface pile of carpets. In this way the workshops conjured the presence of an industrial 'structure of feeling' that had characterised the experience of working-class life at Firths in Bailiff Bridge.[60] Conversations extended out and ex-workers 'passed on' to newcomers the technique of tying the weaver's knot – an early fundamental technique of learning the art of carpet making. Our hope was that newcomers would bring a supple approach to these social encounters and bring their own

intrigue about the history of a transformed place to the local community centre where the workshops took place. In the second workshop the mutual 'passing on' of skills was captured in a series of photographs which formed the *Intertwining Threads* exhibition in the director's Boardroom at Clifton House, built by Firths in 1901.

Female ex-workers were in the majority at the second workshop, several of whom had worked in the setting or mending. Interaction between the two halves of the community deepened, and with our photographer Simon Warner in tow, female worker hands featured predominantly in the photographs. In this way, the exhibition added to one of the long-running threads in this book: the centrality of women's work in the factory. The photographs spotlight female hands and in the process offer a paean to their carpet-making labour. The centrality of place in terms of where the workshops happened – in the community centre at the heart of a village stripped of its industrial past – gave pivotal meaning to the affective poignancy of the project. Our aim was for mutual, two-way conversations to arise, so that some kind of agenda setting about what mattered to all participants interested in feeling pride about Bailiff Bridge could take place. This process aimed to make a model of cohesion; along the way we made a photographic exhibition as part of the workshops for both sides of the community. The book now locates the formation of Firths' early beginnings and proudful industrial history within the climatic and geographical context of the region.

Setting the scene

To imagine Firths' early beginnings, a consideration of the region's physical geography enables an understanding of why textiles became the locus of economic growth from the medieval period. Halifax and its isolated Pennine valley environs consist of low-quality topsoil. The short growing season made it difficult to sustain much beyond subsistence farming and drove upland famers into by-employments – mainly in weaving. Calderdale's fast-moving moorland streams and becks provided another advantage by providing a flow of soft water to support the dyeing and finishing of yarn and cloth.[61] The

transition to the 'factory system' was not without suffering and resistance,[62] but between 1770 and 1930 mill towns and villages, which brought employment to communities, sprung up across the area. Today the sheer number of mill remnants which texture its distinctive landscape offers a flavour of the rapid development of the region's history: the website *Yorkshire Industrial Heritage*, for example, lists 1,645 textiles mills in West Yorkshire.[63] The Wikipedia page *List of Mills in Calderdale* cites 348.[64] It was within this vibrant and fertile atmosphere of growth that Firth, Willans and Company established blanket-making facilities at Flush Mills, Heckmondwike in 1822. Growing standards of living produced a hunger for carpet both at home and overseas, and Thomas Freeman Firth looked to extend his premises. He attended an auction at the White Swan in Halifax and acquired a small worsted mill in Bailiff Bridge along with a house, surrounding fields and a warehouse.[65] Thus, T. F. Firth and Co. was set up in Bailiff Bridge in 1867. An assessment of the site pre-purchase must have shown its eminent suitability for carpet manufacture. Three becks joined in Bailiff Bridge, giving the company a pure water supply. The crossroads at the heart of the village made for an easily accessible transport system by horse and wagon which linked to a local railway station at Brighouse. The firm was nourished by a ready supply of labour in Bailiff Bridge and in the surrounding populous villages of Wyke, Hipperholme and Brighouse – all within walking distance of the mills. But this labour supply was often because the factory system and the introduction of the power loom drove handloom weavers into wage labour and exploitation.

This portrait of a humble blanket-making firm set within a sometimes dank and moist landscape was mapped and narrativised across a host of materials: in Firths' advertising,[66] in a lecture designed for student visitors to the firm;[67] and this early history exists today on local history websites. Patrick Joyce suggests that throughout the nineteenth century close associations were forged between factory buildings and industrial communities.[68] Robin Pearson argues that this repeated sense of the past is key to how industrial communities conceptualise their sense of identity.[69] Historically, the upright beacon of mill chimneys peppered across the landscape has continued to signal belonging and a sense of place in community life. Today they remain an important symbolic motif of the region's industrial heritage

and form part of the atmospheric flavour of the area's identity and artistic culture. The writer Phyllis Bentley (1894–1977) made a spirited defence of the aesthetic value of mill chimneys, 'skilful and beautiful structures ... most unjustly disliked'.[70] She also used the Halifax cloth industry as the setting for her book *Inheritance*, a saga which was later made into a series for Granada Television. Some of the mills across West Yorkshire are considered outstanding. Saltaire Mill in Shipley for example, built by Titus Salt in 1853, is a grade 2-listed building. Bradford artist David Hockney's only permanent collection is curated across its magnificent and expansive stone floors.[71] More recently, the streets of Halifax and its clutch of local towns and their surrounding environs of mills and moors form the brooding, dramatic backcloth to the recent acclaimed television crime drama series *Happy Valley* written by local writer Sally Wainwright.[72]

Given that the book sketches humble beginnings for Firths, one could be forgiven for reacting with incredulity to the development of its international reach, expansion at home and prestige as a company. From the late 1800s Firth and Co. had aspirations beyond the local. In 1888 it established one of the earliest carpet firms in the US, The Firth Carpet Company, at Firthcliffe in New York State. Another factory was later added at Auburn, and Firths became an important US carpet producer. As these expansions and acquisitions show, companies across the British carpet industry were built primarily by entrepreneurs from very prosperous families, some of whom formed part of Britain's nobility. Thomas Freeman Firth, the son of founder Edwin Firth, and later William Ackroyd, managing director of the Bradford Dyer's Association, who bought shares in the business in 1909, were made baronets due to their success as carpet manufacturers.

Firths shared a patriarchal management structure in common with the rest of the industry; as Neville Bartlett notes, 'just over 100 men became carpet manufacturers between 1861 and 1913'.[73] It also held a deeply conservative outlook expressed in the twentieth century in the cartel-like associations, such as the Carpet Manufacturers Association and the Federation of British Carpet Manufacturers, that dominated the industry with strategies such as price fixing. It was a squirearchy which held powerful influence over which carpets were valued and protected, such as luxury woven carpets, and those

which would be subject to hierarchical 'quality' judgements, such as the lower-valued tufted.

Across the twentieth century business in Bailiff Bridge continued to expand; the further acquisition of land enabling the company to build Victoria Print Works for drum printing for the Tapestry process in 1901. Birkby Lane block (known today as Clifton House) was added in 1909, the floors of which had been strengthened so that the building could house a warehouse. Expansion continued as shed followed shed, adding to those existing on Victoria Road (see Figure 0.3).[74] The site at Bailiff Bridge was to be the manufacturing base of innovation and continual adaptation right up until 1966 – the year in which the carpet industry's prosperity peaked.

In the 1920s and 1930s, Firths led the way in terms of some of the industry's technical capabilities. In 1932, it became known for its development of a Wilton face-to-face loom, the first of its kind in the UK, in which two carpets are woven simultaneously, face to face, after which 'a circular knife moving across the breast of the loom cut the "Siamese twins" asunder'.[75] During the Second World War large parts of Firths mills, such as North Vale Mill, were given over to the war effort for use by the General Electric Company. After the war, the production of Tapestry made from warp and weft printed yarns was eclipsed by the demand for pile carpets such as Axminster and Wilton. These carpets could be produced in 'seamless broadloom' in widths designed to be cut so that wall-to-wall carpeting could be fitted in domestic rooms. This style of carpeting, which may seem peculiar to young readers familiar with the wooden or tiled flooring fashionable today, was to dominate domestic carpeting until the 1990s (see Figure 0.4).

In 1951 Firths took pride of place at the nationally prestigious Festival of Britain at London's South Bank in the 'Hall of Production', where a demonstration of a carpet design encapsulating both traditional and modern styles was woven by a female weaver for the delectation of visitors. In the lead-up to 1966, known as the peak moment of the UK carpet industry, Firths adapted to the scientific and modernist abstract designs required by consumers; it also widened its repertoire of technical materials to include hard-wearing synthetic fibres which blended wool and nylon. As the photograph in Figure 0.5 demonstrates, the legacy of the expansion that these manufacturing incentives brought came to dominate the landmass of the village.

Figure 0.3 Commissioned map of Firth Carpets Limited in Bailiff Bridge, by Eva Jew, 2024. Reproduced with permission from the artist.

26 *Threads of Labour*

Figure 0.4 *Emperor Abstract* Axminster broadloom leaflet. This highly patterned wall-to-wall carpet typically featured in the living rooms of my 1970s childhood. Reproduced with permission from Firth Carpets Archive, Bankfield Museum, Halifax, Box B.4.8, ref. 2005.46.

Figure 0.5 Aerial shot of Firth Carpets Limited in Bailiff Bridge, circa 1985. Reproduced with permission from Michael Rooney.

Today the Victoria Road sheds and the works buildings behind and to the left of Clifton Mill have given way entirely to new residential housing.

Researching Firths in Bailiff Bridge

When I returned to the village as a researcher in 2016, most of the ex-Firths workers I interviewed for the study had left during the 1990s. The community had felt the precarity of dwindling jobs, processes of closure, piece-by-piece dereliction, demolition and ruination. And gradually new-build residential housing, aesthetically distinct as a result of its pale brick, had been built over the once-mills: the sheds that had housed looms on Victoria Road and the dye house up Birkby Lane. But by 2016, there had been a 14-year gap since the demolition of Clifton Mill in 2002. Much had happened and I wanted to hear stories of ex-worker and local resident experiences of these layers of change. I put out a call for people on facebook.com and out to the local press. A group of 25 people were interested in taking part. Initially I held a series of meetings at Bailiff Bridge Community Centre. I posed two broad questions to the small groups who came along: what was working life like at Firths and what are your memories of the village? In the second I asked them to reflect on life in the village post-2002 after the demolition of Clifton Mill. The meetings themselves were convivial, even though some of them brought people together from very disparate parts of the factory, such as the wages department, sales, weaving, setting and warehouse dispatch. People swapped known narratives about life in the village and there was much talk of ex-Firths workers they knew and kept in touch with.[76] These meetings were important for identifying the emerging themes for the book: attitudes to community, nostalgia for industrial work and culture, and responses to altered place. They were also important because they helped me to think about deepening my work with individual community members.

I wanted to harvest responses to the experience of living in a radically altered village and the best way to achieve this was to ask ex-workers to lead me on individual walk-and-talk or 'go-along' tours[77] around the sites and spaces they had habitually used. Mobile interviews using the form of 'walk and talk' enabled the capture of

people's responses to spatial, architectural and sensory change.[78] The tours were designed to elicit memories of the village that captured the transition from an industrial to an ex-industrial village. Tim Edensor argues that ruins prompt 'involuntary memories' unpredictably *in situ*.[79] Often re-ignited by the seasons, smells, sounds or atmosphere, they can hurtle people back to a powerful recollection. Walk-and-talk tours, with their emphasis on embodied recall, may re-kindle memories previously etched into the body by habituated ways of walking and being in the atmosphere of the village.[80]

While sensuous and embodied experiences have a central place, this book also tells the story of Firth Carpets Limited through a wonderful selection of visual sources. Photographs of people at work pique our curiosity because they are rarely part of the domestic family album. One of the most intriguing photographs for me growing up was a photograph of my mother with her work partner in the setting at Firths in the early 1960s (see Figure 0.1). It was the only existing photograph of her at work and for me it held an aura. It allowed me into a dimension of her life I had never seen: her unknown skill at operating strange machinery, a positive relationship with a co-worker I barely knew, and a baffling and complex workroom that I wanted to explore because the works buildings in the village cloaked workers from public view. Motivated by this intrigue, I asked people in the study to bring any existing photographs featuring themselves at work or their time as Firths employees. I was also keen to harvest their memories as a means of capturing the micro-changes of temporality in the processes of spatial change in the village. These were discussed over a post-tour cup of tea in a local cafe. Impossible in many cases to date precisely, photographs flooded in from a range of contexts: some were personal, snaps of workers at looms or in the offices, though these were relatively rare; some looked 'professional' as though they had been commissioned by Firths; others were of involvement in Firths sports clubs or days out. There were some by workers who had recorded the process of dereliction and demolition through photographs. A rich cache of around 500 photographs (ca. 1880–2005) which offer an extraordinary visual record of life and work at Firths within the village were donated. I cannot imagine this book without the photographs and visual sources I found along the research journey; they tell a story which could not exist without the contributions made by the

community story it tells. Some workers brought saved or treasured items – pens, pieces of carpet and in one case an ornately carved piece of stone they had managed to salvage from the demolition process of Clifton Mill. Taken together, focus groups, tours of the village, photographs and donated objects offered a way of understanding the layers of change experienced by the community.

Workers also brought saved copies of *Tuned In*, the staff magazine published for the carpet division at Bailiff Bridge. The magazine, which ran between 1993 and 1997, provides a particularly fertile seam of material which shines light onto the cultural and organisational life of Firth Carpets Limited up to closure in 2000. An important wing of its programme of paternalism, it acted to construct a sense of worker inclusion through its photo-essays on workers and departments, sports club results and social activities. From its features on young apprentices to retirement parties, it provided a powerful portrait of the cohesive community spirit of the firm. Often workers who brought in editions could identify themselves or remembered co-workers, and leafing through the pages remained a source of pleasure years later. The editions tell a compelling story about the meaning of work in a carpet factory in the period; about the characteristics of the valued worker, the links between different types of work and how workers interconnected to each other. But they require careful reading strategies, prompting questions about the backstage activities of the firm and the things that are left out across a febrile and final decade in the firm's history. The magazine informed and reassured workers about the business health of the company, but it was also a tool to manage worker compliance in terms of the adaptations and challenges the company undertook to stay afloat during the recession of the 1990s.

My visits to the Firth Carpets archive collections were some of the most pleasurable moments of discovery about the company. Both Bankfield Museum and West Yorkshire Archive Service contained fabulous collections containing a breadth and variety of material far beyond a single book. They range from advertising brochures showcasing the range of carpets and rugs and correspondence about the takeover of Firths by Readicut, to photographs of workers absorbed in their work on the factory floor. The prestige of the company was conferred through the impressive record of royal and prime ministerial visits: King George V and Mary of Teck were

photographed with William Ackroyd in the courtyard of Clifton Mills in 1933.[81] Prime Minister Margaret Thatcher is photographed with the managing director David Melbourne (1993–1997) and the local MP, Donald Thompson, inspecting a carpet.[82] Her successor John Major was welcomed in 1993; being shown around the mills and opening the new tufting division. A commemorative plaque, which presumably hung outside the tufting shed, is available to view.[83] There are photographs which visualise the spaces of the factory works and buildings, piquing curiosity given that these spaces were the preserve of workers hidden behind factory doors. It was wonderful to be able to see into one of the design studios of the 1930s. Acting as further evidence that work was gender segregated at Firths, a group of young, suited and occasionally bespectacled men are caught looking away from their designs to meet the camera's gaze.[84] Relatedly, Bankfield Museum holds an undated collection of bright, original and inspiring hand-painted carpet designs. Available to peruse, they illustrate the art, as carpet designer Thomas Marchetti described in the late 1940s, of painting design onto squared paper, such that each square represented a tuft of wool.[85] These are the documents my mother worked from as a design clerk in the early 1970s, as she counted each square so that she could order the correct amounts of yarn for each bobbin in the setting, to get ready for weaving. Figure 0.6 shows a female worker at Firths punching loom cards from a design document. There are photographs of employees working at looms, some of which are so awesomely complex to the lay viewer that they resemble what Bertram Jacobs wittily described as 'the engine room of a battleship'.[86] And the archive also brought unusual anomalies: I found one reference to men's taste in carpets featured through the prism of a brochure aimed, as was usual during the period, at women as primary domestic consumers in the 1950s. 'Spotlighting You: How to Decorate with Confidence' was produced by Firths' sister company, the Firth Carpet Company in New York. Its pages mark out several 'types' of consumer: Mrs Clubwoman, Mrs Home-is-my-Castle, Mrs Golden Years – and for each an ideal type of carpet is advised. Towards the back, the pamphlet addresses the implied female reader with ideas about how to decorate a separate 'ideal man's room'. Followed by a 'Do's and Don'ts' list, the reader is warned: 'Don't on any account use slippery little occasional rugs. A man likes a deep, cushiony wide carpet underfoot.'[87] Men, it

Figure 0.6 Worker counts the tufts from the design so loom cards can be made, circa 1930s. Reproduced with permission from John Waddington.

seems, were as partial as women when it came to the haptic pleasures of the sensuous and cushiony feel of wool in their own domestic spaces. And objects, such as the final sample commemorating the 1867–2002 history of Firth Carpets, which an ex-worker told me was made in the last weeks of the life of Firths as a manufacturing company, was donated by a Firths ex-employee to the Bankfield Collection.[88] What these items and photographs offer are glimpses of work and how it was practised across the twentieth century.

Archives provoke a set of feelings for the researcher and are in that sense affective spaces. In *Dust* Carolyn Steedman amusingly describes the historian's visit to the archive as an anxious activity which manifests as a type of fever. Her description of restless insomnia in the 'bed of a cheap hotel' the night before the trip to the archive, and the physical repulsion of the dust and the debris of the bed, become a metaphor for the archive itself. Her metaphor is rich. It describes the pressure that the dead and their attendant documents exert on the researcher: 'You think: I could get to hate these people;

and then: I can never do these people justice; and finally: I shall never *get it done*'.[89] There is, I think, some truth in her characterisation of the exigencies of archival visits. But for me there was a different set of feelings that first day I encountered the series of large catalogues containing the company's advertising activities during the 1920s and 1930s at Bankfield Museum. As I turned the first pages, I was in awe of the vibrant colours and the intricate designs, and I could hear my mother's mantra: 'we made beautiful carpets'. My mind ran to the ways my own home draws on my enthusiasm for vintage home interiors and I thought: 'I would give anything to be able to buy one of these rugs' (see Figure 0.7 for the type of rug I covet from the archive). But bubbling underneath the practical longing for a 1930s Firths rug was a more powerful affective surge as I contemplated those pattern books. It was about the endeavour and pride of the interconnected chain of workers and their investment in making them, combined with the sincerity of the pen-and-ink handwriting which carefully dated each entry within its catalogue, which made it impossible to keep a dry eye. I realise that the affective experience of the archive was the result of looking backwards through my own lens at the loss of Firths and Bailiff Bridge. To me, it seemed incredulous that the collections are there by happenstance because when firms close, their materials are at high risk of disposal. I was told that the Firths Collection at Bankfield Museum existed because an especially observant archivist who happened to be driving through the village crossroads managed to salvage all he could manage to transport from the skip as the company buildings were being closed. Anxious to go back and retrieve more, his endeavours were thwarted when he returned to it days later to find the skip had been collected and its contents thrown away.

Outline of the book

At the start of the research, I set up an all-female focus group with a loose set of questions that aimed to ask about women's experience of working at the factory. They fiercely defended Firth Carpets from any suggestion that gender had organised their experience of work. While there had been 'banter' from male workers, 'you took it as a bit of fun'. There was, they argued, no 'women's perspective'; rather,

Figure 0.7 The extra fine Wilton Carpet, *The Furnishing Trades' Organiser*, 1924. Reproduced with permission from Firth Carpets Archive, Bankfield Museum, Halifax, Box B.4.8, ref. 2005.43.

as one respondent told me, 'women and men just integrated'. Yet my mother's personal story which opens this introduction testifies to a gendered work experience at Firths. Actually, across the twentieth century Firth Carpets, in line with the carpet industry as a whole, was riven by gender division. Men dominated management and they had jobs as engineers, weavers, mechanical repairers and supervisors, or as overseers of women in finishing departments. Women, on the other hand, worked in less skilled areas of the factory and their working conditions and pay were inferior. At the same time, the industry itself was engaged in manufacturing a consumer product that had to cater to women as taste keepers and overseers of home management. As workers they were local, cheap and flexible. Their filigree needle skills, often learned in, and unpaid in, the home, were relied upon. Yet conversely, lauded as discriminating and discerning housekeepers and represented as elegant arbiters of taste, they were at the forefront of the imagination of the design and marketing departments. While no chapter is purely devoted to a discussion of how gender organised female experience of work at Firths, the material of each necessarily collides with the absolute centrality of women. Time and again, gender emerges as a thread through the chapters.

In this vein, personal stories from my parents' working lives mark the opening of chapter 1, 'Histories'. The chapter shows that work available in the twentieth century to my parents was structured along starkly gendered lines from the mid-1800s. Luxury rugs made for the discerning Victorian female manager of the household were on display where the chapter begins: the auspicious moment of the 1851 Great Exhibition. The chapter charts the technological development of mechanised carpet production in the latter part of the nineteenth century. Placed in a geographical region which was climatically suitable for textile production, it places Firth, Willans and Co. within an industry which was able to capitalise on the wealth generated by Britain's global economic domination. It traces the hunger for carpets and upholstery in the rooms and railway carriages in the rapid urban development of Britain's public city buildings and middle-class homes. Beyond the domestic market, T. F. Firth and Sons contributed millions of square yards of carpet in exports across Britain's empire and made the savvy business decision to open The Firth Carpet Company in New York State

in 1888. The chapter looks at how Victorian prosperity began to fade by the 1870s as protective tariffs began to close the doors of world markets. Turning to the twentieth century, selected 'moments' then take the stage: the dour and hedonistic inter-war years of the 1930s before the start of the 'long boom' and the affluent years of the 1950s, aptly concluding with T. F. Firth and Sons' contribution to the 1951 Festival of Britain.

Part two of 'Histories' shows how Firths moved from a 'tangible' entity to an intangible or virtual concern. Taking 1966 as the last moment of prosperity for the industry, it considers writing from the field of deindustrialisation in the global North, arguing that 'capital flight' is not always applicable to manufacturing, which carried on against the slow-motion processes of deindustrialisation. 'Declinism', it argues, offers an unhelpful approach to understanding firms which adapted their working routines and practices to carry on manufacturing. To discuss the strategies the company used to stay afloat in the economically difficult 1970s and 1980s, up to take-over in 1997, it draws on management newsletters and marketing brochures from the archive.

Chapter 2 begins with my own practices of nostalgia and the affordances they offer me as I look back on my connection with industrial culture. Offering a contribution to the debate on nostalgia as a maligned critical practice, it turns to interviews with ex-Firths workers to ask how they interact with photographs of Firths and Bailiff Bridge. Here I investigate how the mnemonic imagination uses nostalgia as a practice to assuage loss. Drawing on the idea of what Valerie Walkerdine and Luis Jimenez call the 'affective history' of company towns, where workers moved in rhythm and time, often in social groups where they made affective bonds as co-workers, the chapter suggests that nostalgia resides in worker bodies.[90] Importantly, while ex-workers used nostalgia to reflect on the positives of the rootedness of industrial work and culture in the twentieth century, none of them wanted to go back in time; rather, they could critically sift out the good things from the past in the move to carry them forward for work in the future.

Chapter 3 begins with Sherry (local resident) and Jerry's (ex-creeler and local resident) account of Bailiff Bridge from the 1940s, when Sherry felt hemmed in by mills and the electrifying energy of production, to the present moment, where she knows very few people in

the village. It then turns to how the community responded to demolition, compounded after the landmark event when what one ex-worker called the 'iconic' Clifton Mill was pulled down in 2002. Using walk-and-talk tours and interested in embodied responses to architectural, spatial and sensuous change in an ex-industrial landscape, it asks first about the importance of works buildings and examines *in situ* what happens to human security when the ability to 'hold' communities is erased. Secondly, it examines what the subjective consequences were for the affective ties that had held the working community together. Arguing that nostalgia fails to deal with what environmental philosopher Glenn Albrecht calls 'imposed place transition',[91] when places are transformed beyond recognition without community consent, it argues that his term 'solastalgia' provides a more fitting description, particularly for what ageing ex-workers felt about the loss of the village's community and sense of place.

Ex-resident and artist Catherine Bertola's story opens chapter 4 with a reflection on her return to the village before we began work on our project, *Intertwining Threads*. This chapter charts the series of community workshops, devised in collaboration with the artist, and two halves of what ex-workers experienced as a fractured community. These events drew on the visual motif of carpet making and the meld of 'revenant energies'[92] still harboured by ex-workers. Open to the whole community, the project aimed to carve out conduits of mutual respect in convivial spaces so that a conversation about carpet making and the history of place would open up. It aimed to build a model of community cohesion to do the grassroots granular work of what the government's North–South Levelling Up programme is evidently failing to provide.

Notes

1 A. Offer, 'British Manual Workers: From Producers to Consumers, c. 1950–2000', *Contemporary British History*, 22:4 (2008), 537–571, p. 538.
2 T. Piketty, *Capital in the Twenty-First Century* (Cambridge, MA: Harvard University Press, 2014).
3 Women could be sacked for becoming pregnant in the UK in the 1960s. It was not until 1975 that Britain launched its first maternity legislation,

The Employment Act, but even then many women were unable to benefit from it because it required qualifying periods of employment.
4 C. Steedman, *Landscape for a Good Woman* (London: Virago, 1986), p. 19.
5 Discussed in ibid., p. 16.
6 J. Emery, 'After Coal: Affective-Temporal Processes of Belonging and Alienation in the Deindustrializing Nottinghamshire Coalfield, UK', *Frontiers in Sociology*, 5:38 (2020), 1–16, p. 6. See for example the contributions in S. High, L. MacKinnon and A. Perchard (eds), *The Deindustrialized World: Confronting Ruination in Post-industrial Places* (Vancouver: University of British Columbia Press, 2017).
7 K. Gildert, *North Wales Miners: A Fragile Unit, 1945–1996* (Cardiff: University of Wales Press, 2002).
8 N. Hedges and H. Beynon, *Born to Work: Images of Factory Life* (London: Pluto Press, 1982). These are selected examples; it must be said that *Born to Work* is an inclusive text with images of female and immigrant workers within its pages.
9 L. Price, *Wool Textile Workers and Trade Union Organisation in the Postwar Wollen District of Yorkshire*, unpublished PhD thesis, University of York, 2015, available at: https://etheses.whiterose.ac.uk/12120/1/Thesis%20CORRECTED.pdf (accessed 12 February 2025).
10 Ibid. Price quotes the 1963 Census of Production to ascertain that while there were small fluctuations, the split was half and half between male and female labour in the wool textiles industry, p. 79.
11 Price, ibid., quotes 'Media Gross Weekly Earnings for Women in 1971', *A Profile of Kirklees*, Table 3.12, p. 80.
12 I viewed the exhibition in May 2021. It exhibited items from the Firth Carpets Archive, which is housed at Bankfield Museum in Halifax.
13 B. Jacobs, *The Story of British Carpets* (London: Carpet Review, 1968), p. 2.
14 T. Marchetti, Lecture 'About Carpet Design', *The Wool Education Society* (London: Department of Education of the International Wool Secretariat, 1954), p. 15. Halifax Central Library, Local Studies ref. 6773.
15 L. Houliston, 'Furnishing the Home', in J. Styles and M. Snodin (eds), *Design and the Decorative Arts: Victorian Britain 1837–1901* (London: V and A Publications, 2004), p. 102.
16 Interestingly, clothing textiles history has seen far more labour organisation. See for example L. Laframboise, '"La Greve de la fierte": Resisting Deindustrialisation in Montreal's Garment Industry, 1977–1983', *Labour/ Le Travail: Journal of Canadian Labour Studies*, 91 (2023), 57–88.
17 Price, *Wool Textile Workers*.

18 Ibid. Price quotes an article published in *The Guardian* newspaper on 25 April 1968 – also adding that 90% of these workers covered the nightshift.
19 Firth Carpets Limited was taken over by Readicut International group to become part of a diversified portfolio of companies in 1968. Subsequently, it was bought out by the US textile giant Interface in 2000. In both cases, the company continued to manufacture in Bailiff Bridge under the name of Firth Carpets Limited. Interface decided to close the company in 2002. Some years later, a new company called 'Firth' set up business in Bailiff Bridge. According to its website, 'In 2009 the Firth brand was revived by Michael Rooney in 2009, a former director of the company, determined to recreate the quality and traditions of the original organisation. Available at: https://firthcarpets.co.uk/about-firth/ (accessed 17 February 2025).
20 J. A. Hargreaves, *A History of Halifax: From Pre-historic Times to the Present Day* (Lancaster: Edinburgh University Press, 1999), p. 290.
21 Ibid.
22 'Double Shock As 700 More Jobs Go', *Evening Courier*, 26 April 1991. Halifax Central Library, Firths and Bailiff Bridge file.
23 'Where Are All the Workers? Labour Deputy Tours Fighting Carpet Firm', *Evening Courier*, 8 February 1992. Halifax Central Library, Firths and Bailiff Bridge file.
24 'Carpet Jobs Under Threat', *Evening Courier*, 1 September 1992. Halifax Central Library, Firths and Bailiff Bridge file.
25 'Firm Puts 1.5 million into its Future', *Evening Courier*, 6 October 1993. Halifax Central Library, Firths and Bailiff Bridge file.
26 C. Beatty and S. Fothergill, 'The Long Shadow of Job Loss: Britain's Older Industrial Towns in the 21st Century', *Frontiers in Sociology*, 5 (2020), 1–12, p. 3.
27 C. J. Whalley, *Exit Zero: Family and Class in Postindustrial Chicago* (Chicago: University of Chicago Press, 2013), p. 68.
28 L. Taylor, 'He's Making Our North: Affective Engagements with Place in David Hockney's Landscapes from 'A Bigger Picture', *Participations: Journal of Audience and Reception Studies*, (2016), 13:2, 1–23.
29 The site of the loss of Firths in Bailiff Bridge is also overlaid with the lost opportunity to discover or know my biological father, who I believed worked there. See my chapter on the experience of how the person who I thought was my biological father kept cropping up as I conducted the research for this book: L. Taylor, 'Losing a Father in an Ex-industrial Landscape: A Researcher's Emotional Geography', in N. Ferreira et al. (eds), *Families in Motion Ebbing and Flowing*

Through Space and Time, (Bingley: Emerald Publishing Limited, 2019, pp. 177–194.).
30 L. McKenzie, *Getting By: Estates, Class and Culture in Austerity Britain* (Bristol: Policy Press, 2015).
31 S. Lee Linkon, 'Narrating Past and Future: Deindustrialized Landscapes as Resources', *International Labor and Working Class History*, 84 (2013), 38–54.
32 V. Walkerdine and L. Jimenez, *Gender, Work and Community after De-industrialisation: A Psychosocial Approach to Affect* (Basingstoke: Macmillan, 2012).
33 S. Lee Linkon, *The Half-Life of De-industrialization: Working-Class Writing about Economic Restructuring* (Ann Arbor, MI: University of Michigan Press, 2018).
34 L. Trelford, '"There Is Nothing There": Deindustrialisation and Loss in a Coastal Town', *Competition and Change*, 26:2 (2022), 197–214.
35 Andy Clark and Ewen Gibbs trace this trend in Inverclyde and Lanarkshire in Scotland, now dormitory settlements for professionals working in larger cities. See A. Clark and E. Gibbs, 'Voices of Social Dislocation, Lost Work and Economic Restructuring: Narratives from Marginalised Localities in the "New Scotland"', *Memory Studies*, 13:1 (2020), 39–59.
36 C. Stanton, *The Lowell Experiment: Public History in a Postindustrial City* (Boston: University of Massachusetts Press, 2006).
37 Beatty and Fothergill, 'The Long Shadow of Job Loss', p. 2.
38 Ibid.
39 See M. Gray and A. Barford, 'The Depths of the Cuts: The Uneven Geography of Local Government Austerity', *Cambridge Journal of Regions, Economy and Society*, 11:3 (2018), 541–563.
40 P. Taylor-Gooby, *The Double Crisis of the Welfare State and What We Can Do about It* (Basingstoke: Palgrave Macmillan, 2012), p. viii.
41 I. Tyler, *Stigma: The Machinery of Inequality* (London: Zed Books, 2020), p. 163.
42 S. Virdee and B. McGeever, 'Racism, Crisis, Brexit', *Ethnic and Racial Studies*, 41:10 (2017), 1802–1819, p.1805.
43 C. E. C. Tattersall and S. Reed, *A History of British Carpets; from the Introduction of the Craft until the Present Day* (Leigh-on-Sea: F. Lewis, 1966).
44 A. Finlayson, 'Who Won the Referendum?', openDemocracyUK, 26 June 2016, available at: www.opendemocracy.net/uk/alan-finlayson/who-won-referendum (accessed 12 February 2025).
45 L. Telford, '"Levelling Up? That's Never Going to Happen": Perceptions on Levelling Up in a "Red Wall" Locality', *Contemporary Social Science*, 18:3–4 (2023), 546–561, p. 547.

46 R. Hudson, '"Levelling Up" in Post-Brexit United Kingdom: Economic Realism or Political Opportunism', *Local Economy*, 37:1–2 (2022) p. 60.
47 HM Government, *Levelling Up: Levelling Up in the United Kingdom*. White Paper (London: HM Treasury, 2022), available at: https://assets.publishing.service.gov.uk/media/61fd3ca28fa8f5388e9781c6/Levelling_up_the_UK_white_paper.pdf (accessed 17 February 2024).
48 C. Yang, C. Stevens, W. Dunn, E. Morrison and R. Harries, '"Why Don't They Ask Us?" The Role of Communities in Levelling Up', *Working Paper*, Institute for Community Studies (July 2021), p. 6.
49 Beatty and Fothergill, 'The Long Shadow of Job Loss', p. 2.
50 L. Taylor, 'Landscapes of Loss: Responses to Altered Landscape in an Ex-industrial Textile Community', *Sociological Research Online*, doi:10.1177/1360780419846508.
51 HM Government, *Levelling Up*, p. xii.
52 Hudson, '"Levelling Up"', p. 60.
53 'Levelling Up Fiasco as Councils Spend Only 10% of Budget', *The Times*, 15 March 2024.
54 Information about the Brownfield Fund on the West Yorkshire Combined Authority website, available at: www.westyorks-ca.gov.uk/projects/brownfield-housing-fund/ (accessed 22 July 2023).
55 D. Richards, S. Warner, M. J. Smith and D. Coyle, 'Crisis and State Transformation: C-19, Levelling Up and the UK's Incoherent State', *Cambridge Journal of Regions, Economy and Society*, 16:1 (2023), 31–48.
56 Yang, Stevens, Dunn, Morrison and Harries, '"Why Don't They Ask Us?"', p. 10.
57 Ibid., p. 15.
58 Catherine Bertola makes site-specific installations, drawings and films that address the invisible histories of women whose roles and contributions to society are overlooked and undervalued. The work gives voice to untold narratives, excavating the past to confront inequalities. She graduated from Newcastle University in 1999, and lives and works in Newcastle upon Tyne. Her work has been commissioned and exhibited nationally and internationally with organisations such as Leeds Museums and Galleries, the V&A Museum, Bronte Parsonage Museum, Whitworth Art Gallery, National Museum Wales, Museum of Arts and Design (New York), Crafts Council, Government Art Collection and several National Trust properties. In 2017 she was awarded a Leverhulme Trust Artist in Residency to carry out research with historian Dr Rachel Rich, Leeds Beckett University.
59 An Independent Social Research Foundation mid-career fellowship award meant that I could work on the Firths project across 2021.

A drive up Birkby Lane 41

60 R. Williams, *Marxism and Literature* (Oxford: Oxford University Press, 1977).
61 This information about geography, climate and land conditions in Calderdale is available at: https://www.visitcalderdare.com.
62 See for instance E. P. Thompson, *The Making of the English Working Class* (London: Penguin, 1968), pp. 297–346.
63 List of Yorkshire Textile Mills, accessed at: www.yorkshire.u08.eu/list/.
64 List of Mills in Calderdale, accessed at: www.en.Wikipedia.org/wiki/List_of_mills_in_Calderdale. It must be noted that this list does not contain information about whether these mills have been demolished.
65 Anonymous, 'Notes and Information for Visitors', Firth Carpets Archive, Bankfield Museum, Box B.4.8, ref. 2005.234.
66 Firth Carpets brochure, 'An Introduction to Carpet Making' (undated) from my personal collection.
67 Anonymous, 'Notes and Information'.
68 P. Joyce, *Work, Society and Politics: The Culture of the Factory in Later Victorian England* (Brighton: Methuen, 1980), p. 111.
69 R. Pearson, 'Knowing One's Place: Perceptions of Community in the Industrial Suburbs of Leeds, 1790–1890', *Journal of Social History*, 27:2 (1993), 221–244, p. 221.
70 D. Russell, *Looking North: Northern England and the National Imagination* (Manchester: Manchester University Press, 2004), p. 63.
71 For a fascinating account of Jonathan Silver's regeneration of Salts Mill in Saltaire see J. Greenhalf, *Salt and Silver: A Story of Hope* (Bradford: Hart and Clough Limited, 1997).
72 BBC, Red Production Company, 2014–2023.
73 N. Bartlett, *Carpeting the Millions: The Growth of Britain's Carpet Industry* (Edinburgh: John Donald Publishers, 1966), p. 180.
74 Anonymous, 'Notes and Information'.
75 Jacobs, *The Story of British Carpets*, p. 123.
76 Interestingly, I made one of the five focus group meetings a female-only group, but the women who attended insisted that gender had not been an important dimension of their experience at Firths (see below).
77 This way of researching community members has its roots in health studies. See R. M. Carpiano, '"Come Take a Walk with Me": The "Go-Along" Interview as a Novel Method for Studying the Implications for Health and Well-Being', *Health and Place*, 15:1 (2009), 263–272.
78 Eighteen people wanted to take me on a tour of the village. I asked them to lead the route as a deliberate policy: I wanted ex-workers and local residents to narrate the route on foot. These tours took place between February and June 2017.

79 T. Edensor, *Industrial Ruins: Space, Aesthetics, Materiality* (Oxford: Berg, 2005), p. 45.
80 P. Connerton, *The Spirit of Mourning: History, Memory and the Body* (Cambridge: Cambridge University Press, 2011).
81 King George V and Mary of Teck in the courtyard at Clifton Mills, West Yorkshire Archive, ref. WYC: 1538/10/1.
82 Margaret Thatcher, Donald Thompson and David Melbourne, West Yorkshire Archive, ref. WYC:1261/25/1.
83 Commemorative plaque for John Major, West Yorkshire Archive, ref. WYC: 1261/3.
84 Photograph of designers in their studio, West Yorkshire Archive, ref. WYC 1538/10.
85 Marchetti, 'About Carpet Design', p. 6.
86 Jacobs, *The Story of British Carpets*, p. 125.
87 'Spotlighting You: How to Decorate with Confidence', Firth Carpet Company publication, Firth Carpets Archive, Bankfield Museum, Box B.4.8, uncatalogued.
88 I was also proudly given this sampler by an ex-Firths worker at a focus group meeting. In a green colourway, it features the Firth Carpets brand symbol of the stag's head often used in the company's marketing materials. Movingly, the dates signify 135 years of carpet manufacture.
89 C. Steedman, *Dust* (Manchester: Manchester University Press, 2021), p. 18.
90 In *Gender, Work and Community*, p. 51, Walkerdine and Jimenez argue that 'affective relations are part and parcel of the most traditional communities'.
91 G. Albrecht, '"Solastalgia": A New Concept in Health and Identity', *PAN: Philosophy, Activism, Nature*, 3 (2005), 44–59, p. 48.
92 G. Bright, 'Feeling, Re-imagined in Common: Working with Social Haunting in the English Coalfields', in M. Fazio, C. Launius and T. Strangleman (eds), *Routledge International Handbook of Working-Class Studies* (Abingdon: Routledge, 2020) p. 217.

1

Histories

Part I: Carpeting the world, 1867–1959

When I cleared the house after my mother died, I came across a carefully preserved chain of correspondence belonging to Dad. Kept in a green metal box from his years as an airman in military service at RAF Cairnryan, Stranraer in the early 1950s, it contained a paper trail of references and employment contracts which spanned his time in carpet manufacture. He left school in 1945 with three 'O level equivalents' and took up an apprenticeship that same year as a loom tuner at Blackwood, Morton and Sons Ltd (BMK) at Burnside Works in Kilmarnock. During his time at BMK, he spent some years at the company's Chenille Axminster factory at Finaghy, Belfast, supplementing his professional life with a course in textile technology at Queen's College. The saved correspondence tracks his rise as a 17-year-old from his apprenticeship at BMK to weaving manager at Thomson Shepherd and Co. Ltd, at Seaford Works in Dundee in 1963. Leaving that city in 1963, James Taylor was prepared to travel the 309 miles from Dundee to make a better life in Heckmondwike, West Yorkshire. There he took a position at The Heckmondwike Manufacturing Co. Ltd as assistant works and weaving manager. His 1965 reference tells 'whom it may concern' of the company's regret at their inability to offer him an intended 'long-term promotion'. It commends his development on 'new cloths and backings', adding that Dad had been 'largely responsible for the installation and running in of new Broad Axminster Gripper and Wilton looms'. He joined Firth Carpets Limited the following year – in 1966, the year in which the industry reached its peak in the UK. There he developed his management career with specialisms

in Axminster weaving and quality assurance. After early retirement in 1990 Dad created a CV. It cites his contribution to Firths' contracts with Marks and Spencer, Whitbread, Shipping Lines and institutions such as The House of Commons and The House of Lords. The narrative arc of this career shows diligence, hard labour and accrual. He was 'energetic, forceful in getting things done and he possessed an excellent technical training', remarks one company director. Each communication shows that he stepped from one position to the next while enjoying the rootedness which enabled two marriages, four children and an adopted step-daughter. Post-retirement it was clear from several rejection letters that his hopes of securing some kind of consultancy hire had been dashed in a declining industry with less call for his expertise in quality woven carpets. But Dad had effectively managed, across a seamless 44 years, to keep a 'job for life' across two of the main carpet-making regions in the UK.

My mother's work-life story was different. Nancie Thornton was born into a carpet-making region and was surrounded by woollen textile mills which offered easy access to employment. While there are no written records, I know partly from experience and passed-down stories that while her father Frederic was a plumber, her female family line had ample experience of labouring in local carpet mills. While there seems to be no evidence that my grandmother Doris, born in 1896, was employed in local mills, it would have been highly likely that her sisters, Mae and Annie were in the inter-war years. My mother's siblings certainly were. Her oldest sister, Ella was at Goodacres Carpets in Kendal as setting manager in the late 1950s and worked with my mother in the same role at Firths in the 1960s. Mum's second older sister, Kate was a yarn spinner and her husband Jack did shifts as a weaver – both were at Kosset Carpets in Brighouse. Their daughter, my cousin Linda, visited Ella in the summer holidays as a 14-year-old and had a job at Goodacres in the six-week holidays fetching the bobbins needed for the setters. As was usual for female textile employees, the women of my family sought local jobs to fit their caring and domestic duties as mothers, wives and, in my mother's case, as a carer for her elderly father. Only Ella enjoyed a degree of geographic mobility, probably because she became a spinster. She held a post at Kidderminster, eventually ending up at Crossleys in Halifax, but her travel to firms outside the region was unusual for women at the time. Their jobs as spinners

and setters were categorised as 'semi-skilled' and would have been performed in pools of female staff. Their employment was conceived as 'work', not as a career. Nancie had no formal educational qualifications, lived near to Firth Carpets Limited and walked the one-and-a-half-mile journey from the rented family home where she had lived with her parents and two older sisters in Lane Head, Brighouse to the Bailiff Bridge mills in the setting in the early 1950s. The journey there became yet more convenient when her parents moved to a council house, about a quarter of a mile from the Works on the Stoney Lane council estate in the adjacent village of Lightcliffe. Nancie resigned from her job as design clerk in 1979 – the year she married my stepfather. As a working-class woman, 'not having to work' signified the status and significance of marriage. Unlike Dad, aside from a few wage slips, there were no references or employment contracts charting her employment trajectory after she died. There were just two existing historical documents. A photograph of her in the setting in the early 1960s and a wall-to-wall Axminster carpet, chosen by Mum, in a mauve colourway from the *Buckingham* range, first fitted in her lounge in 1989, which did not leave the home until her death in 2022.

Often shared in fragments over the years, small personal stories told to me by my own family, in particular my late parents Nancie and Jim, offer intimate portraits of how employment and family life were negotiated in mid-twentieth-century Britain. By asking what came before and during these post-war narratives, they help to map change, not just across individual life courses, but also across generations. To understand the company and the relatively stable work it offered men and women of the twentieth century, I needed to ask: What resources fuelled the starting point of Firth Carpets Limited as a flourishing supplier in a consumer industry and how had it managed the fluctuations that come with economic change? What technological transformations meant that carpets could be made available for mass consumption? And how did the company establish its successful domestic markets and its impressive global standing?

T. F. Firth and Sons began its life in the British Empire. The Victorians needed carpets and upholstery to clothe rapidly expanding public buildings and transport systems. Increased standards of living created demand for home furnishings and a rug was often at the

centre of a room. The company took advantage of the technological development of mechanised looms and could extend its wares both domestically and internationally, though the opulence of the high-Victorian period would become strained by the end of the nineteenth century. Yet Firths continued to manage change through innovation and prestige across the twentieth century. This chapter maps how the company navigated the specific challenges of the gloomy and hedonistic 1930s, as well as the 1950s, a decade straplined by *Carpet Annual* as 'the best in the history of the carpet trade'.[1] Sometimes thought of as the start of the 'glorious thirty', it contained the relative stability and rise in employment that enabled my Dad's rise from an apprentice tuner to Axminster manager.

Mum and Dad's stories are descendants of the classed and gendered history of carpet factory workers. Dad's story tells movingly of his hard work, enterprise and ambition. He was able to learn the trade at a historical moment when social mobility was far higher than it is today. As a young man he could start his role as an apprentice in a skilled trade and later join an overwhelmingly male management structure, whose members were likely impressed by his military service, in the firms where he found work. His first wife held the family fort during his night-school textiles course and she would have been expected to accompany him with their young family as he moved south to West Yorkshire. These factors enabled a career signalling the continuity of masculine management across the stability of the mid-century decades in Britain; factors which were new at the time and have been unparalleled since.

My mother's story is different, yet no less typical of thousands of other female textiles employees. Sex-segregated work was 'fairly absolute', with jobs classified as masculine or feminine in the inter-war years. A 1929 government enquiry found 'no overlap' between jobs performed by men and women.[2] Moreover, in 1931 West Yorkshire held the highest concentration of female employees in the country: 41.9% in textiles compared with the growing new light industries of consumer goods in London at 39.9%.[3] My mother's female elders would have laboured in lesser-paid gender-segregated factory departments, mostly in 'finishing' roles of setting, winding and sewing. Carpet firms exploited cheaper female labour throughout their history. Firms also relied on a ready-made local labour pool of female workers. Sure enough, my mother and aunt Kate's family commitments and

low pay anchored them to local work. Factory legislation was harsh on women and their children whose employment rights were less favourable. Aunt Kate was 'let go' from Firths for staying at home to look after her sick children and she would have sought work in another factory on a piecemeal basis. Only Ella enjoyed the mobility and lack of constraints that being childless and unmarried brought.

While women were the mainstay of the labour force, their competence in making and choosing pleasing domestic interiors is a repeat pattern through this chapter. Just as my mother had the say about which Axminster carpet would be fitted to the lounge floor in the late 1980s in her family home, from the mid-1800s women were seen as the decision makers for curating the surfaces of each room in the home. Women were conceived as 'choosers' in consumer terms and their taste cultures played a key role in both carpet design and advertising strategies. As Mirium Glucksmann has argued, they were in 'a circuit of production and consumption ... involving women at both ends, and women acquired a centrality to capital as consumers and producers'.[4] At moments of urban development in which residential development grew, there was greater call for carpets as part of the domestic interior ensemble. In those moments, magazines, interiors exhibitions, advertisements – or what might be termed the 'cultural intermediaries' that gave recommendations to women about how to choose and consume interior goods – surged into public view.

Carpeting Victorian Britain

Twenty-two British carpet manufacturers exhibited at the Great Exhibition of the Industry of all Nations in summer 1851. Opened by Queen Victoria, the exhibition signalled the peak, relative to other European economies, of British economic superiority. By the mid-nineteenth century, Victorian Britain was the world's primary manufacturing centre, earning the strapline 'workshop of the world'. Britain was head and shoulders above its competitors, especially in machinery. By the 1850s, mechanised carpet production was well underway and West Yorkshire was an established regional producer.[5] Queen Victoria is said to have much admired the Mosaic tapestries John Crossley and Sons of Halifax exhibited at the exhibition.[6]

The exhibition was a spectacular sensual feast – certainly visually and given that visitors could touch the carpets on show, it must have yielded haptic pleasures too. A celebration of national pride in manufactured goods, its outward message meant: 'modernity, progress, civilisation, internationalism'.[7] But, as design historian John Styles argues, anxiety about the ability to sustain British global competitiveness bubbled below the surface.[8] There was disquiet at this time about the repeal of customs duties that had protected Britain from overseas imports. Fear that Britain's design kudos in visual aesthetics was weak, especially in luxury decorative goods, had driven the organisation of the event.[9]

The exhibition was popular, its six million footfall largely female, with a mixed-class constituency from the skilled working class to the landed elite. The event visualised and created a hunger for decorative homeware across the strata of society. The desire for fancy homeware swept across middle-class homes as increased living standards created what Chris Breward calls the 'cult of domesticity'.[10] Successful home decoration reflected a moral and spiritual outlook and was central to the tightly compartmentalised order of Victorian society. Both men and women enjoyed what John Tosh described as 'bourgeoise domesticity'.[11] But, above all, it signified the homemaking attributes of the 'lady of the home'; choosing carpet to go alongside furniture, engravings and other decorative ware was seen as a female preserve.

The growth of British carpet manufacture must be understood within the economic and social context of empire. Mid-Victorian Britain was the foremost European imperial power: it governed a quarter of the world's land and a fifth of its people.[12] It was also the wealthiest nation in human history. While Britain was deeply class stratified, increased wealth raised the standard of living for most sections of society across a populace that had exponentially expanded from 19 million in 1841 to 37 million by 1901.[13] The landed nobility had made an accommodation with industry and commerce during the eighteenth century, and these class factions now needed to furnish their opulent country houses to signify their interests in art, design and architecture. The professional middle classes, with a thirst for the respectability property ownership conveyed, needed decorative goods to show their taste in ornamental style. Status multiplied a hunger for visual novelty for a whole manner

of fancy goods from curtains to carpets. Bartlett uses Rowntree's study of the artisan faction of the working class in York, in which the living room would likely be covered in linoleum as an example of this late nineteenth century floor covering.[14]

While homes needed decorative furnishings, so too did the vastly expanding public and civic buildings that constituted the growing urban landscape of Britain. As Eric Hobsbawm reminds us, in 1750 there were only two cities with 50,000 inhabitants; by 1851 there were twenty-nine, nine of which held 100,000 people.[15] The transition from manufacturing towns to industrial cities accelerated during the nineteenth century. Between 1801 and 1851 the towns 'experienced a population explosion' but it was the second half of the century when a 'cumulatively weightier expansion' occurred, in which Leeds, for example, grew by two and a half times to 429,000.[16] The growing civic and commercial built environment of town halls, libraries, hotels and entertainment establishments was supported by municipal or private means. Historian Simon Gunn provides detail of one of the most select and private establishments: the gentleman's club. The seclusion of societies and political clubhouses provided a sanctuary away from the noise, pollution and frenetic energy of the city for middle-class men of the period. It was also seen as 'a refuge for men away from feminised domesticity'.[17] Comprising a reading room, a kitchen and a library, these spaces needed to be both dignified and opulent. Extravagant spending on wood panelling, lighting and, of course, carpets made their interiors calming, comfortable and elegant.[18]

Moving between these public, civic and social spheres meant increased travel and transport also needed to be furnished, in terms of both upholstery for seating (made by a wing of T. F. Firth and Sons at Flush Mills) and underfoot. The new railway system connected these urban centres and spaces through the power of steam. By 1852, the early network had been laid and was progressively developed to century's turn, compressing time and space. It hurtled goods through new stations and across viaducts. Travelling to and from the urban centre of cities such as Manchester, Birmingham and Leeds for 'those engaged in business' was, according to Simon Gunn, understood in terms of 'a tidal metaphor' which was 'applied to the mid-Victorian city, the ebb and flow of population marking its diurnal rhythm'.[19] Travelling by train – the favoured method of

travel after 1850 – took on a ritualised order and punctuality as middle-class commuters travelled by the same train, in the same compartments and seats, with regularity each day. Transport was laid on for concert series that catered for the middle and upper classes, such as the Hallé in Manchester, and special trains carried them from the prosperous suburbs.[20] And because the Victorian middle class required fitting surroundings in which to publicly display their personhood, train carriages needed comfortable upholstery, just as the buildings of the Victorian urban experience needed commodious floor coverings. The shift to power looms across the carpet industry aimed to cater for those needs.

By far the most opulent was Axminster, a carpet aimed at very wealthy customers which aped Turkish carpets; expensive because it was knotted by hand in a time-consuming process. The key feature of this period, which ushered in cost-reducing strategies to extend markets, was the shift to power looms. Brussels and Wilton carpets began to be replaced by Tapestry, cheaper because the dye was printed onto the yarn and a greater percentage of the worsted was visible in the loop on the carpet surface. Tapestry handlooms, of which there were 1,300 across the industry before 1853, were replaced by 900 power looms. Chenille, a less costly imitation of Axminster carpets, underwent mechanisation in the 1880s. What is clear is that female labour was central during this period of expansion in the West Yorkshire region. In 1871, 8,431 textile workers were employed in Halifax compared with 1,552 staff in extractive and metallurgical industries. Almost half of those employees were women. The speed of production aimed to meet the demand of the middle classes and highly skilled artisans wishing to 'imitate the way of life of their wealthier neighbours'.[21] Though, as Neville Bartlett qualifies, 'it is doubtful if carpets were in common use below the middle-class strata of society'.[22] While the spread of the broadloom, which made seamless carpets, was comparatively slow, most manufacturers had them in place by the 1890s. Interestingly, these changes brought a wave of deindustrialisation[23] as hand production gave way to power looms with the loss of 4,300 jobs country-wide, though Yorkshire gained employees as laid-off hand-weavers settled in towns such as Dewsbury and Heckmondwike where hand-weaving still thrived.[24] But the upward trend of female workforce numbers continued to 1891 and up to century's turn, so that by 1901 women and girls outnumbered male textiles workers by 11,668 to 7,674.[25]

Edwin Firth and Son in the nineteenth century

Demand for carpets produced a frenetic atmosphere of competition in the West Yorkshire region. Firth, Willans & Co.[26] was just four miles away from John Crossley's of Halifax, which was the largest company in the British industry by 1840.[27] Crossley's sons were keenly enterprising. They pursued market domination through innovative manufacturing techniques, gained with the acquisition of a portfolio of valuable patent rights which meant other factories had to seek their permission to manufacture carpets using these techniques or be forced to vacate the industry. Crossley's exploited Richard Whytock's patent of the Tapestry power loom and acted as the dominant producer, owning half of Britain's 1,300 Tapestry looms by 1850. By 1872 Crossley's had 6,000 employees and its mills at Dean Clough covered 20 acres, making it the largest carpet manufacturer in the world.[28] But while Crossley's quelled smaller regional companies, T. F. Firth and Sons emerged as a prosperous concern. While Crossley's dominated Tapestry production in 1890, T. F. Firth and Sons was its only competitor in business in the region, running 80 Tapestry looms by 1889. It opened the Axminster department at Clifton Mills in 1898 and had established a Paris office by the end of the decade. The Firth Carpets Archive shows it could afford to pay a commercial traveller selling its wares a handsome salary plus commission, one that rose from £285 per annum in 1888 to £447 by 1892.[29] Significantly, Firth owned one of the first carpet concerns to be set up in the US: the Firth Carpet Company 'Firthcliffe' in New York State.[30] Established as a means to circumvent the preventative tariffs on British carpet exports to the US, it manufactured tapestry velvet carpets and piece goods.

Carpeting the world

Today it seems astonishing that Britain in the mid-nineteenth century produced almost half of the traded goods of the globe. Britain's chief exports were in cotton, coal, iron and steel: goods that came from its portfolio of industries driven by the power of steam. Political economist W. S. Jevons, writing in the 1860s, argued that Britain's confidence lay in products reliant on coal; superiority over its competitors was rooted in the 'fire and furnace', forged from the development of its coal-centred technologies in the 1760s.[31] Britain's competitive advantage lay in semi-finished goods such as the plain

cloth and yarn produced in Lancashire. Oldham, at this time, became one of the wealthiest towns in the world. As Christopher Lawson argues, Oldham's rise was the result of indentured labour, naval dominance and 'a reliable combination of raw material sources and a near stranglehold on the enormous colonial and quasi-colonial markets of India, China and much of Africa'.[32] By 1882, 82% of world textiles came from Britain.[33] But while Britain led in coal-based production, its rivals in continental Europe, as W. S. Jevons also noted, excelled in the production of aesthetically pleasing luxury goods.[34] Critical commentary after the Great Exhibition of 1851 admired the architecture of the Crystal Palace but many of the British ornamental pieces displayed inside were considered tasteless, both by Britain's cultural elite and by the French.[35]

What, then, was the situation regarding the export trade of finished homeware goods which needed a visual aesthetic to appeal to world markets? John Styles argues that while Britain was not a dominant trader, it still exported decorative goods successfully. Britain was more dependent on its overseas markets than its competitors Germany, France and the United States, and it exported greater volumes of goods. But British carpets held their own, their export sales central to the growth and prosperity of the industry at this time. Steam aided the fast production of the 'quality' mechanised carpets such as Tapestry but Britain was also able to cater to more opulent tastes with hand-made Axminster. Neville Bartlett's book, *Carpeting the Millions* shows sales across the globe rose from a million yards in 1818 to 12 million in the 1870s, peaking further to 13 million in the late 1880s.[36] But the problem with business history is that it tends to evade the imperial basis of Britain's manufacturing success in the nineteenth century. Britain sold to Europe. France, the most discriminating nation for adjudicating the worth of the artistic industries, held a keen interest in Britain's high-quality carpets and purchased 861,000 yards between 1861 and 1863.[37] Large quantities of British carpets also reached the United States, in fact a third of the industry's output was absorbed by the US market by mid-century.[38] Some firms were heavily dependent on the US market; Crossley's, for example, sold goods worth £500,000 to the US out of the £1,100,000 that was its total annual sales figure.[39] Australia's demographic expansion probably accounts for a fourfold increase to 50,000 yards between 1808 and 1840, according to Bartlett.[40]

But if, as Lawson argues, cotton's success was an empire narrative, so too was the success of carpets. To allude again to my earlier point about business history, Bartlett's statistics enable the calculation of the profit figures for Britain as an island nation. But Britain was not a nation, as Gurminder Bhambra reminds us, 'but an empire'.[41] Both Canada and Australia were under Britain's colonial rule. Missing from Bartlett's business history quantification of Britain's carpet sales ledger is any discussion of the geo-power of Britain's supreme economic position as an imperial power.

As the nineteenth century progressed, markets in developed nations such as the United States and Germany began to contract.[42] Simultaneously there was a stark increase of sales in the developing 'white dominions' of the empire: Canada, Australia, New Zealand and South Africa, as well as 'honorary' dominions in Latin America such as Chile. Carpet exports increased exponentially to Canada and Australia. Indeed, Bartlett speculates that Canada may have allowed smuggling to the US when the country placed high import duties on foreign trade. A further trend was that markets opened up in the non-European British colonies of Africa, Asia and India, and became increasingly central.[43] These latter markets became lucrative; rivalry over them was less combative and, importantly from a British perspective, as John Styles argues, they were more forgiving about design aesthetics.[44] Dianne Lawrence's work on carpet consumption in the colonial home in the latter part of the nineteenth century is germane here. Making it clear that once again colonial consumption was a female preserve, she offers an insight into empire purchase, domestic consumption and the value attached to commodities like carpets. In 1894 carpets were exported by large yardage to Cape Town, Melbourne, Sydney, Calcutta, Madras and Bombay. Reminding us of the haptic appeal of luxury underfoot, Lawrence argues that as far as the genteel colonial woman was concerned, carpets 'were an essential element in the domestic ensemble'.[45] Often the first surface experienced on entrance to a room, a carpet prompted the expectation that a number of other luxurious surfaces would be encountered for the delectation of the visitor, giving the woman of the home the ability to attend both to 'detail and the all-important control of space'.[46] Carpet squares were fashionable in Australia and India despite hot climates; having a 'rich carpet at the centre' was essential to the genteel aesthetic, seen as a specifically feminine

competence.[47] Lawrence's research shows that British carpets were bought by the new 'native' Indian middle-class customers despite the difficulty of obtaining them locally. And she records a moment when a New Zealand customer felt delight at the availability of 'real Brussels' at a local wholesaler.[48]

But the lush days of Victorian prosperity were set to end: the reign of free trade embraced by Britain mid-century waned after 1870. As imperialism and nationalism were ramped up, developed nations responded by increased protectionism in the form of prohibitive tariffs. Yorkshire's woollen industry took an especially heavy blow. British exports fell dramatically in the US from 6,800,000 yards in 1872 to 516,000 in 1877.[49] European markets closed their doors, then the McKinley Tariff of 1895 cut by half the export of worsted cloth to the US, and at this point 'it was predicted', as Gary Firth argues, 'that grass would grow on the streets of Bradford'.[50] The carpet industry also suffered. Tariffs erected in Europe in the 1880s and again in the 1890s practically terminated the sale of British carpets into European homes. Developed nations grew their own carpet industries to supply home demand. As a result of its reliance on US exports, John Crossley and Sons faced grave financial difficulties and, in response, the company set up factories in Russia and Austro-Hungary. At the same time, T. F. Firth and Sons enjoyed prosperity from its adroit business decision to open the prosperous 'Firthcliffe' in New York State and a concern at Auburn. But while markets in the 'dominions' of Australia, Canada and South America had peaked in the 1880s, shrinkage followed in the 1890s. Some of this downward trend was recovered between 1905 and 1907 in South America – though it was never to reach its previous peak and favourable tariffs granted by Canada meant that by 1909 the Canadian market was the most buoyant for British carpets in the early twentieth century. But there would be no return to the heights of the Victorian peak years.

Firths in the twentieth century

This chapter turns now to the manufacturing activities of T. F. Firth and Sons Limited during the twentieth century. It looks through the lens of two different moments: the inter-war years of the 1930s and the 'affluent' 1950s of the 'long boom', or the period from 1945 to

1975. Using archival sources, it shows how the firm navigated circumstances of global economic flux and socio-cultural change to establish itself as an industrial enterprise which held global reach and prestigious standing within the home market.

The dour and bright 1930s

Rather than conceptualising the 1930s as a 'deadspace sandwiched between two world wars', Tim Strangleman argues it acts as a 'totemic decade' marking the significance of the post-war 'long boom' known as the 'glorious thirty', or the period from the mid-1950s to 1975.[51] He argues that the decade was shot through by a set of dichotomies such as North/South, decline/growth and traditional/modern. Indeed, debate about the Depression era is one of contrasts: some identify it as a dour moment of hunger marches, the dubious appeal of fascism across Europe and an unsuccessful general strike – a historical juncture to which successive generations never wanted to return. Conversely, other historians mark it as a time of post-war pleasure seeking. Popular leisure expanded, housing construction boomed; marking a 'major transition to housing tenure', prices fell and lifestyle consumption, particularly in relation to the home for those who could afford it, flourished. It was a moment of 'domestic ideology' which influenced a substantial section of the working class in the 1930s. It was a moment when women's magazines, women's sections of the national press and advertising portrayed an image of the idealised housewife in a modern, hygienic, labour-saving home. Beyond the kitchen, show homes (and their accompanying brochures) featured a 'co-ordinated lifestyle universe' in which furniture was complemented with matching wallcoverings, light fittings and carpets.[52] The sections which follow look at how T. F. Firth and Sons Ltd negotiated these contrasting economic and social circumstances, including the need to please the female consumer, from its location in the North.

The Great Depression, the longest and deepest of the twentieth century, came after the US Wall Street Crash of 1929. By 1932, unemployment had peaked at 3.5 million . The Conservative-leaning national government emphasised the need to work inside the empire by erecting tariffs for goods from the US, Germany and France, and gave preferential treatment to Commonwealth members. It also exhorted the public to 'Buy British' in an effort to protect home industry and

jobs. The trade journal *Carpets, Rugs, Linos and Floorcoverings* in 1931 featured Firths' effort for the national good in '"Buy British!" Combating Foreign Competition'.[53] Advertising its new range of Jacquard Hair Squares, *Ajax*, which featured 'modernistic design' to meet the prevailing 'vogue in house furnishings', the piece lauds the company for 'entering so effectively into a zone of the carpet trade tacitly monopolised by Continental makers'. Showcasing the 'innovation' 'British Made by Firth's' label sewn onto the carpets, the article asserts: 'Messrs. Firths are justified in emphasising that if the British public will only insist upon having British-made carpets, they ... would be able to employ more labour and the country at large would witness a return to national prosperity.'[54]

Regional inequality along the North/South axis was stark in this period. While regions in the South of England enjoyed prosperity,[55] the North faced decline as the traditional industrial regions contracted; its chief exports of cotton and coal plummeted and shipbuilding fell.[56] The human consequences of mass unemployment were grave in government-termed 'special areas': the Northeast, areas in Lancashire (employment in cotton halved between 1912 and 1938) and South Wales. Hobsbawm's was a gloomy and brooding description: 'The grimy, roaring, bleak industrial areas of the nineteenth century', uncomfortable yet thriving in England's North, gave way to 'the grime, the bleakness and the terrible silence of the factories and mines'.[57] For Hobsbawm, it was a slump which followed a war, casting an atmospheric 'shadow of these cataclysms' which infected everyday life.[58] Fear of mortality or injury in war or hunger and poverty in peace produced 'an acrid fog of anxiety'[59] inhaled especially by citizens located in what the Labour Party termed 'distressed areas'.[60] No wonder, when Guinness sought to find premises in Britain in 1932, they chose the salubrious Southern location at Park Royal as opposed to the ruined spaces of the North.[61]

The spatial reach of Firths

T. F. Firth and Sons Ltd, as both firm and purveyor of carpets, actively sought to build a brand image to guard against insecurity in tough economic times. The name 'Firths' travelled across time and space in local, national and global contexts. On my early visits to the archives I was struck by the three oval cameo images of Victoria and Clifton Mills at Brighouse and Flush Mills at

Heckmondwike, which featured in advertising and journalism from the 1920s and into the 1930s (see Figure 1.1). During this period, the physical places of production, the mill buildings with their smoking chimneys, set against the backcloth of the place of production were proudful – they *mattered*. How did the firm, its products and its workers, manage and negotiate the competing rough and smooth challenges of the 1930s?

Economic geographer Denis Linehan's work on the intensive industrial surveys carried out in the inter-war period offers insight into how industrial regions were managed and constructed. Essentially the South was constructed as a more desirable business location than the North. Looking at regional, state and political party surveys which were designed to be accessible to the lay citizen, the health of the economy was attached to places using maps, cartoons and stories.[62] Disseminated in the public realm, they circulated in the Industrial press and forged popular discourses (and nourished anxieties) about what constituted desirable and undesirable commercial spaces. The surveys visualised economically divergent data, called the 'drift from the North',[63] which urged business to relocate to the prosperous South. By the mid-1930s, economic stagnation stubbornly persisted and government was keen to encourage the growth of new business enterprise. 'Why not build your factory in the centre of the densely populated area of the South of England?' proclaimed an advertisement from *Southern Railways* over a map of England with a bold arrow South: 'TRADE HAS MOVED SOUTH'.[64] These kinds of popular representations of economic geography must have sent a shudder of insecurity through a firm like Firths – a typical medium-sized, family-run and -financed concern – from its vantage point in the North. No doubt cognisant of emerging conceptions of 'successful' industrial space, in November 1934 Firths opened a new London Showroom in EC1 through which to promote and sell carpet-ware. The invitation to the opening, printed on heavy-gauge paper, implies that increased business and the need for prompt service 'compelled the directors to seek more commodious and convenient premises'.[65] The image of the showroom is *modern*. Palatial, spacious, well lit, with cubed modern shelving. Clad in earthy colours there are inviting tables and raised display boards where trade representatives and customers can see and feel carpet and furnishing samples (see Figure 1.2). This modern approach to the showroom was already

Figure 1.1 *The Furnishing Trades' Organiser,* June 1924. Reproduced with permission from Firth Carpets Archive, Bankfield Museum, Halifax, Box B.4.8, ref. 2005.43.

Figure 1.2 Invitation to Firths' new London Showroom, 1934. Reproduced with permission from West Yorkshire Archive Service, Calderdale, WYC: 1538/11/1.

foregrounded in Firths' marketing strategy for carpet squares. 'Attractive Modernity replaces Old Fashioned Styles' is the title of the 1932 trade advertisement for the 'Richmond' tapestry square; its art deco-style, with urban machine-like motifs using a bold geometric design to 'replace the more old-fashioned styles'.[66]

Furthermore, Northern concerns acted agentically. Linehan shows that Ministry of Labour surveys of the mid-1930s were used politically by regional development councils to lobby Whitehall and win industrial development. For example, representative of the cotton industry Raymond Streat fused the Lancashire Industrial Development Council with the Travel and Industrial Development Association: together they organised an international campaign to advertise Lancashire's industrial significance in London, Toronto and France. In this way, Streat managed to re-script the region's economic geography in ways which challenged the idea of it as an unproductive area. In similar vein, the archive contains a collection of cut-outs from the trade press in which Firths' marketing appeared – evidence that Firths was cognisant of the themes about the divergent economy

in circulation during the period. Firths took the initiative, becoming a power broker of Northern carpet manufacturing by using a marketing strategy which acted to widen the spatial reach of its image across Britain in public venues. The archive holds a poster that was placed at the Paramount in Newcastle: 'The Whole of the Magnificent carpets in the Paramount Theatre ... were manufactured by T.F. Firth'[67] – but Firths also advertised in far-flung public venues in the South. 'The carpets in this theatre', read a poster advertisement placed in The New Theatre, Oxford in 1934, 'were supplied by PIXTONS LTD. and manufactured by T. F. FIRTH & SONS LTD', before leading the reader back to the proudful location of Firths at Clifton Mills.[68] In-situ publicity posters showed the vibrancy of Firth Carpets and the company's professionalism in carpet fitting as experienced by consumers at the venue.

Moreover, Firths identified shipping as a mobile market for its carpets. In this way, Firths' products extended the spatial scale of the company's fabrics and furnishings during this period. The *Journal of Commerce* contained two adverts in the summer of 1931 featuring modern line drawings of ships; Firths providing 'an unequalled choice for all ship furnishings. Special designs are prepared as required' (see Figure 1.3).[69]

In 1934 *The Railway Gazette* offered a view of an upholstered and carpeted corridor coach, 'the attraction of good upholstery on the L.M.S.R',[70] its strapline assuring the reader that Firths' products 'are to be found on railways, ships, and in hotels around the world'.[71] From the cameo ovals of the physical mills in West Yorkshire, Firths' products travelled the seas and cut through the air space of the vessels it had furnished. Exports to Australia, New Zealand and South Africa swelled during this period as a consequence of the Ottowa agreements of 1932, devised to stimulate empire trade by offering preferential import duties. Casting its net across the empire, Firths dealt with 'foreign and colonial offices in Melbourne, Christchurch, Toronto and Johannesburg', with 23 agencies in places such as the West Indies, China and Sweden.[72] T. F. Firth and Sons had global spatial reach.

These survival strategies enabled Firths to successfully navigate a tough decade, but Lancashire struggled; when the Yorkshire Institute of Economic Affairs approached the Ministry of Labour for a survey to understand the problems of industry in light of the country's economic woes, its request was declined because the West Riding

Figure 1.3 *Journal of Commerce,* 1931. Reproduced with permission from Firth Carpets Archive, Bankfield Museum, Halifax, Box B.4.8, ref. 2005.43.

of Yorkshire was considered 'too prosperous'.[73] Indeed, an article in the *Sunday Referee* in December 1933 featured an aerial photograph of the enormous landmass of Clifton Mills. Photographs of chairman Sir William Ackroyd and the spacious Clifton Mills showroom headlined: 'HERE ... is an industry over which the scourge of unemployment has passed lightly'.[74] Even in the most difficult year of 1931, T. F. Firth and Sons boasted it employed 'close upon 3,000 workers'. While the archives refuse to yield the number of women workers in this figure, the 1930s saw growth of female workers amounting to 29.7% of the workforce nationwide.[75] Indeed, production in the British carpet industry underwent a marked increase from 21,500,000 square yards to 40,600,000 in 1937.[76] Why was the industry able to manage at such a troublesome economic moment? Why was Firths relatively safe in this period?

Fitting carpets at home

In contrast to the atmospheric gloom of Hobsbawm's account of the 1930s, historian Martin Pugh sketches a brighter decade.[77] He

argues that, unlike Germany or the US, Britain's depression was not sustained; despite high rates of unemployment, most people were actually employed and the period between 1933 and 1937 saw economic growth. Moreover, the end of war austerity brought postwar hunger for creature and home comforts and, frankly, pleasure. The slump had brought a fall in the price of consumer goods and people's wages felt more fulsome. Significantly, key changes to housing tenure meant that a mortgage became achievable for ordinary people, using the 'easy terms' offered by building societies. Indeed, the 1930s saw the most rapid expansion in home ownership of the twentieth century, though it was mostly an expansion for lower-middle-class buyers. Building materials were cheap: in 1925 it cost £510 to build a home; by 1934 the cost had fallen to £361.[78] Around 4 million homes were constructed during the inter-war years.[79] The private sector built 133,000 homes in 1931 but by 1936 the number had risen to 279,000.[80]

The boom in housing in turn helped fire up the economy. Home ownership was lauded by politicians as a pathway to responsible citizenship for the national good. This change brought the allure of the 'domestic ideal'[81] – young people craved the privacy of independent living a new home brought, an ideal that had eluded their parents' generation. But more specifically – and to pick up the thread running through this book – the implied homemaker was the female member of the household. She was addressed by a host of cultural intermediaries with a vested interest in marketing lifestyle homeware. Women's magazines and events like the *Daily Mail*'s Ideal Home exhibition acted to showcase fashionable, attractively designed furnishings and consumer goods.[82] The targeted middle-class housewife was professional, scientific and able to manage machinery from vacuum cleaners to electric irons produced by the expanding light machinery industries for the efficient running of the home. Just as the women of my family 'finished' carpets they could not hope to afford, the assembly lines of these industries were filled with working-class women making domestic commodities for middle-class housewives.

Female recruitment to this new industry was demonstrable through rising employment figures: between 1931 and 1951 the percentage of women in work aged from 35 to 59 went up from 26 to 43%.[83] In this way, the 'modern housewife' was fastened to the 'shift in industrial production and the restructuring of the economy towards

domestic consumption'.[84] Beyond the kitchen, the ideal household was shown to aspire to the clean-line zeitgeist for an uncluttered *modern* aesthetic. The Firths Richmond Tapestry square alluded to earlier was marketed to chime with and create a hunger for such an ideal. In her discussion of the inter-war years, historian Clare Langhamer argues that the 1930s were characterised by the aspirant dream of a modern home but people would have to wait until the 1950s to realise, negotiate or refuse it.[85]

Carpets for public leisure

If the achievement of a modern home eluded many people across the decade, disposable income meant that, for some at least, the shorter-term pleasures of leisure expanded. Dance halls needed to cater for the post-war 'dance craze' and cinema going became the most popular leisure activity of the decade. The number of cinemas grew: there were 3,000 in 1926; by 1938 there were 4,967.[86] By 1939, 23 million people regularly attended a cinema each week! Influenced by the opulent and expansive aesthetics of big American picture houses, chains like Odeon and Paramount built huge concerns seating up to 2,000 viewers. Of significance here is the adornment of space with soft furnishings for seats and underfoot: 'glamorous plush seats, marble staircases, wall-to-wall carpeting, coffee lounges' were the order of the modern 1930s cinema experience.[87] To enter some cinemas 'was truly to enter a palace of dreams' recalls Jeffery Richards, as some cinemas set out to create fantastical experiences such as Italianate auditoriums or, as in the case of the Astoria at Finsbury Park, a Moorish walled city.[88] The expansion of indoor leisure spaces created business opportunities for the carpet trade. The Firths Carpets Archive testifies to the cinemas it furnished and carpeted at this time, including the Regal at Stockton-on-Tees, the Majestic in Rochester and the Regal at Godalming.[89]

Rhythmical worker and consumer bodies

Firths also acted to innovate in carpet production. As Bertram Jacobs testifies, 'Firths were the first to introduce backing in their Firmoda quality'.[90] A new type of carpet, the *Firmoda* was specifically designed to problem solve carpet fitting in public buildings. Advertised in journals such as *Architectural Review* during the 1930s, *Firmoda* promised to revolutionise carpeting with a stiffened, adhesive backing

that locked permanently, 'even when cut to fit unusual shapes'.[91] It was also innovative because it acted to work with the rhythmical movement of the consuming customer body. The more tread *Firmoda* received from feet traversing an auditorium, the less visible the joins became. It could also be cut so that 'Patterns, monograms, trade-marks etc. can easily be inlaid with FIRMODA'.[92] One advert shows an insert of countless smartly trousered legs and brogues alongside skirted, stockinged calves on heeled court shoes rhythmically walking over *Firmoda* across a handsomely carpeted foyer (see Figure 1.4).

Another advertisement from *The Architectural Review* shows two pinstripe-suited architects presiding over a *Firmoda* fitter at work as he uses his hands to fit the join. Strangleman argues that in the 1930s the authentic industrial worker was 'lionized' by the Documentary Film Movement.[93] This was due to the development of Socialist Realism in the USSR in the 1930s and the impact of this on left-leaning culture in Britain. But there is a dearth of textile workers in the surviving material; it is the masculine worker body engaged in heavy labour in coal, steel and shipbuilding which is valorised, and this trend was compounded in representations across the twentieth century. See for example, the magnificent chiaroscuro effect of Nick Hedges' photograph which renders heroic a steel worker using stiff bodily poise and specialist tools to manoeuvre red-hot molten metal in the factory on the front cover of *Born to Work*.[94] But look closely at the worker in Figure 1.5. Smartly turned out, while his sleeves are turned up he wears a white shirt, tie and waistcoat. The muscles of his forearms show subtle signs of movement as he carefully frames the weight of his body to kneel to fit the carpet in view of the delighted onlookers. It is possible to argue that the carpet fitter in the image is being differentiated from workers in 'heavy industry'. Dapper and neat, his poise conveys a sense of adroit skilfulness. Visually subordinated to the bosses while not radically sartorially differentiated, the advert elevates him as a 'modern craftsperson'. Gentrified, he appears to be a cut above the heavy-industrial worker.[95] The carpet fitter, essential to the professionalism of how carpets adhered to the surfaces of ships, cinemas, a whole manner of public and domestic venues, is however given even less visual representation than the weaver.

In tracing the look and meaning of working bodies moving in systematic ways, it is important to contextualise their wider currency

Figure 1.4 Firths capitalised on cinema growth with *Firmoda*. Reproduced with permission from Firth Carpets Archive, Bankfield Museum, Halifax, Box B.4.8, ref. 2005.43.

Figure 1.5 The textile worker body as featured fitting 1930s *Firmoda*. Reproduced with permission from Firth Carpets Archive, Bankfield Museum, Halifax, Box B.4.8, ref. 2005.43.

in inter-war ideas about how the modern body is conceived and visualised. According to David Matless, the modern leisure body emerged out of advice about exercise, fresh air and diet in the construction of landscape citizenship. But ideas about leisure began to concede to ideas about the worker body. In modern dance, Rudolf Laban linked industrial bodily labour, with its kinetic rhythm, with modernist dance to develop a balanced physique. 'Whether in the open air, the factory, the gym or the dance hall,' Matless argues, 'the assumption is that the modern body must be balanced, composed and harmonious'.[96] In these ways, while not wrought through heavy muscular work, the effective textile worker body must be physically agile enough to balance and compose the core and work rhythmically with limb muscles using considerable skill.

Traditional vs modern design in the 1950s

If the 1930s is characterised as a dichotomous decade, debate is also divided about the 1950s. Dominant versions, familiar to both historians and the lay public, recount the decade using 'comfortable and familiar' images of the consolidation of the welfare state, political consensus, new modernist aesthetics, the fall of empire and new kinds of social stability.[97] Yet these accounts have faced criticism. Attacking the policies of 1945, for example, Corelli Barnett argues that the welfare state was an expensive and unrealistic diversion, constructed by a technically inept public school elite unable to prioritise the need for an industrial policy to address national decline.[98] In similar vein, national prosperity did not mean the end of social class or absolute poverty. Positive gains included the end of rationing in 1954. Tim Strangleman charts an organisational culture of post-war worker citizenship at Guinness in its in-house magazine in the period.[99]

'Affluence' is also a contested term associated with post-war Britain, but there is agreement, as Avner Offer argues, that 'The 1950s and the 1960s were good – rising wages, standards of living, work for everyone who wanted it'.[100] Harold Macmillan's mid-century maxim, that Britain had 'never had it so good' marked an important epochal shift in social relations. Shinobu Majima and Mike Savage argue that affluence brought an 'inner change' to the everyday doings of social life. As economic constraint receded, a new kind of expressive individualism came to the fore.[101] There were modern objects to hire or purchase on the high street, consumer spending increased

and new advertising strategies generated consumer longing. The domestic economy was central: working-class women, as Miriam Glucksmann argues, had been key to the assembly lines which made goods such as cake makers and vacuum cleaners, and by the 1950s the process of production and consumption – with women at both ends of this circuit – had become consolidated, with middle-class women as the primary consumers.[102] Yet, as Savage argues, even though the growth of national income was more acute than it had ever been in its history, affluence was slower to gain traction in Britain compared with its European counterparts. Consumption patterns also lagged behind the Continent: 'This was because Britain was experiencing a declining gap between the wealthy and the poor until 1973, not due to the "levelling up" of the former poor but due to the levelling down of the former wealthy, a process that was partly related to the decline of the nobility and the shrinking of the empire.'[103]

Editions of *Carpet Review* during the 1950s relate a story of success across the decade. In similar vein, the 1951 edition of *Carpet Annual* reports increased production – 39 million square yards compared with the 32.5 million of 1949. It boasts: 'One of the best decades in the history of the British export carpet trade', with healthy sales across the Dominions, USA and Sweden.[104] Rapid and successful sales are evoked in a photograph from 1956 showing a lone worker looking down an aisle of the carpet despatch shed at Firth Carpets Limited, with rack after rack of rolled carpet ready to go.[105]

The only setbacks in the first half of the 1950s were labour shortages and the high price of raw materials such as jute.[106] In this period of relative affluence, the carpet industry continued to cater for a luxury market of genteel customers. Historically, expensive and luxurious woven carpet, with its aristocratic associations, had always been heavily defended in the British industry. Evidence suggests it wanted to keep it that way: pride is almost audible in the 1955–1956 edition of *Carpet Annual* which proclaimed that 65% of all manufactured carpets were all-wool Axminster.[107] The industry understood that these carpets were not affordable even for comfortably off middle-class consumers. For example, a 1955 edition of *Carpet Review* contains a feature which campaigns to lower hire purchase deposits. It was an industry that preferred to provide finance to

manage the consumption of its expensive wares, rather than innovate products to meet lower-middle or working-class needs.[108] Time and again, the archive testifies to a powerfully conservative industry averse to altering time-assured traditions and unwilling to advertise beyond trade in an age of affluence. In the 1950s, industry publications *Carpet Annual* and the weekly *Carpet Review* oscillate between acceptance and condescension towards new developments in design and manufacturing. Pockets of copy show *The Carpet Annual* struggled with abstract 'modern' designs. In the feature 'Review of Carpet Design', writer Hugh McKenna reassures its readers in relation to 'contemporary designs': 'it is apparently unlikely that any radical change will take place in the popular types selling today ... there are still hurdles to cross before these carpets become a major feature in the trade'.[109] Elsewhere, a director at the International Wool Secretariat called for the need for 'good solid carpet designs and not those of a meretricious, flashy character'.[110] Steeped in the comfort of traditional designs, the publication was also averse to the assault on wool carpets coming from scientific new technical innovation in synthetic fibres such as nylon and acrylic (such as the one sold at T. F. Firth and Sons Ltd named *Acrilan*). Firths did begin to cater to the 'new expressionism' referred to by Savage and Majima by widening its repertoire, but, at its heart, it shared the conservative attitudes shown by the trade publications towards new designs and materials such as acrylic and nylon.

One regular feature in *Carpet Review* was 'Men of the Month'. Its function was to discuss key promotions, laud the senior management of the top manufacturers in the carpet industry and promote the social events of industry associations. The photographs which illustrate the features, which show dark-suited men with cigars dining together, visualise the industry as patrician, highly traditional and entirely male dominated.[111]

It was this group that felt a worrying event on the horizon by the mid-1950s: the arrival of tufted carpet from the USA. Made predominantly from synthetic fibres, it proved resoundingly popular in the early 1950s in the United States. Design historian Judy Attfield argues that key players in the industry, 'riddled by hierarchy', used their committee and association clout to act like cartels which strenuously kept tufted carpet out of Britain.[112] *Carpet Annual* 1955–1956 began to acknowledge the growing presence of the 'cheap

floor-covering known as tufted carpets'[113] and continued its protectionist approach to woven carpets. To that end, The Carpet Manufacturer's Association, established in 1864, used price fixing to control the industry and kept the doors closed to tufted manufacturers until the 1970s. Attfield argues that the industry acknowledged that plain woven and tufted carpets could not be distinguished by the general public.[114] Given this, an analysis of the divergent trajectories of woven and tufted carpets must be understood in relation to the hierarchies of the carpet industry.

In the US tufted was seen as an entrepreneurial innovation, a story of the social mobility of lowly gold-rush pioneers working from 'cement-block buildings with a tin-end wall for ease of expansion'.[115] But tufted carpet's birthplace was problematic in the context of British anti-American sentiment at the time. The image of American affluence, with its promise of social mobility displayed through the consumption of goods, held an appeal for the British. But with it came a wave of anxiety about the damaging excesses of consumer culture.[116] By contrast with tufted carpet, woven carpets carried the elite cachet of opulent hand-knotted Turkish rugs imported in the fourteenth century. Tufted's 'cheapness' was within the grasp of British families: the industry realised the importance of this development and had to respond. By 1955 two large concerns manufacturing tufted carpets were in business: Cyril Lord based in Northern Ireland[117] and a consortium comprising five long-standing firms, including Crossley's of Halifax. Anxious that proximity to the site of production might besmirch their family names, the latter ensured that its factory was sited 'away from the traditional woven carpet district'.[118] Kosset was the brand name, Luddenden Foot in Brighouse was its site of production, and it became known by fluffy-white-kitten advertising with its mission of attracting a female audience.

Mike Savage's work offers an enlightening perspective on why the patrician carpet barons were so keen to keep distance from the idea of producing cheap, Americanised goods. By the late 1940s the middle class had become highly cognisant of the 're-distribution of social esteem' – a process that had begun during the war.[119] Improved living standards made it difficult for the middle class to continue to define themselves, as they had done, against the gritty, primitive lifeworld of the working class. Consumer goods were available across class groupings and spaces where the middle classes

had become accustomed to treatment in line with their privilege. In health care, for example, those higher up in class status could be selected before others in the doctor's queue, but these advantages were being eroded as social provision was universalised.[120] During this time the owners of the carpet industry wanted to hold on to their moral superiority – they saw American culture as a 'trashy' degradation of British concerns with 'quality' and tradition – by defending their production of luxury carpets in the spaces of the Victorian mills built and managed by their forebears.

Yet while industry management strove to protect conservative tradition, the key players in the industry also wanted a part in the contemporary modern zeitgeist, and T. F. Firth and Sons were central to the 1951 Festival of Britain's celebration of modernity. 'We shall be delighted to show you our carpets from Clifton Mills in the "Telekinema" on the South Bank Site', announced the T. F. Firth and Sons Ltd brochure, 'and the fine Moquette from Heckmondwike in which 3,500 seats in the Royal Festival Hall have been upholstered'.[121] With a footfall of eight and a half million to the London exhibition, two thousand villages across Britain organised local festivals. Becky E. Conekin argues the Festival of Britain was an 'autobiography of the nation'; an expression of a country endeavouring to re-generate its identity after the war.[122] Not everyone could exhibit; as Gerald Barry, one of the key organisers, explained, hire stands were not for sale: 'they would get there by merit or not at all'.[123] It was a mark of public recognition therefore that Firths played a central role in carpeting significant segments of the exhibition space. Given the significant proportion of female workers at Firth Carpets Limited, a female weaver is shown operating a 'Platts Brothers' loom, 'one of the most *modern*' (my emphasis) in the 'Hall of Production' (see Figure 1.6).[124]

The festival was a government project which 'set the parameters of a social democratic agenda for a new and modern Britain'.[125] Planned mostly by Labour Party members, with a pedagogic remit for improving the nation, it called on the scientific and technical expertise of a host of middle-class professionals to represent Britain's past and herald its future. It aimed to act as a salve for the nation's people after the war. Organised around themes such as modernity, progress, science and industrial design, it hoped to steep publics in cultural knowledges on a journey towards becoming modern, cultured

72 Threads of Labour

This loom which you will see being operated by Firths in the Hall of Production is one of the most modern Spool Looms made by Platt Bros., of Oldham, Lancashire. One of the designs being woven at the festival is illustrated opposite.

Carpet design based on the accidental disposition of jewels. The colouring was developed by the use of almost basic primary colours for the conventionalised jewel motives on a full beige ground

Figure 1.6 Firths featured at the Hall of Production at the Festival of Britain, 1951. Firth Festival of Britain catalogue. Reproduced with permission from West Yorkshire Archive Service, Calderdale, WYC: 1538/11/4.

citizens. But it served up, as Conekin argues, an insular narrative about the nation: it was silent about empire and was careful not to include 'foreigners'; it was keen to construct a sense of a 'deep' and 'universal' past and insisted on the idea that above all New Britain should strive to be modern.

The event also hoped to aid national recovery by encouraging tourism. An official pamphlet produced by the organisers stated that 'visitors to Britain will be encouraged to visit your industrial and rural areas' to view the people, their place and its products.[126] The Firths brochure assumes this mode of address and encourages a visit to Firths Mills. Elsewhere, the brochure anticipates the reader-tourist: 'Should you travel ... you will find examples of the fine products in the hotels of Bath, Stratford-on-Avon'[127] Interestingly, as Conekin argues, the festival was concerned to break away from the 1851 Exhibition and directed tourism to destinations which avoided cities with high Victorian architecture; they were 'too laden

Figure 1.7 Firths encouraged tourism across the UK. Firth Festival of Britain catalogue. Reproduced with permission from West Yorkshire Archive Service, Calderdale, WYC: 1538/11/4.

with association of capitalism, imperialism, class conflict'[128] In this way Firths had carefully adhered to the festival's design remit by favouring examples from Georgian cities with their restrained classical architecture – by mentioning Bath and Stratford-on-Avon as places to view their carpets. This was the kind of architecture favoured by design critics of the period and by the Council of Industrial Design (COID) (see Figure 1.7). The point must be made however, that Classical architecture in no way evades class difference or empire. The prosperity of these cities came directly out of an economic system built on the back of slavery and imperialism.[129]

Dedicated to educating publics about design and taste, the festival encouraged the idea that the home was the best place to urge the public to subscribe to a new modern national agenda. It aimed primarily to reach women, the holders of the purse strings when it came to choosing and spending in Britain's homes. Egalitarian in orientation, it sought to democratise good taste and aspired to the

notion that everybody could begin to appreciate objects that were both aesthetically desirable and functional. The middle-class festival planners who were COID members wanted to encourage clean, spacious, modern homes, and this meant dispensing with the bulky, cosy, traditional furniture of the 1930s. It was about leaving behind the dreary privations of war. For the middle-class promulgators of taste, science and technology were central to the idea of a brighter Britain.[130] These elements were embraced in the construction of the festival: the famous steel suspended architectural structure was named 'Skylon' after 'nylon' – considered then a marvellous futuristic innovation in fibres. Similarly, the 'Telekinema', where images of Firths' carpets were being beamed out to festival audiences, represented a technical innovation in film and television projection that was to endure as the permanent National Film Theatre. But planners also wanted to etch modernist, scientific design more firmly into the fabric of everyday life. The Festival Pattern Group was influenced by a crystallographer who argued that 'crystal-structure diagrams' were an exciting new motif for textile designs.[131] Featuring 'molecular structures of compounds such as insulin and haemoglobin', the designs drew on the natural beauty and rhythm of symmetry and repetition.[132]

Thus these two middle-class camps of the 1950s appear at odds: a conservative, patrician middle class controlling the carpet industry on the one hand and a left-leaning COID promulgating modern aesthetics in national textile design on the other. Mike Savage argues that middle-class identities were in flux in the profligate 1950s. His detailed empirical work on Mass Observers shows a new middle-class faction who sought to dis-identify both with the privilege of gentility, which they saw as antithetical to post-war democratic values, and the working class, whose bettered position threatened their middling status.[133] Savage argues that this new middle-class faction became attracted to the idea that they embodied scientific managerial and technical attributes required for leading the nation. In this way, his work offers an understanding of the centrality of science and technology so important to COID at the time.

How, then, did Firths navigate the competing textile ideas of traditional vs modern? Certainly the industry made attempts to understand consumer opinion. Firths' management were cognisant of the 1948 British Carpet Exhibition, held in London, which

conducted a quiz directed at exhibition visitors to identify what the public wanted from carpets, and which included questions about 'New Look' modern designs.[134] The quiz itself testified to divided opinion: an 'art student' is appreciative of the new designs, while a 'designer' suggests that, 'instead of the New Look, let's develop the old'.[135] The answer was that Firths chose to spread risk across its repertoire by producing modern and traditional, or straddled both with what the industry termed 'middle-of-the-road contemporary' designs. An example of the latter was the carpet woven in the Hall of Production at the Festival of Britain, with a design 'based on the accidental disposition of jewels' on a 'full beige ground'. Quasi-abstract bright primary-coloured jewels are haphazardly fashioned against a neutral beige background (see Figure 1.6). Mid-decade, an advertising feature appeared in the journal *Furnishings from Britain* titled, 'Equally "At Home" with any Interior Style'. This shows three possible room sets, two traditional and one modern, to suggest the versatility of Firths' all-wool seamless Wilton (see Figure 1.8).

Elsewhere, Firths' abstract modern design *Alwyn* in 'all fibro quality' is featured as a 'Design of the Year' (1958–1959).[136] Minimalist Scandinavian-style furniture, a television, two chairs and a low coffee table are featured as the only pieces of furniture in a spacious room. A green, modern design is centre stage in this brochure for Broadloom (see Figure 1.9).[137]

Clare Langhamer argues that war 'intensified "home"' for men as a signifier of warmth, privacy and comfort; women were more interested in appearance and the desire for a modern home.[138] While in the Festival of Britain, the design media and textile manufacturers worked to promote modern design, writers on the period maintain that the take-up of modern aesthetics was complex. For Langhamer, even by the end of the 1950s a large percentage of people were marginalised from home-centred society. She suggests that the promotion of 'modern' aesthetics rarely 'achieved a total victory' – rather, women exercised 'chooser and spender' tactics which swung between old and new.[139] Angela Partington argues that the 'glib moralising' of the spirit of modernity failed to account for resource constraints that class and race brought to practices of home consumption.[140] In similar vein, Deborah Sugg-Ryan argues that the popularity of the Tudorbethan style in the small 1950s suburban semi was precisely

Figure 1.8 Firths catered for traditional and modern. *The Ambassador*, 1955. Reproduced with permission from Firth Carpets Archive, Bankfield Museum, Halifax, Box B.4.8, ref. 2005.43.

Figure 1.9 Firths extended its repertoire to cater to new markets. Reproduced with permission from Firth Carpets Archive, Bankfield Museum, Halifax, Box B.4.8, ref. 2005.182.

because people wanted 'to live in the past rather than in a modern machine' and as 'actants' people chose strands of the modern and comfortable in their homemaking practices.[141]

Conclusion

Part I of this chapter charts how T. F. Firth and Sons Limited navigated changing circumstances from the nineteenth century to the 1960s. A producer of high-quality carpets since 1867, T. F. Firth and Sons took advantage of mechanisation in the Victorian period to cater for mass consumers. The company held global reach, exported widely across the British Empire and catered for exponential urban growth from the 1850s to cater for a thriving domestic market. In the twentieth century the firm acted agentically to survive the 'hungry' 1930s, maintain a 3,000-strong workforce and power the mills that absorbed the landmass of Bailiff Bridge. In the relatively stable

post-war 1950s, it was nourished by the prosperity of the industry, and its carpets and upholstery enjoyed pride of place at main events at the prestigious 1951 Festival of Britain. As the clean lines of modernist abstract design melded with synthetic, scientific materials, Firths extended its product repertoire, but it did so with caution, protecting what the firm considered to be its key strength: traditional luxury woven carpets. By the mid-1960s it had become one of the Big Six leading carpet manufacturers in the UK. It exported to 'every carpet consuming country', shipping to 40 export markets.[142]

My parents' working lives bear out the historical antecedents of the gendered history of Firth Carpets in this period. Male and female textile workers had different and unequal lives both at work and at home. From its inception in the Victorian era the carpet industry was unapologetically and visibly patriarchal and maintained a masculine management structure. It offered a pathway to my stepfather, an aspirant working-class man, who with virtuosity and hard work could move, to a limited extent, into middle management. On the other hand, female textile workers were undervalued by the dynamics of industrial capitalism in the carpet industry more widely and at Firth Carpets Limited. As Rozsika Parker argues, fine art is often associated with masculine excellence and has historically stood as the hierarchical superior to women's 'craft'.[143] The carpet industries exploited the craft skills of women in 'finishing' departments, as an adjunct to the unpaid sewing they were often required to do in the home. Women provided an abundance of cheap embodied labour and were rendered relatively invisible in spatially sex-segregated departments with lower pay and dramatically less favourable employment rights. Their work in these departments acted as a barrier to professional advancement. At the same time, women were caught in a circuit: they were both the producers and hailed by the advertising media as the discerning consumers of the 'domestic ideal' at certain moments across the account of history provided in this chapter. But, like countless working-class women, my mother would have to wait her whole working life before she could afford an Axminster carpet for her own home.

Nonetheless, workers who lived and witnessed a thriving Firths across the twentieth century, and who contributed to the quality imperative of its carpet production, understood the largesse of the company: Firths was prestigious and world renowned and its reach

and importance were etched into the mentality of its workers.[144] By tracing how Firths operated through fragments in the archive, I hope its stories will come into dialogue with the shifts of thinking around the meanings and values of industrial work as it became eclipsed by processes of deindustrialisation from the mid-1970s.

Part II opens with a foray into the business 'Firth', housed within the now rented accommodation of a once-Firth Carpets building, Clifton House. Purveyor of bespoke carpets and existing under the Firth Carpets brand, it exemplifies the characteristics of today's carpet business. Used as a starting point in the contemporary from which to look backwards, the chapter then examines the process of deindustrialisation to ask: how did Firth Carpets Limited shift from a physical, geographically expansive company to a small non-manufacturing concern?

Part II: carrying on, 1966–2002

Part I of this chapter looked at the importance of the miniature oval cameos which sketched the physicality of Clifton, Victoria and Flush Mills in 1920s T. F. Firth and Sons advertising. Today 'Firth Carpets', a carpet company whose director is an ex-Firths employee, is still operational in one of the only remaining Firth Carpets buildings, Clifton House. Firth is an example of a company which has developed to keep manufacturing carpet in the UK. The company has faced challenges: changes in consumer lifestyles, cheaper imports since the 1980s and the turn to laminate and wood flooring have signalled changes to organisational practices and routines for survival in a high-cost location.

Industrial machines were the tangible assets of the nineteenth century in the UK and the foremost tools of economic growth. A recent McKinsey Global Institute Report argues that investment in intangible assets 'rather than tangible assets in an increasingly dematerialized world'[145] will shape business growth in the global North. Intangibles which undergird the knowledge economy across the digital landscape consist of technology, software and human capital. Manufacturing, it argues, requires synergistic relationships with intangibles – in research, brand marketing, and digital and analytics capital – to stay afloat.[146] Firth is a small concern and represents a significant break with the past: it shares some features of the platform business model by operating as an intermediary between client and manufacturer and it has invested in intangibles.

This shift tells us a great deal about change in how industrial work is organised. In stark contrast to the spatial physical geography of the mills of Firth Carpets Limited, with its large stock of machinery and workforce, Firth operates from a single office. Like Airbnb, Match.com and Uber, it is weightless; it carries no stock.[147] Manufacture is outsourced, carpets produced in places such as Belgium, Northern Ireland or small factories in West Yorkshire in bespoke orders for clients. Marketed through the digital environment of its website, it speaks to the values of the contemporary customer: it offers a 'total flexibility' bespoke service for the luxury homemaker, hotel or corporate setting. It promises to supply products 'when and where you want them' to fit tight budgets and schedules. Firth Carpets' room sets feature elegant plain carpets, a variety of multi-textured, décor

ranges and modern rugs. Rather than advertising material which conveys the long-standing history and family ownership of a large company concern, Firth advertising is light: brochures are svelte, pared down and unburden the customer of the product journey. The sample booklet is plain, matt grey; sample squares of carpet have reference numbers rather than names. In this way Firth makes manufacture invisible: its labour, people and factory buildings.

Yet, as product design experts argue, place-based associations carry significant cachet for product;[148] thus Firth locates itself within T. F. Firth Carpets as 'a trusted brand for over 150 years'.[149] This strategy, of using the history and place of Firths, is difficult for cheaper imports to imitate. In the last 60 years carpet business in the village has shifted from accommodating one of the Big Six carpet manufacturers in the UK in the 1960s – a spatially expansive physical entity, employing thousands of women and men – to Firth, virtually a one-man concern: modern, neutral, logistically efficient and weightless. What wider factors caused the material solidity of Firth Carpets Limited to 'melt into air'?[150]

Part I of this chapter ends in the mid-1960s – in a moment of prosperity. Part II now traces the periodicity of the spatial contraction this opening vignette describes. It explores some of the features of the process of deindustrialisation from the highpoint of carpet manufacture in 1966 to the takeover of Firth Carpets Limited by Interface in 2000. It looks at where Firth Carpets Limited stood in relation to the wider carpet industry. In recognition that Firth Carpets did not relocate to a cheaper locale, choosing instead to carry on manufacturing, it mines a variety of materials from the archives to investigate the survival strategies it chose to maintain business. Taking up the thread in earlier chapters of the differential pathways and opportunities which characterised how men and women were positioned into gendered work at Firths, it draws on the staff magazines *Trim Lines* and *Tuned In* to shine light on how the company handled female entry into more middling, white-collar roles in the 1990s as the years rolled towards closure.

Deindustrialisation across the global North and the UK

Deindustrialisation was experienced in the latter part of the twentieth century across old industrial communities in the developed world in

different political and national settings in North America, Canada, Russia and across Eastern and Western Europe. Beginning around 1975, its features mark the end of post-Second World War economic expansion, or the 'long boom'. Deindustrialisation is most usefully approached as a process or series of shifts rather than a 'clean break' between boom and bust. Alice Mah argues that the decay of industrial plant and buildings is best described as a process of 'ruination' on the move rather than a static entity.[151] Similarly, economic historian Jim Tomlinson argues it is best understood as a shift in the labour market. Edging attention away from the economic balance sheet to employment welfare, Tomlinson's focus is on unequal pay, employment precarity and attendant changes to government social security. Its consequences, he argues, were so profound that the narrative of deindustrialisation runs through post-war British history like the letters in seaside rock.[152]

The idea of process illustrates the shifts which characterise deindustrialisation in the 1970s and 1980s. Tomlinson's account of the changes to the UK labour market are illustrative of economic restructuring from manufacturing to service industries. Barry Bluestone and Bennett Harrison argue that this had consequences for wage distribution in the US, as technological change ushered in high-skill well-paid jobs for the few, a paucity of jobs in the middle and a glut of low-skilled jobs for the many, a tendency which acted to widen social inequalities through wage polarisation.[153] Gone were the days when working-class people like my dad with few qualifications could take home a decent wage. Local industries in the developed world were also subject to capital flight, when in pursuit of cheap and flexible labour, companies migrated to far-flung global production sites.[154] Discussion of restructuring often focuses on the effects on urban centres, but peripheries in the form of one-company towns and villages like Bailiff Bridge, were also affected.[155] For sure, the period is marked, as Alice Mah notes, by a series of debates which articulated transition or co-existence across the period: from state to market, from Fordism to post-Fordism, and from community to capital.[156] Yet its corrosive process in the UK, as Christopher Lawson argues, was 'the most rapid and sustained in the global North'.[157] In the late 1950s 40% of the UK workforce was employed in manufacturing. Today that figure is under 10%.

How are we to understand the factors which contributed to deindustrialisation in Britain? Central to Lawson's perspective is

Britain's 'imperial story': his argument refuses to place slim focus on Thatcher's governmental policies of the 1980s; rather, a focus on the longue durée is necessary – the shift from Britain as empire with an overwhelming grip on imperial and commonwealth markets in the mid-nineteenth century to a nation unable to compete when those same markets atrophied in the twentieth century. For Tomlinson, globalisation and government policy are factors, but especially significant for him is that the fall in the amount of employment in the industrial sector was motored by changes in technology and cycles of demand which made for increased efficiency of production. This, in turn, drove down the price of produced goods,[158] such that, although in 1957 48% of UK workers were employed in industry, that figure had fallen to 15% by 2016.[159] Governmental policies played a part – inflated sterling from 1979–1981 during the Thatcher administration hastened deindustrialisation – and were accompanied by 'passive neglect',[160] with a lack of policy designed to cope with deindustrialisation during the 1970s and 1980s. These factors were arguably compounded by workers who perhaps unwittingly carried on against a backdrop of pedestrian decline. While those writing outside the UK chart forms of collective resistance to redundancies or closure which provoked what Jackie Clarke describes as 'violent or spectacular protests',[161] as in the case of Cellatex and New Fabris in France in the 2000s, Rory Stride shows that female textile workers at the carpet firm James Templeton in Glasgow had not only forgotten the name of their union but had also fallen into a resigned acceptance of the inevitability of mill closure.[162] The case of Firth Carpets strikes a similar chord. Workers were thanked by the managing director of their parent company, Readicut in the late 1970s for not participating in industrial action. Indeed, up until closure there is no evidence that Firths workers in Bailiff Bridge took any strike action.

Deindustrialisation in the UK carpet industry

The year 1966 marked a peak in British manufacturing history. It was the highlight of the post-war boom: 35% of gross domestic product was based in manufacturing and, according to the Select Committee on Trade and Industry, looking back in 2002, 8.7 million workers enjoyed employment.[163] Historians have argued that Britain's relative decline in the post-war period came from other trends: the deleterious financial impact of the Second World War, the lack of state-supported incentives to produce a fiscal plan during the 1960s,

the growing force of foreign competition.[164] Right-wing historians have held other views: Martin Weiner argued that the elite harboured anti-industrial sentiments which led to a disinterested approach to entrepreneurial investment; while Corelli Barnett argued that the Labourite socialist construction of the welfare state diverted attention away from the development of a robust industrial policy.[165]

For most Britons, the 1960s had delivered a decent standard of living. In contrast, in the 1970s accounts of the deindustrialisation of Britain's manufacturing employment began to replace the idea that manufacturing would continue. International competition was defined as a causal reason, but a number of factors were associated with deterioration during this decade: industrial unrest leading to strikes, unemployment, rising cost of living through inflation and the balance of payments. These issues amounted to a febrile climate as political leaders both left and right struggled to exert control.[166] It was the crises of the 1970s that enabled a new model of power to emerge, one that dominated the late twentieth and early part of the twenty-first centuries: neoliberalism.

Margaret Thatcher's right-wing government came to power in 1979, heralding the start of a long period of monetarism and neoliberal governance. Her leadership was characterised by a belief in unbridled capitalism, the free market and profit as the central driver of social progress. Undergirding these principles was a socio-economic model of competitive social relations. In fact, she argued that the national character of British people comprised entrepreneurial and individualistic traits.[167] While Tony Blair's subsequent New Labour government was more concerned to define the state's role as moulding citizens to the needs of the global market, his administration continued to valorise neoliberal individualistic competition. Blair's heroes of neoliberalism were entrepreneurs flexing to adapt to world markets to make Britain competitive, but Blair barely used the term 'neoliberalism'; to him, its world values offered 'common sense' as part of the inevitable 'way of the world'.[168] Together these leaders established a world view in which neoliberal hegemony 'inscribes itself into the topography of everyday life, sculpting a landscape through which we largely must flow', including the atmosphere in which British manufacturing had to survive.[169]

The carpet industry was not immune to the wider socio-political economic downturn of the 1970s. The publication *Carpet Annual*

acted as a barometer which featured both national and international data and summary information about the health of the industry.[170] As the UK summary in the 1971 annual proclaimed, 'the 18 months to March 1970 proved to be ... the most difficult and least profitable for UK carpet manufacturers since the war'.[171] A conservative publication which was still influenced by the shadow of the tradition-steeped carpet firm owners (many of whom were barons), the 1971 issue expressed deep anxiety as the demand for luxury woven carpets was eclipsed by tufted in 1969. To that end a campaign to encourage sales of British Axminster and Wilton woven carpet was launched. National and local advertising was ramped up and a lifestyle promotion campaign which featured room sets and a showroom made by the British Carpet Centre showing samples of woven was opened. Footfall, which included the Queen, amounted to 64,000 visitors. A Gallup poll conducted afterwards was reassuring for industry traditionalists. It concluded that, after visiting the centre, 72% of respondents were more aware of woven, as opposed to 30% of those who knew of tufted synthetic fibre carpets.[172] The deeply held conviction of the superiority of woven doggedly persisted, despite the mass-market potential of the more financially accessible tufted in an increasingly tough and rapidly changing business-scape. Indeed, woven was to decline in the UK by 18% in 1980.[173]

But if these statements and measures signalled a warning of sea-change, the crisis was set to deepen across the 1970s. If 1979/80 'was one of the most difficult', as proclaimed by the 1981 *Carpet Annual*, 1980 'was the worst trading period' for the British industry.[174] A host of drastic changes brought this about: housebuilding slumped and high interest and mortgage rates lowered the number of first-time-buyer houses – both meant a shortfall in carpet consumption at home. In addition, inflated world oil prices caused energy and raw materials costs to rise as inflation soared, causing a trade recession – which placed the UK at a disadvantage in comparison to US and Canadian competitors. The over-valuation of sterling drove down overseas competitiveness while simultaneously increasing the efforts of importers. In fact, imports rose by 40% during 1980 – double the figure of two years earlier.[175] Meanwhile, the British industry's determination to protect woven carpet produced a sluggish approach to tufted, a sorely missed business opportunity as the exponential development of tufted carpet irreversibly 'changed the pattern of the

international carpet trade'.[176] This opened an opportunity for the US and Canada to export tufted to the UK. Carpet machine makers in the UK were selling machinery to countries such as the USSR, Brazil and Japan. Indeed, Japan was racing ahead, developing fine-gauge state-of-the-art tufting machinery such that it became one of the world's largest exporters, offering competition that could not be matched by traditional carpet-manufacturing countries like Britain. Taken together, the reader can almost sense the sigh and shake of the head of the 'world survey' section of the annual as it concludes, 'the whole structure and hierarchy of the carpet industry as we have known it in the years from 1950 to 1978, has taken on a different aspect. Its features have changed, be it in raw materials, management, marketing methods and most of all in technical aspects.'[177]

From declinism to 'evolutionary economics'

How did Firth Carpets Limited navigate the macro-climate of the 1970s onwards and the complex factors of the carpet industry at this time? As historians Jim Tomlinson and David Edgerton argue, the problem with declinism is that it overlooks the more complex pattern of economic development emerging out of the British post-war economy as the services eclipsed staple industries.[178] A prominent argument made in deindustrialisation literature is that employment and production moved to other regions for cheaper production sites and more flexible labour.[179] To be sure, employment figures in the UK during the deep recession of the 1980s show that unemployment increased to 3 million by 1985, which amounted to 13.3% of the workforce.[180] But even so, the UK continued to be a significant locale for manufacturing. Firth Carpets kept going. The 'business critical' challenge was to adapt to increasingly knowledge-rich forms of mechanisation as the UK economy restructured in response to the barrage of competition, changes in consumer behaviour and technological change.

In their writing about how the carpet industry coped in this period, business studies academics John R. Bryson and Megan Ronayne model the strategies senior management used to stay afloat. Their 'common sense' description of the carpet business is underpinned by a neoliberal approach. For them, the companies which bravely and adeptly managed these circumstances did so to make their firms as competitive as possible. Behind their history is an implicit belief

in free-market capitalism and entrepreneurial tactics as business actions which 'work best' from a management perspective. But what is useful for our purposes here is that their model affords a visualisation of how management organised their workers to navigate a complicated range of factors to maintain competitiveness.

Bryson and Ronayne argue that 'evolutionary economics' is a 'firm-centred' detailed analysis of how management evolved or adapted their workers to respond to global competition. Undergirding their model is the idea of business as an endlessly flexible entity which must manage its workers to swiftly and continually adapt to external socio-economic circumstances – a set of demands that must have been challenging for workers. Adaptation, they argue, took place across three sites: resources and capabilities (which aim to be unique and offer barriers to imitation), behaviours (decision making and problem solving) and organisational routines (which must guard against becoming 'stale'). While the structural changes of deindustrialisation brought 'capital flight' – the downsizing and offshoring of manufacturing in low-cost locations – they argue that this approach tends to obscure a focus on the more local 'strategies, alterations or adaptations to routines, practices, processes and products developed by firms located in high-cost production locations' which enabled industry to *keep going* during moments of accelerated deindustrialisation.[181]

For example, during the 1960s carpet production across the industry became highly standardised in the UK (a process called 'commoditisation', sometimes referred to as cost stripping, where unique qualities are minimised to keep products low cost). This meant that low-cost locations could imitate them and undercut carpet production in high-cost locations. One response to this was the trend to mergers and acquisitions in the 1960s which led to a period of business consolidation in British textiles. However, as a result British manufacturers found themselves outcompeted by European concerns in the textile industry when they entered the European Common Market in 1974. While Britain offered scale and standardisation, continental rivals used non-price-based elements (quality, brand, heritage, place of production) as competitive tools in a bid to counter commoditisation. Whereas cost stripping can easily be copied, evolutional economics draws on a 'resource-based' approach which analyses how resources, routines and capability

strategies, such as a place of production which emphasises 'heritage', can be used instrumentally to produce distinctive goods which are hard for rivals to imitate. Used together, cost stripping and resources can combine to make 'sustainable, competitive' weapons in a marketplace.[182]

The coming pages draw on Bryson and Ronayne's model to understand Firths' agility at using competitive resources in its management routines, by investing in new plant technology and steering its product development to keep hold of its contribution to carpet manufacture in the UK. But while Bryson and Ronayne's 'firm centred' approach to the period allows an analysis of business agility, their focus on management tends to underplay how crucial management of the workforce was for overseeing change and adaptation. It must have felt challenging for workers to be expected to constantly shift in line with new routines. I argue that it was judicious management of the workers – how the challenges were presented to them and how they were addressed as a primary 'asset' – that enabled a relationship that encouraged them to adapt. The first section mines examples from the archive: it looks first at key business decisions Firths took as a result of hiring an external business analyst, its takeover by the Readicut group and the decisions it made in relation to its product portfolio. It then moves to how it managed its workforce through change. The second section turns to the two in-house magazines: *Trim Lines* from Firths Furnishings and *Tuned In* at Firth Carpets to build a picture of textile business in the context of the concerns of the 1980s and late 1990s.

The 'difficult' 1970s and early 1980s
Analysis, mergers and acquisitions, and product portfolio

As Bryson and Ronayne state, carpet manufacturers maintained a vigilant watch on competition and committed to a continual process of adaptation to stay afloat. In 1968, Michael Ackroyd, the managing director of Firth Carpets Limited, commissioned the London firm P. A. Management Consultants to produce a report, 'The Present Position and the Next Three Years'.[183] It offered an analysis of T. F. Firth and Sons Limited with two subsidiary companies: Firth Carpets in Bailiff Bridge and Firth Furnishings in Heckmondwike. In the early pages of the report, it established the significance of the Carpet wing of the business – it had 6% market share of traditional

woven carpets and a 20% export record (twice the average for the industry) and was making good preparations to start production of the 'more expensive qualities' of tufted. In neoliberal capitalist vein, with the maximisation of profit at the centre of its recommendations, the report also cautioned significant weaknesses for what the authors describe as a 'static concern'. They noted a conservative dividend policy and no evidence of 'diversification'; a sluggish top- and middle-management approach to 'rigorous profit-making' and inadequate management accounting which hampered swift decision making.[184]

In addition, the report argued that considerable savings could be made to overheads. P. A. Management Consultants 'rooted out' blocks to lucrative behaviours in management culture with the potential to block change and minimise value through 'same path' dependency.[185] Senior management, with their eye on lucrative dividend value and the speculative gains that could be made for shareholders, sought the analytical lens of a professional consultancy to identify which routines and practices had become stale. Acquisitions and mergers were central adaptation strategies for owners to minimise risk across manufacturing portfolios; such mergers helped to strengthen the industry during this period. In that same year, when weakness and strength were identified at T. F. Firth and Sons, the company was acquired by Readicut International Limited and became part of their diversified portfolio of textile companies. Workers benefited because their work continued, but these changes were centred primarily on the interests of members of the capitalist class – the shareholders.

During the 1970s there were several Readicut Chairman Employee reports. The 1975 and 1976 reports continued to allude to 'difficult' times. But clearly the Readicut Group continued to minimise its risks and 'diversify'. A letter dated May 1976 reports on the acquisition of 'Plasticisers', together with three of its allied companies.[186] A company which sold synthetic fibres and developed, manufactured and marketed plant for their production, Plasticisers was one of Europe's largest producers of polypropylene fibre. Developed in 1951, polypropylene was the most significant commodity plastic used in a wide variety of applications.[187] Highly colourfast, moth resistant and fire retardant, it became one of the most widely used technical materials for carpets and rugs in the future. Essentially, most of the plain-coloured wall-to-wall carpets purchased today are made with 100% polypropylene fibre. They are popularly chosen because they are durable, stain resistant, easy to clean and affordable.

These factors make them a practical choice for high-traffic areas of the home. The decision to acquire Plasticisers was a highly effective strategic decision.

While acquisitions were crucial, a watchful eye over product-market portfolio was also imperative, Ansoff argues, especially for high-cost production locations.[188] Non-price competition, for example design, technical elements, style and advertising strategy aligned to a company's heritage, becomes competitively powerful because firms in cheaper locations find those characteristics hard to mimic. While the company bought into the higher-quality end of tufted, Firths was a conservative company and its senior management had been involved historically in the fierce protection of luxury carpets. Firths' traditional and proud expertise lay in the quality and endurance of its woven products and it continued its Wilton and Axminster ranges. In the 'Wilton by Firth' brochure (see Figure 1.10), for example, a group of traditional antique clocks and pocket watches is arranged on a Wilton carpet made in a fresh green in an

Figure 1.10 'Wilton by Firth' catalogue, 1976. Reproduced with permission from Firth Carpets Archive, Bankfield Museum, Halifax, Box B.4.8, uncatalogued.

abstract contemporary design.[189] Copy reminds the customer of the long-standing and specifically British history of the Wilton loom, which dates back to the mid-1700s. Firths, it implies, is a company capable of extending Wilton's 'aristocratic heritage' by taking the 'time to weave' to produce an 'almost old-fashioned' devotion to lifetime quality in any domestic setting. This was no fatuous claim: T. F. Firth and Sons had over a hundred years of long-standing history of weaving high-quality carpet since the 1860s in Bailiff Bridge.

But how did Firths address its workforce about its decisions over which carpet ranges would continue in its portfolio? Part of the Manager's Report, dated August 1982 (see Figure 1.11), lays out the grave challenges which threaten the industry, and announces the decision to 'hold onto and improve our position in those parts of the market place in which we are strong and we could see a continuing demand for our products – in particular the contract market and the quality end of the domestic market'.[190] Overleaf the report launches 'a major assault on the Axminster market' with the release of a new design in the company woven staple, *Buckingham*. But across its product market portfolio, it had to cater for rapidly changing mid-century fashions in its carpet and rug range. The blue colourway of one of Firths' best-selling carpets, *Buckingham Leaf* was advertised widely in the 1970s. A leaflet produced by Firths has an outlandish abstract pattern on the *Cabana* shag-pile bedroom rug (see Figure 1.12), here arranged so that just-out-of-bed toes encounter the softness of yarn.[191] Just as Kosset Carpets of Brighouse had used two fluffy white kittens lying on a carpet, designed specifically for the eye of the female family consumer, as though to evoke the haptic pleasures against the skin, as the branding symbol for their advertising, Firths used two blond identical twin girls who would usually contemplate each other as they experienced lying on the carpet, denoting 'twin value' (see Figure 1.13).[192] In this way, advertising worked to ensure that Firth Wilton (80% wool, 20% nylon) could be high end, traditional and patrician, or, in terms of the Adonis range (50% wool, 50% Acrilan), part-synthetic, youthful or family orientated, and hard-wearing.

Managing change in the workforce
Given that this period was politically febrile and economically unstable, Firths needed to maintain a reassuring communication

FINANCIAL HIGHLIGHTS

�֍ Sales volume fell by 15% over the period with the Woven sales falling by 40% and Tufted sales rising by 24%.

�֍ The number of people employed by the company fell by 41% from 1293 in 1979 to 747 today.

✭ The closure of our Australian and Canadian operations and the sale of buildings and plant which were no longer required (both home and overseas), produced cash proceeds of £1,493,000.

✭ We continued to invest in the future, spending £973,000 on plant.

✭ Our investment in stock fell by £1.658,000 due both to the fall in sales volume and to our drive to reduce it in order to improve the bank position.

✭ The improvement achieved in the bank position caused a reduction in interest paid from £297,000 in 1979/80 to £40,000 in 1981/82.

TURNOVER AND PROFIT

£ 21.4MN | 17.1MN | 18.2MN
169,000 | −871,000 | 1,001,000
R.O.C. 2.3 (%) | — | R.O.C. 14.5 (%)
1979/80 | 1980/81 | 1981/82

PROSPECTS FOR 82/83

The main priorities of a return to profitability and of eliminating our bank overdraft were achieved in 81/82. Very few companies in the carpet trade did as well and the unpleasant measures taken in the previous two years were proved to be correct.

The prospects for 82/83 do not at the moment look as good. In the first place 81/82 had a boost to profits of perhaps £200,000 arising from it being a 53-week year. Secondly, an exceptional tufted contract in the final quarter and a government grant. None of these are expected to be repeated.

In addition, the domestic market appears to be in an even worse state than last year and we are suffering, particularly in axminster, from widespread jobbing by other companies. There is, however, no reason why we should not achieve a reasonable result in this current year if we continue to operate as we are now, but taking appropriate action if the market place undergoes any significant changes.

BUCKINGHAM One of our new designs recently launched for a major assault on the Axminster market.

🦌 Firth Carpets. So beautifully British.

2005.106.7

Figure 1.11 Firth Carpets Limited manager's report, 1982. Reproduced with permission from Firth Carpets Archive, Bankfield Museum, Halifax, Box B.5, ref. 2005.106.7.

Figure 1.12 The abstract design of *Cabana*. Reproduced with permission from Firth Carpets Archive, Bankfield Museum, Halifax, Box B.5, ref. 2005.133.2.

Figure 1.13 Key brand symbol of the 1970s: the Firth twins. Reproduced with permission from Firth Carpets Archive, Bankfield Museum, Halifax, Box B.5, ref. 2005.16.

channel with its most valuable asset: its skilled and semi-skilled workers. After all, to maintain an agile approach to perpetual change and adaptation – to ask its workers to seek innovation, to network with new workers, embrace technical development and to maintain quality – it needed to clearly communicate the strategies it was undertaking to protect jobs and maintain livelihoods.

Firths produced leaflets to inform, educate and reassure its workers during the 1970s.[193] A double-page spread carried an encouraging announcement from its chairman to workers, asserting that in 1975 Firths had sold 13% more carpets and up-lifted profits by 79%, despite the fact that it had been 'a very bad year for the country and for manufacturing industry generally'. Addressing the workforce as upstanding citizen-workers, it reminds readers what earning 'Britain's daily bread' brings to national prosperity, 'because it is only the people who make things and sell them who create the nation's wealth'. Readers are given a breakdown of Firth worker contributions of tax and national insurance and given a graphical explanation of inflation. They are informed of the company's broad brushstroke financial incomings and outgoings, told of plant investment in Axminster and tufted, and of new sprinklers to protect workers from fire risk.

Rounding off the report is 'Our Investment In People', next to a line drawing of employees. Significantly, the lead staff member is female: an acknowledgement of the value of the sizeable population of women workers at Firths. The company sets out its deal with its employees: an expectation of hard work and efficiency in exchange for good care for its 'prime investment' of workers. Interestingly, and at odds with the neoliberal analysis by P. A. Management Consultants alluded to earlier, with its swingeing recommendations to aggressively pursue profit maximisation, here is evidence that Firths addressed its workforce in progressive terms. In line with the idea of keeping communication open, it reports on the value of 'participation groups' and 'daily communication and consultation', because involving staff is, it explains, 'vital to a healthy Company'. This is qualified with an acknowledgement that adaptations to routines have taken place, but added is a soft warning about the possibility of impending precarity: 'all workers must be fully involved to meet the responsibilities and *changes required to maintain a secure future*' (emphasis mine).

However, Firth's good relationship with employees went further than the day-to-day communications required to get work done. Being on good terms and listening to the worker voice meant that trade union activity could be kept at bay, especially when beyond the walls of the mills trade union 'disruptions' were in evidence. As the 1976 Readicut report states: 'our relationship between management and employees has remained most satisfactory and we have been completely free of disruptions which, unfortunately have beset some undertakings in the public and private sectors'. Cognisant of the difficulties that industrial action could have wrought, the report turns to the worker-reader to thank 'the loyalty and enthusiastic endeavours of our employees'.[194]

Carrying on: in-house magazines in the 1980s and 1990s

Firth Carpets produced an in-house magazine called *Tuned In*. Serving 'Brighouse, Yorkshire and Islington, London', its editorial team at Bailiff Bridge was skeletal. The magazine had a design manager, was edited by the company personnel manager and photographs were supplied by the company photo-journalist. A free publication, it was kept and valued by ex-workers. The Firth concern invested in two staff magazines. I was given access to seven copies of *Trim Lines* from 1985–1993 produced by Firth Furnishing at Heckmondwike, the wing of the Firth business whose manufacturing focused on fabrics and moulded carpets for cars and coaches,[195] as well as seven copies of *Tuned In* which chart the years 1993–1997.

These sister company publications, which were edited in bespoke ways for each plant and addressed each factory as a separate world, offer a lens through which to look at how these companies spoke to their employees about the health of Readicut's Firth portfolio in the last decades of the company's history. Broadsheet black-and-white newspaper format *Trim Lines* set the generic form and tone, and gives a historically specific picture of textiles business life in the context of concerns of the 1980s. *Tuned In*, produced in a more up-market colour magazine format, provides a contrast, with changes Firth Carpets experienced a decade on in the mid to late 1990s. These publications offer a rich and unique picture of the company, from the vision it sought to produce for its workers about the health of the business to the distinctiveness of the Firth brand. They illustrate how workers were addressed by management under the constant

pressure to adapt their routines and practices against the backcloth of a carpet industry which faced considerable challenges. They also offer insight into the Firth community, from how young employees were perceived and how workers were represented across their work–life trajectory to the continuing relationship Firths sought to foster with its retirees.

But while at face value their tone appears benevolent, Firths was a business and, as such, their purpose was highly instrumental. Popular in the US in the 1920s and 1940s and utilised by large concerns such as Ford, General Electric and Goodyear, staff magazines acted as an effective arm of 'welfare capitalism', otherwise known as industrial paternalism.[196] They were used strategically at particular historical moments to secure worker loyalty and divert worker anxiety as work was 'rationalised' from artisanal practice to mechanised mass production in the US in the 1920s. Constructed around what David Nye calls 'a community defined by the corporation', they acted to realise managerial aims and consolidate corporate power.[197] Using Electric General's magazine *Works News*, Nye argues that by 'distracting and pacifying its workers' it avoided strikes and increased its profits.[198] Arguably, staff magazines benefited firms, not their workers, in the sense that they were investments which brought capital returns to their shareholders.

From the late nineteenth century, as Elspeth Brown argues, corporate experts from engineers to industrial psychologists recognised the potential and power of 'realist' photography.[199] Drawing on 'photography's indexical relationship to the real', managers used representational strategies to break down both psychological and corporeal elements of the ideal 'efficient' and loyal worker which were carefully curated for the eye of the staff-reader.[200] Photographic images and copy were used to manage emotions, often deploying an address using the observational tone from a worker's point of view to create familial 'inter-connectedness'. Peopling publications with a high number of employee faces bound readers into the sense of a 'corporate family album' which made spotting co-workers, or indeed themselves, in their pages attractive to their intended readership.[201] In this way, corporate strategy could be cloaked in an appeal to the 'family' and could generate quite powerful feelings of allegiance in order to circumvent trade union activity.

While Nye and Brown's observations are made about the late nineteenth to the early twentieth century, they can be seen in relation

to Firths' need to navigate the difficult years of the economic recessions of the 1980s and 1990s. In the last decade of Firth Carpets' production, local press archives chart the dwindling numbers of jobs.[202] The line taken in *Trim Lines* and *Tuned In* shows how management attempted to ease the ups and downs, such as the difficult years following the 1991 recession, of socio-economic change. No wonder management decided to produce *Tuned In* as a way to inform, incite, warn, inculcate and reassure the existing workforce.

Continual evolution: adaptations and routines in Firth factories

In both publications the front page usually took the form of an announcement of business news by an address from the managing director. In *Trim Lines*, while 1985 announces that profit targets are fully met, it warns of the need to mine new markets.[203] But thereon until 1990 successive issues reassure readers with the impression of healthy productivity. In a feature titled 'Weaving' in the 1985 edition, about the 'kingdom' of the weaving manager, 44,000 metres of automotive carpets are produced each week;[204] in 1987 the front page shouts 'All Time High with RECORD SALES', announcing the recruitment of 'more work for more people' and 40 new jobs;[205] in 1989 the front page celebrates a high quality-rating award by Ford Motor Company followed by a Jaguar excellence award the following year.[206] Across these years prosperity is signalled as pages extol the success and reach of Firths exports – featuring the work of sales reps in Canada and the pride of Firths trim on greyhound coaches traversing states across the USA. Investments in new machinery and new innovations such as 'textile bonding' signal a futuristic sense of longevity to readers.[207] The tone is aspirant: signalled by the aim to win the British Standards Institution quality kitemark BS5750 and the forward-looking prospects of lifted EU restrictions in 1992.[208] The journal was clearly a voice of encouragement and reassurance from management to workers about the company.

Trim Lines was also a tool with which to communicate the current issues and challenges on the shop floor. It showcased problems and how to resolve them – through discussion, issue spotting and action. The 1989 edition, for example, reported on a new strategy for 'the drive for total quality' and told how eight teams had been formed across the company. The feature, 'Good Housekeeping in Action',

was about the implementation of the strategy. Workers had been able to air disgruntlement: 'the three-shift system bred resentment due to poor communication'; and by focus on the conflict, the piece offered a process for how to better manage discarded waste.[209] Elsewhere, features directly address workers about the shared responsibility for quality. In a feature 'After QI and Jaguar – Target BS5750!' written by the quality director, the features of quality are described as undergirding all company processes: 'from customer enquiries, through sales, design, development manufacture, inspection and despatch. THEREFORE IT INVOLVES ALL OF US'.[210] Indeed, this edition is peppered with messages for workers who toe the company line by using memorable mantras: workers are asked to 'spread the Quality gospel' to accompany the rhythm of work. These kinds of pieces build a vision of successful industrial production, but it is one that all workers must shoulder responsibility for around the company key accent: high quality.

The story in-house until 1989 at Firth Furnishings is a good one: no mention of financial instability, precarity, redundancy or downturn. The backcloth of struggle is held back from workers. But by 1992 the fault lines begin to appear. Noticeably, the address from the managing director speaks to the 'very tough time' the company has battled dealing with the recession and admits to 'problems with our fabric business'.[211] All fabric markets – 'bus, coach, rail and aircraft are seriously depressed' – to the extent the company's fabric line faced closure. 'We can never predict the future', he warns, though he also reassures that 'we are certainly moving to a far more secure level of security for our people': looking to BS5750, the chancellor's budget offering favourable tax reduction on new vehicles and price reduction across the board, the piece expects a sales boost in 1993, but there are 'no celebrations yet'.[212]

In this same edition, Firth hires an independent consultancy to conduct 'an investigation' to improve 'all aspects of the organisation's operation'. The feature is accompanied by a head-and-shoulders photograph of a woman with a neutral expression (see Figure 1.14), bearing the caption 'Just Jane, Socio-psychologist who conducted the confidential interviews'.[213] This article admits serious disclosure of financial problems and ends with the admission that this is the first time Firth has conducted 'this type' of survey. But, in a move that shows that Firths' management was not purely top-down, it

HOW WOULD **YOU** IMPROVE THE COMPANY?

Just Jane, Socio-psychologist who conducted the cofidential interviews.

Firth as we are all aware is continually seeking to improve the way in which the Company operates. This has been demonstrated in recent years by the number of quality awards that the Company has been presented with. However, there is need to take the improvements achieved further forward. One initiative is this area will involve an investigation into how best the Company can improve all aspects of the organisations operation.

An improvement team has already been set up at management level with the objective of eventually involving all employees in such teams. There are no 'taboo' areas, everything from the environmental issues such as toilets, canteen etc. through to marketing, working methods and training need to be examined. Thus the agenda is not fixed, and rather than the Directors and Managers dictating as to what areas need to be looked at, the Company realises that it needs to seek the views of all its employees on the issue of how the organisation operates and how best to improve it.

Figure 1.14 Investigating improvement; Just Jane in *Trim Lines*. Reproduced with permission from John Waddington.

ends by demonstrating its motive was to 'open communication' among all employees.

It is interesting, then, that in 1993 Firth Carpets bursts on to the scene with the first edition of *Tuned In*. In contrast to *Trim Lines*, the colour print and semi-gloss weighty paper give it a more up-market image. The front-page feature marks an auspicious moment: it bestows praise on Mark Fielden, the former MD, for investing in a 'decade of progress' in Firth since 1983 and ushers in managing director David Melbourne. His address heralds a future-projected agenda and an injection of investment to power the company forward in an era of 'competitive siege' from 'the UK, Europe and the rest of the world', issued with the warning that things will 'get tougher'. Announcing refurbishment of woven department looms and a re-organisation of the tufted department, this edition feels like a moment of business optimism – of new leadership and fresh investment. 'The major contributor to success will be those reading this first edition of "Tuned In"', it tells the reader.[214]

Business success follows across two subsequent years – with a presentation by the duchess of Kent for the British Wool Marketing Board award for 'Tufted' in 1993[215] and news of a multi-million-pound contract to carpet British Telecom's offices and stores.[216] In 1994, Prime Minister John Major opens the new tufting division: 'his endorsement of Firth has been a tremendous success in promoting the Company'; though significantly his visit is relegated to page 5,[217] less important than the front-page reassuring news in darker times as five years of contract work with British Airport Operators is secured. The Summer 1994 edition reports on the fruition of a ten-year relationship with International Contract Services, when Firth secures partnerships with floor contractors in a business consortium, ways no doubt of minimising business risk, with a host of companies across the UK and Europe.[218] These partnerships gave Firths a gateway to government contracts, local authority work, retail companies, and sports and leisure venues. Such business ventures saw an increase in production of technical carpeting products designed for environments with a public, heavy-weight footfall – a world away from the luxury woven products that Firth Carpets had histori-cally been so proud to produce. One of its tufted 80% wool, 20% nylon carpet tiles, *Masters of Art*, with technical ranges, were named after artists such as Rembrandt, Goya and Lautrec.[219]

Firths published its staff magazines to inform employees about new adaptations and challenges. It did so with tones of reassurance but was also a tool to deal caveats that complacency, or failing to take responsibility, could risk the loss of the reader's job and livelihood. The threat of precarity was a useful tool which management could hold over employees to secure loyalty and increased productivity. *Tuned In* also offered a way to disseminate the messages from staff development activities, the 'quality' mantra that had the air of a rote company chant. Firths also had no compunction about features which dealt soft forms of surveillance to root out negative attitudes, by hiring 'Jane the socio-psychologist'.

Interestingly, both series of magazines run down their business features in the later years of their life. From 1985 *Trim Lines* offered a carefully detailed journal, with lengthy prose pieces about company decision making and future plans. But by 1993 there is simply less to report in terms of business. The front-page feature shows the managing director accepting an 'Investing in People' award from Gillian Shephard, the secretary of state for employment. The accompanying copy is downbeat: 'improvement' of company systems and employees is emphasised as the only way to secure 'improvement of employment' to address the 'issues facing the company' required to build Firth competitiveness.[220] There are no more features about business success in this edition. And in the case of *Tuned In* in Summer 1996, either the magazine editorial was understaffed, or the business success of Firth began to enter serious decline – while the front page covers the carpeting of war museum Royal Armouries,[221] the rest of the magazine, aside from the re-furbishment of the design studio, is devoted to sports and community features. The final edition in 1996 holds news of 'multi-million-pound orders' from BA, Concorde, Midland Bank and DSS Social Security, but the feature is vague in terms of business detail. In both magazines the emphasis is on 'model employees', winning employee of the month accolades and features on individual employees amidst the sport, long service and community news.

Work and workers at Firths

Brown argues that photography in the corporate magazine falls into two types, one of which is the 'work portrait'.[222] In contrast to the impressive documentary images by leading photographers of the day used to portray workers in Tim Strangleman's analysis of the post-war

period in the in-house magazine *Guinness Time*, the photography at Firths is functional and modest. However, it is used respectfully to value worker contribution to the firm. *Trim Lines* shows workers in protective clothing performing the skilled movements and gestures required to work at looms or at fabric-moulding machines. At times workers are photographed as individuals, with short text describing the specialist work of 'perching'; or as teams on the production line. As Brown argues, these kinds of worker portraits act to stabilise the worker and offer a sense of pride and contentment in the type of labour performed.[223] Tim Strangleman adds that these descriptions are important because they communicate the skills of workers, so that fellow workers in other departments understand the status and significance of the chain of production in a community of workers.[224] For example, the 'RECORD SALES' front page of 1987 anchors the 'superiority of our carpet ... increased demand and excellent supply record' to images of shop-floor workers at the laminating machine.[225] The caption explains: 'from the softening "ovens" which promote pliability in the triple laminate material ... a team of four at work on the Rover 200 interior piece carpets'.[226]

Other features within the magazine qualify as both 'work portrait' and Brown's other type of corporate photography: the 'domestic snapshot'. The role of the personal feature in corporate magazines is to represent a heteronormative 'order' in relation to how classed, raced and gendered ways of seeing are produced in relation to Firths' industrial community. *Trim Lines* visualises a company which in the 1980s employed its own workers rather than outsourcing. Its pages include employees across the class spectrum, including the unskilled, largely female workforce. In the feature 'Next to Godliness', factory cleaner 'Carol' is chosen from a team of five women, featured smiling at the camera with a vacuum cleaner and praised for providing well-being and a proudful environment for 'the place we work'. But work is given relatively short shrift, as the affectionate feature spills over into Carol's large family before moving to both her own and her family's sports interests.[227]

By contrast, professional women with qualifications or in leadership positions are respectfully profiled. Features are shorter, less detailed and tend to fall quickly to details about marriage partners or children. A new buyer from Germany who holds a degree in English and Economics, for example, is brought in to liaise with European car customers. We hear about her former job, the region she comes

from in Germany and her sports interests. But perhaps anxiety about highly qualified women is assuaged by the need to add a joke element: positioned on page 3 the caption below her smiling photo reads: 'one thing Anke did not expect to be when she came to Firths was a page three girl'.[228] White-collar women are presented more softly in their attire in contrast to the suited corporate look of the male management workers, and they are invariably smiling to camera. *Trim Lines* is more comfortable and sympathetic – less *anxious* – in its treatment of blue-collar female workers who work in mending or setting.

But it is in more lengthy features, where *Trim Lines* spotlights particular individual workers, either new to Firths, working at the company or on retirement, that the firm's deeply conservative values about the 'good' worker stand out. In these ways, the neoliberal values of individualisation referred to earlier come into play. In relation to this, there are marked differences in how male and female workers are represented. Male workers, from a variety of positions, are generally given more space within the pages. These profiles do a good deal of cultural work to showcase what the good male worker means in the company – he has commitment, organisation and a type of grit. The magazine is keen to foreground military and armed services across the worker ranks. A fabrics finishing supervisor has a whole page dedicated to his years in the Navy, his gunnery expertise and his call-up to the Falkland Islands. Retirement features give copy space to military service. Alternatively, work colleagues are well rounded by civic, community and public roles and interests. A financial accountant, described as a 'very English gentlemen' is an ex-mayor, a member of the Old People's Committee and treasurer of the Arthritis Care organisation.[229] Military and community service show stamina, dedication, commitment and teamwork. Hard work expressed as 'workaholism', is used noticeably to positively describe male managers during this period.

New colleague profiles often outline previous work experience and further three-dimensionality is provided in all individual profiles by interest predominantly in sport or the arts. The tendency to shift from work to the personal in relation to sport, personal interests and family is a means, according to Brown, of hi-jacking 'ideologies of kinship, hierarchy, togetherness'.[230] But for Nye, sport, personal interests and family were drawn upon to deliberately displace

discussion of work in the pages of the staff magazine. In this way, sport tournaments were the sites where workers displayed their qualities. Team leagues, of say football or archery, rather than offices or factory floors, were the sites where antagonisms and conflicts were worked through. The shift in work profiles, he argues, is ideological: 'sports offered a safe democratisation – leaving industrial hierarchies intact'.[231]

Industrial photography has a long-standing history of producing meanings about gender, class and race which are always inflected by the cultural politics of the era. The firm's magazine shows Firths' approach was no exception. In *Trim Lines* black and brown male workers are part of the blue-collar workforce at Flush Mills in Heckmondwike. Workers from Jamaica, India and Pakistan are invariably featured at their looms, and their military service, hobbies and sporting interests form part of the profiles. While immigrant workers are shown in teams alongside white workers, they are often grouped together, for example the feature 'Tufters Three' shows three South-Asian tufting machine workers (see Figure 1.15). It is hard not to question the inclusion policy of the journal given that we are told they 'stopped the Trimline reporter on his way to another job and asked for their photographs to be taken'.[232] It is noticeable that management remains a white preserve and workers of colour are not featured in Firths' sports teams. In places the copy oscillates between respect for skilled work and nervous jokes which show unease and misunderstanding about cultural difference expressed by remarks about faltering pronunciation or marriage customs. But there are examples where the magazine features respectful copy, illustrative of reasonable, working inter-racial bonds between workers. Using an attempt at gentle humour, one feature states in what could be read as broken English: 'Allah Ditta of the designer's stubble, sharply creased trousers, eyes of hawk', as the worker stands attentive to the loom.[233] *Trim Lines* also visualises differences in the classed and raced constituency of workers at Flush Mills in Firths Furnishings in Heckmondwike and Clifton and Victoria Mills at Bailiff Bridge. In contrast, in a more racially diverse work environment at Heckmondwike, it is significant that there are no people of colour in the pages of *Tuned In* – an entirely white publication.

Tuned In takes a different approach to workers. Workers as individuals or teams are not shown doing or demonstrating work;

THE WEAVERS OF FIRTHS

Allah Ditta of the designers stubble, sharply creased trousers, eyes of hawk

Mohamed Saleem didn't know he'd had his picture taken until he saw the camera flash

Figure 1.15 Tufting machine workers at their looms in *Trim Lines*. Reproduced with permission from John Waddington.

rather, features show workers near to machinery, or photographs are taken with groups of workers gathered socially, smiling to camera. In contrast to *Trim Lines*, the magazine holds no reportage on company incentives to use the magazine as a firebrand for enlisting the agency of workers to a cause such as 'quality'. Using the same functional photographic style, workers are profiled and there is a sense of inclusion – from the resident nurse in the consulting room to the financial and export managers, but the magazine feels less inclusive of non-skilled workers. In contrast to *Trim Lines*, worker profiles on male workers tend to focus on military service

for retirees rather than current workers. Worker profiles are very interested in sports – those organised within the firm, but especially for management; sport beyond the firm is a form of cultural capital. The management services manager holds the spotlight in the 1993 edition and is pictured with his son in a wetsuit on a wrecked ship on the Isle of Mull. Avoiding work entirely, the piece talks about 27 years of sub aqua diving and his present holiday with his wife in the Austrian Tyrol.[234] Or, as Nye argues, rather than mis-represent work by discussing the worker in entirely positive terms, possible conflicts or the reality of the difficulties of work are displaced onto personal lives or the leisure arena.

In this way, worker profiles are concerned to demonstrate the access to masculine lifestyle choices that being a manager at Firths can afford, while circumventing any management conflicts he might be involved in. Women are also profiled – the style of presenting them here follows the lead of *Trim Lines* in terms of a patriarchal and heteronormative workspace of the 1980s. Women are included and their roles respected – Dr Hogg is brought in to lead the Laboratory section of the technical department and a feature on telemarketers praises the fine-tuned decision making required by the women to 'help the client come to the right buying decision with efficiency and certainty'.[235] But women are often required to smile and be the attractive face of the firm. For example, the new London telephone receptionist is photographed with the caption, 'Mrs E. takes smile and style to work' even though her role does not require her to be seen.[236]

The importance of community

What both magazines construct very clearly is a sense of a harmonious, intergenerational community marshalled by the Firth paternalistic wing. Workers are named to give a feel of familiarity and intimacy. Across these decades the magazines promoted the idea that Firths embraced its people across the life course. Young and old are incorporated: from school leavers who wish to shadow workers to get a feel for the industry to lengthy retirement profiles for long years of service which give the impression of a job for life. In each magazine, employee profiles contain personal details – the configuration of their family, their favourite holidays and hobbies – to give a three-dimensional portrait of workers. There are births, deaths, marriages and features on worker illness. The sheer number of features on sport show that it was highly valued by the firm, no

doubt for promoting team and interpersonal work skills, but also, as Nye argues, in a move to not misrepresent work: 'it gave endless substitutions for and translations of work into other realms'.[237] Performed either privately, for example aerobics for women or as part of Firth teams, sport is always mentioned in profiles – even inactive worker interest in games (such as dominoes) is recorded. Each edition shows the retirement party, given annually to retirees from Firths – showing that the paternalistic wing of Firths was prepared to keep a sense of responsibility for the well-being of workers beyond their working life in the firm.[238] No wonder the ageing ex-workers I spoke with felt bereft of the tradition of care for older workers when the factory closed.

Takeover by Interface

In December 1997, US multinational company Interface bought out Firth Carpets in a deal worth £30 million. Local newspaper the *Evening Courier* said the move had 'swept away' in excess of '130 years of Yorkshire ownership at the heart of the region's carpet industry'.[239] In these early years of buy-out, there remained some optimism that the acquisition was complementary and mutually beneficial and would bring new jobs. Some Firth workers moved to the Interface factory holding at Shelf. But the piece in the *Evening Courier* hinted at tensions when a 'stand-alone' company must 'integrate in a group the size of Interface'. And the reference to a 'whole new culture ... which had to be grafted on to a firm which can trace roots back to 1822' implied the enormity of the task looked insurmountable.[240] An article in the *Evening Courier* in February 2001 reported that managing director David Melbourne tried to buy Firth Carpets from Interface when the company failed to thrive in the takeover, but his bid was unsuccessful. Unable to sell the company as a 'going concern', 300 employees were to be laid off and buildings, land and machinery required disposal. The Union representative for the Transport and General Workers Union, described the decision as a 'major blow to the area'.[241] In 2002 photographs featured in the piece 'Goodbye to a Landmark' (see Figure 1.16) show the chaos, disorder and destruction of the early process of demolition of Clifton Mill, the frontispiece of Firth Carpets Limited. The article informs the reader that the site had been purchased by a land developer and that Calderdale council had

Figure 1.16 Local press report the demolition of Clifton Mill, 2002. Author's newspaper cutting.

supported plans for the redevelopment of the site for offices and approximately 100 homes.[242]

My own conversations with ex-workers and management about the takeover were understandably guarded. Interface, with its focus on technical flooring solutions and emphasis on environmental sustainability, is still in operation.

Conclusion

Part II of this chapter looks backwards in the rear-view mirror from the existing small concern Firth Carpets in Bailiff Bridge to consider the moves and actions Firth Carpets Limited deployed to carry on manufacturing against a backdrop of the shift to the values of neoliberal governance, as well as fiscal challenges, fierce global competition, accelerated technological change and altered consumer values. It argues that features which hastened the process of deindustrialisation, such as 'capital flight', fail to account for the strategies firms in high-cost locations put in place to stay in business. Looking at Firth materials – its internal communications, employee newsletters and adverts – enables a close look at the firm's attempt to keep making carpet. Firth Carpets was prepared to reach out to a management consultancy to analyse its failings in a competitive market. In 1968, it yielded to the offer of acquisition takeover by Readicut, an overarching company with a diversified portfolio which allowed Firths the autonomy to maintain a degree of independence. What emerges is a conservative, traditional company, proud of its product portfolio of upholstery and woven carpets (the latter of which its own workers could not afford to consume themselves), but which conferred pride on workers who felt privileged to be part of making high-quality carpets.

Firths recognised the importance of prudent marshalling of workers as a key asset: its management's address in the 1970s shows a perception of employees as a constituency of citizens to be managed and informed but also a force to be consulted, listened to and from whom management could learn. From the mid-1980s staff magazines reflect different worlds at Flush and Clifton Mills in relation to the representation of staff: at Flush *Trim Lines* is more inclusive of a broader range of the skilled and unskilled, whereas *Tuned In* speaks to a white lower-middle to upper-working-class cohort. The

staff magazines demonstrate a shift to the increased individualisation of workers, seen largely through atomised profiles at pains to make workers unique in their lifestyle choices and attributes, in which male workers are taken more seriously than female workers. How workers are represented tended to naturalise a white middle-class managerial view of gender, class and race in heteronormative ways. Nonetheless, inclusion no doubt brought forms of emotional interconnectedness and a sense of a Firths family. In this way, the 'peopling' of the magazine shines focus away from the back-stage issues of a struggling concern. And as the reader encountered the increased diminution of business, leisure, sport and a vision of continued community connection based on kinship and togetherness take up the final editions.

Notes

1 *The Carpet Annual, 1951*. Firth Carpets Archive, Bankfield Museum, Box 4.5, ref. 2005.86, p. 17.
2 M. Glucksmann, *Women Assemble: Women Workers and the New Industries in Inter-war Britain* (London: Routledge, 1990), p. 55.
3 Ibid., p. 44.
4 Ibid., p. 6.
5 N. Bartlett, *Carpeting the Millions: The Growth of Britain's Carpet Industry* (Edinburgh: John Donald Publishers, 1966), places Yorkshire as the second-largest main manufacturing district in 1850, operating 1,497 handlooms compared with 2,455 in Worcestershire and 21 in Wiltshire. See Table 1, p. 10.
6 B. Jacobs, *The Story of British Carpets* (London: Carpet Review, 1968), p. 57.
7 J. Styles, 'Introduction', in J. Styles and M. Snodin (eds), *Design and the Decorative Arts: Victorian Britain 1837–1901* (London: V and A Publications, 2004), p. 9.
8 Ibid., p. 10.
9 Hurtful for Britain was the fact that France managed to swoop most of the artistic accolades. But it would be wrong to assume that imperial superiority signalled racist condescension towards the cultural objects of the non-European world. Victorian designers admired Islamic style and Indian textiles, untouched as they were by commercial imperatives. See M. Snodin, 'Style', in Styles and Snodin (eds), ibid. for a discussion of Islamic design in 1842–1845 and the favourable reception of Islamic objects at the 1851 exhibition, pp. 45–46.

10 C. Breward, 'Fashionable Living', in Styles and Snodin (eds), ibid., p. 99.
11 J. Tosh, *A Man's Place: Masculinity and the Middle-Class Home in Victorian England* (New Haven, CT: Yale University Press, 1999), p. 4.
12 E. Hobsbawm, *Industry and Empire: From 1720 to the Present Day* (London: Penguin, 1990), p. 112. It is important to note this claim can be made of mid-Victorian Britain – its decline can be charted from 1860 onwards.
13 Styles, 'Introduction', p. 29.
14 Bartlett, *Carpeting the Millions*, p. 63.
15 Hobsbawm, *Industry and Empire*, p. 64.
16 S. Gunn, *The Public Culture of the Victorian Middle Class: Ritual and Authority in the English Industrial City 1840–1914* (Manchester: Manchester University Press, 2007), p. 11.
17 Ibid., p. 93.
18 Ibid., p. 94.
19 Ibid., p. 73.
20 Ibid., p.144.
21 Bartlett, *Carpeting the Millions*, p. 62.
22 Ibid.
23 Deindustrialisation is often associated with the loss of work in modern factory settings from the 1970s onwards, marking a clear shift from manufacturing to service industries. Yet, as T. Strangleman and J. Rhodes 'The "New" Sociology of Deindustrialisation? Understanding Industrial Change', *Sociology Compass*, 8:4 (2014), 411–421 argue, a view across the longue durée shows a more complex picture, where deindustrialisation simultaneously exists alongside industrial growth.
24 Bartlett, *Carpeting the Millions*, p. 32.
25 J. A. Hargreaves, *A History of Halifax: From Pre-historic Times to the Present Day* (Lancaster: Edinburgh University Press, 1999), p.171.
26 The partnership between Mr T. F. Firth and Mr J. W. Willans carried this title until 1875.
27 Bartlett, *Carpeting the Millions*, p. 20.
28 C. E. C. Tattersall and S. Reed, *A History of British Carpets; from the Introduction of the Craft until the Present Day* (Leigh-on-Sea: F. Lewis, 1966).
29 Bartlett, *Carpeting the Millions*; see Table 33, p. 143.
30 For a detailed exploration, photographs, memories and responses to the closure of Firthcliffe, see R. McCue, *Firthcliffe N. Y.* (CreateSpace Independent Publishing Platform, 2012), ISBN: 9781478206330.
31 Styles, 'Introduction', p. 22.
32 C. Lawson, *Nothing But Smoke and Mirrors: Deindustrialisation and the Remaking of British Communities, 1957–1992*, unpublished PhD thesis UC Berkeley Electronic Theses and Dissertations, 2020, pp.

Histories

23–24, available at: www.pqdopen.proquest.com/pubnum/2808664 (accessed 20 January 2021).
33 As Hobsbawm, *Industry and Empire*, p.127, describes it, 'British policy destroyed the local textile industry as a competitor with Lancashire'.
34 Styles, 'Introduction', p. 23.
35 P. Greenhalgh, 'The Great Exhibition of the Works of Industry' in Styles and Snodin (eds), *Design and the Decorative Arts*, p. 75.
36 Bartlett, *Carpeting the Millions*. See the Graph of Carpet Exports, 1815–1909, p. 50.
37 Ibid., p. 53.
38 Ibid., p. 52.
39 Ibid., p. 53.
40 Ibid., p. 51.
41 G. K. Bhambra, 'Brexit, Trump and "Methodological Whiteness": On the Misrecognition of Race and Class', *British Journal of Sociology*, 68 (2017), S214–S232, p. 220.
42 Hobsbawm, *Industry and Empire*, p. 125, argues that between 1860 and 1890 exports of all goods fell from 25% to 8%.
43 By the mid-nineteenth century, Canada, Australia and New Zealand had been 'settled' by white colonialists, but at the expense of indigenous peoples. These colonies were Europeanised by force.
44 Styles, 'Introduction', p. 24.
45 D. Lawrence, *Genteel Women: Empire and Domestic Material Culture, 1840–1910* (Manchester: Manchester University Press, 2015), p. 36.
46 Ibid., p. 37.
47 Ibid., p. 36.
48 Ibid., p. 90.
49 Bartlett, *Carpeting the Millions*, p. 54.
50 G. Firth, 'Introduction', in Ian Beesley (ed.), *Through the Mill: The Story of Wool in Photographs* (Lancaster: Dalesman Publishing Company, 1987).
51 T. Strangleman, *Voices of Guinness: An Oral History of the Park Royal Brewery* (Oxford: Oxford University Press, 2020), p. 15.
52 P. Scott, 'Marketing Mass Home Ownership and the Creation of the Modern Working-Class Consumer in Inter-war Britain', *Business History*, 50:1 (2008), 4–25, p. 16.
53 Anonymous, '"Buy British!" Combating Foreign Competition', *Carpets, Rugs, Linos and Floorcoverings*, July 1931. Firth Carpets Archive, Bankfield Museum, Box B.4.1, ref. 2005.43.
54 Ibid.
55 S. Ward, *Geography of Interwar Britain: The State and Uneven Development* (London: Routledge, 1988).
56 Hobsbawm, *Industry and Empire*, p. 185. In 1870 British shipyards made 343,000 tons of shipping but by 1938 it had fallen to half a million.

57 Ibid., p. 186.
58 Ibid., p. 187.
59 Ibid., pp.186–187.
60 D. Linehan, 'Regional Survey and the Economic Geographies of Britain 1930–1939', *Transactions of the Institute of British Geographers*, 28:1 (2002), 96–122, p. 117.
61 Strangleman, *Voices of Guinness*, p. 19.
62 Linehan 'Regional Survey', p. 102.
63 Ibid.
64 See advertisement featured in ibid. from *Times Trade and Engineering* (May 1935, p. 16).
65 T. F. Firth & Sons Ltd, *An Invitation* to see the new warehouse, Armour House, St. Martin's-Le-Grand, London EC1. West Yorkshire Archive, ref. WYC:1538/11/1.
66 T. F. Firth & Sons Ltd, advert, 'Attractive Modernity Replaces Old Fashioned Styles'. March 1932, Firth Carpets Archive, Bankfield Museum, Box B4.1.8, uncatalogued.
67 T. F. Firth & Sons poster placed in the Paramount Theatre, Newcastle (1931), Firth Carpets Archive, Bankfield Museum, Box B4.1, ref. 2005.43.
68 T. F. Firth & Sons Ltd advert placed in The New Theatre, Oxford, February 1934, Firth Carpets Archive, Bankfield Museum, Box B4.1, ref. 2005.43.
69 T. F. Firth & Sons adverts 'Carpets & Coverings', *Journal of Commerce*, August and September 1931, Firth Carpets Archive, Bankfield Museum, Box B4.1, ref. 2005.43.
70 London, Midland and Scottish Railway – a company operating from 1923 to 1947.
71 T. F. Firth & Sons advert, 'The Attraction of Good Upholstery on the L.M.S.R. New Corridor', *The Railway Gazette*, May 1934, Firth Carpets Archive, Bankfield Museum, Box B4.1, ref. 2005.43.
72 T. F. Firth & Sons Ltd, two-page feature in *The British Standard Exporter*, 1935, Firth Carpets Archive, Bankfield Museum, Box B4.1, ref. 2005.43.
73 Linehan, 'Regional Survey', p. 109.
74 Reprint, 'Romance is Woven into Your Carpets…', *Sunday Referee*, December 1933, West Yorkshire Archive, ref. WYC: 1538/7/1-3.
75 Glucksmann, *Women Assemble*, p. 40.
76 N. Bartlett, *Carpeting the Millions*, p. 190.
77 M. Pugh, 'Wish You Were Here? Britain between the Wars', *History Today*, 58:8 (2008), p. 45.
78 Scott, 'Marketing Mass Home Ownership', p. 6.

Histories

79 C. Langhamer, 'The Meanings of Home in Postwar Britain', *Journal of Contemporary History*, 40:2 (2005), 341–362, p. 347.
80 N. Crafts 'How Housebuilding Helped the Economy to Recover: Britain in the 1930s', The Guardianonline, 19 April 2013, available at: www.theguardian.com/housing-network/2013/apr/19/1930s-housebuilding-economic-recover (accessed 14 June 2021).
81 Pugh, 'Wish You Were Here?', p. 7.
82 D. Sugg-Ryan, 'Living in a Half-Baked Pageant: The Tudorbethan Semi and Suburban Modernity in Britain 1918–39', *Home Cultures*, 8:3 (2015), 217–244, p. 220.
83 Langhamer, 'The Meanings of Home', p. 246.
84 Glucksmann, *Women Assemble*, p. 241.
85 Langhamer, 'The Meanings of Home', p. 343.
86 J. Richards, *The Age of the Dream Palace: Cinema and Society in the 1930s* (London: I. B. Tauris, 2009), p. 12.
87 M. Pugh, *We Danced All Night: A Social History of Britain Between the Wars* (London: Vintage, 2008), p. 229.
88 Richards, *The Age of the Dream Palace*, p. 20.
89 Advertisements, Firth Carpets Archive, Bankfield Museum, Box B4.1, ref. 2005.43.
90 Jacobs, *The Story of British Carpets*, p. 137.
91 T. F. Firth & Sons Ltd, advert, 'Unbound Edges that Never Fray' *The Architectural Review*, April 1935, Firth Carpets Archive, Bankfield Museum, Box B4.1, ref. 2005.43.
92 Ibid.
93 Strangleman, *Voices of Guinness*, p. 15.
94 N. Hedges and H. Beynon, *Born to Work: Images of Factory Life* (London: Pluto Press, 1982).
95 Thanks to Nick Cox for this subtle observation on the classed representation of the carpet fitter as distinct from 'heavy' manual work.
96 D. Matless, *Landscape and Englishness* (London: Reaktion Books, 1998), p. 90.
97 B. Conekin, F. Mort and C. Waters (eds), 'Introduction', in *Moments of Modernity: Reconstructing Britain 1945–1964* (London: Rivers Oram Press, 1999), p. 4.
98 Ibid., pp. 6–7.
99 Strangleman, *Voices of Guinness*, chapter 2.
100 A. Offer, 'British Manual Workers: From Producers to Consumers, c. 1950–2000', *Contemporary British History*, 22:4 (2008), 537–571, p. 538.
101 S. Majima and M. Savage, 'Contesting Affluence: An Introduction', *Contemporary British History*, 22:4 (2008), 445–554, p. 445.

102 Glucksmann, *Women Assemble*, p. 228.
103 Majima and Savage, 'Contesting Affluence', p. 449.
104 *The Carpet Annual 1951*, Firths Carpet Archive, Bankfield Museum, Box 4.5, ref. 2005.86, p. 17.
105 Photograph of a worker in the despatch warehouse. West Yorkshire Archive, ref. WYC: 1538/10/1.
106 *The Carpet Annual*, 1951, Firth Carpets Archive, Bankfield Museum, Box 4.5, ref. 2005.86, p. 18. Labour was down 13% compared with figures presented in 1939, from 32,000 to 28,700 in 1951.
107 'World Survey', *The Carpet Annual*, 1955–56, p. 19. The Museum of Carpet Archive, Kidderminster, J023/3.
108 'Hire Purchase Control', *Carpet Review*, April 1955. The Museum of Carpet Archive, Kidderminster, J312. Page 71 reads, 'The [National Association of Retail Furnishers] as the president of the Board of Trade to reduce the statutory deposit of 15% to 10%'.
109 H. McKenna, 'Review of Carpet Design', *The Carpet Annual*, 1955–56, p. 40. The Museum of Carpet Archive, Kidderminster.
110 Dr E. G. Carter, the director of the Scientific and Technical Department of the International Wool Secretariat, made this statement while presenting the prize for the Secretariat's Design Competition. 'The "Bad" Old Times', *Carpet Review*, April 1955, p. 97. The Museum of Carpet Archive, Kidderminster, J312.
111 The regular feature, 'Men of the Month', *Carpet Review*, March 1955, p. 97. The Museum of Carpet Archive, Kidderminster, J311.
112 J. Attfield, 'The Tufted Carpet in Britain: Its Rise from the Bottom of the Pile, 1952–1970', *Journal of Design History*, 7:3 (1994), 205–216, p. 205.
113 A. Crossland, 'Technical Developments', *The Carpet Annual*, 1955–56, p. 35. The Museum of Carpet Archive, Kidderminster, J023/3.
114 This claim is credible, though jokes about the inferior quality of tufted carpets are still made by ex-workers from Firths who can distinguish the look and feel of tufted vs woven.
115 Attfield, 'The Tufted Carpet in Britain', p. 207.
116 For a discussion on the anxieties of Americanisation and the rise of mass culture, see S. Nixon, 'Apostles of Americanization? J. Walter Thompson Company Ltd, Advertising and Anglo-American Relations 1945–67', *Contemporary British History*, 22:4 (2008), 477–499.
117 For a discussion of Cyril Lord's business failure, see P. Ollerenshaw, 'Innovation and Corporate Failure: Cyril Lord in U. K. Textiles, 1945–1968', *Enterprise and Society*, 7:4 (2006), 777–811.
118 Attfield, 'The Tufted Carpet in Britain', p. 208. Attfield overstates the case that tufted was sited out of the way of the established, conservative

woven industry – Kosset was actually only three miles away from Clifton Mills.
119 M. Savage, 'Affluence and Social Change in the Making of Technocratic Middle-Class Identities', *Contemporary British History*, 22:4 (2008), 457–476, p. 463.
120 Ibid., p. 459.
121 Firth Carpets' promotional brochure for the Festival of Britain, 1951. West Yorkshire Archive, ref. WYC: 1538/11/4.
122 B. E. Conekin, *'The Autobiography of a Nation': The 1951 Festival of Britain* (Manchester: Manchester University Press, 2003).
123 Ibid., p. 29.
124 Firth Carpets' promotional brochure for the Festival of Britain, 1951, West Yorkshire Archive, ref. WYC: 1538/11/4.
125 Conekin, *'The Autobiography of a Nation'*, p. 4.
126 Ibid., p. 27.
127 Firth Carpets' promotional brochure for the Festival of Britain, 1951, West Yorkshire Archive, ref. WYC: 1538/11/4.
128 Conekin, *'The Autobiography of a Nation'*, p. 80.
129 Thanks to Nick Cox, who points out that while Modernist design favoured Classicism, such a move revealed how the Modernist aesthetic ultimately worked against its ostensibly democratic impulse.
130 Design historians view the official 'good design' of the COID as a didactic imposition on the British public. See for example. J. Attfield, 'Inside Pram Town: A Case Study of Harlow House Interiors, 1951–61', in J. Attfield and P. Kirkham (eds), *A View From the Interior: Women and Design* (London: The Women's Press, 1989), p. 216.
131 Conekin, *'The Autobiography of a Nation'*, p. 60, credits Professor Kathleen Lonsdale – an expert in crystallography – as being the member of the Festival Pattern Group who argued that crystal patterns would make unique textile designs.
132 Ibid., p. 62.
133 Savage, 'Affluence and Social Change', p. 472.
134 The exhibition was organised by the British Colour Council, May 1948, and was held at the Royal Horticultural Hall, SW1.
135 British Carpet Exhibition Brochure, 12–28 May 1948. Firth Carpet Archive, Bankfield Museum, Box B4.1, ref. 2005.61. While the quiz requests opinion from the public about design, it is also condescending about public opinions, which 'could be ignored, since they emanated from people with no qualifications to criticise, or even discuss, design'. 'Comments on the British Carpet Exhibition made through the Quiz', Firth Carpet Archive, Bankfield Museum, Box B4.1, ref. 2005.61, p. 2.
136 *Fibro* was a synthetic carpet.

137 'New Horizons in Broadloom' catalogue, circa 1956. Firth Carpets Archive, Bankfield Museum, Box B.4.8, ref. 2005.182.
138 Langhamer, 'The Meanings of Home', p. 345.
139 Ibid.
140 A. Partington, 'The Designer Housewife of the 1950s', in J. Attfield and P. Kirkham (eds) *A View From the Interior*. (London: The Women's Press, 1995) p. 203.
141 Sugg-Ryan, 'Living in a Half-Baked Pageant', p. 244.
142 C. E. C. Tattersall and S. Reid, *A History of British Carpets* (Leigh-on-Sea: F. Lewis, 1966), p. 82.
143 R. Parker, *The Subversive Stitch: Embroidery and the Making of the Feminine* (Bloomsbury: London, 1984), p. xii.
144 The workers I interviewed, some of whom were born in the early 1930s and grew up in the atmosphere of Firths' prestige in the twentieth century, had a keen and proud sense of the importance and standing of Firth Carpets Limited.
145 E. Hazan et al., *Getting Tangible about Intangibles: The Future of Growth and Productivity*, McKinsey Global Institute Report, June 2021, p. 1, available at: www.mckinsey.com/capabilities/growth-marketing-and-sales/our-insights/getting-tangible-about-intangibles-the-future-of-growth-and-productivity (accessed 19 April 2022).
146 For example, the report argues for investment in innovation capital; a mining company, for example, could invest in 'geological intelligence for exploration'; ibid., p. 5.
147 J. Harris, 'Airbnb, Uber, eBay: In This Intangible World Workers Must Adapt to Survive', *The Guardian*, 8 December 2017, available at: www.theguardian.com/commentisfree/2017/dec/08/airbnb-uber-ebay-workers (accessed 25 March 2021).
148 G. Rusten, J. R. Bryson and U. Aarflot, 'Places Through Product and Products Through Places: Industrial Design and Spatial Symbols as Sources of Competitiveness', *Norwegian Journal of Geography*, 61 (2007), 133–144.
149 Homepage from the Firth website: https://firthcarpets.co.uk/ (accessed 4 February 2025).
150 This expression is taken from the title of M. Berman, *All That is Solid Melts into Air: The Experience of Modernity* (London: Verso, 2010).
151 A. Mah, *Industrial Ruination, Community and Place: Landscapes and Legacies of Urban Decline* (Toronto: University of Toronto Press, 2012), p. 11.
152 J. Tomlinson, 'De-industrialisation Not Decline: A New Meta-narrative for Post-war British History', *Twentieth Century British History*, 27:1 (2016), 76–99.

153 B. Bluestone and B. Harrison, *The Deindustrialization of America: Plant Closings, Community Abandonment and the Dismantling of Basic Industry* (New York: Basic Books, 1982); M. Goos and A. Manning, 'Lousy and Lovely Jobs: The Rising Polarisation of Work in Britain', *Review of Economics and Statistics*, 89 (2007), 118–133.
154 See J. Cowie, *Capital Moves: RCA's Seventy-Year Quest for Cheap Labor* (Ithaca, NY: Cornell University Press, 1999).
155 See S. High, *One Job Town: Work, Belonging and Betrayal in Northern Ontario* (Toronto: University of Toronto Press, 2018).
156 Mah, *Industrial Ruination*, p. 8.
157 Lawson, *Nothing But Smoke and Mirrors*.
158 J. Tomlinson, 'Brexit, Globalisation, and De-industrialisation', VOXEU, 21 April 2017, available at: https://cepr.org/voxeu/columns/brexit-globalisation-and-de-industrialisation (accessed 12 March 2019).
159 Ibid.
160 D. Byrne and S. Ruane, *Paying for the Welfare State in the 21st Century: Tax and Spending in Post-industrial Societies* (Bristol: Policy Press, 2017), p. 50.
161 J. Clarke, 'Closing Moulinex: Thoughts on the Visibility and Invisibility of Industrial Labour in Contemporary France', *Modern and Contemporary France*, 19:4 (2017), 443–458, p. 444.
162 R. Stride, 'Women, Work and De-industrialisation: The Case of James Templeton c.1960–1981', *Scottish Labour History*, (2018) 154–180.
163 J. R. Bryson and M. Ronayne, 'Manufacturing Carpets and Technical Textiles: Routines, Resources, Capabilities, Adaptation, Innovation and the Evolution of the British Textile Industry', *Cambridge Journal of Regions, Economy and Society*, 7 (2014), 471–488, p. 471.
164 See M. Clapson, *The Routledge Companion to Twentieth Century History* (London: Routledge, 2000), p. 172, for a discussion of the blame these critics attributed to spending on the welfare state and nationalisation as a cause for Britain's post-war economic problems.
165 Ibid.
166 M. Pugh, *State and Society: A Social and Political History of Britain 1870–1997* (London: Arnold, 1994), p. 329.
167 J. Gilbert and A. Williams, *Hegemony Now: How Big Tech and Wall Street Won the World (and How We Win It Back)* (London: Verso, 2022), p. 46.
168 Ibid., p. 48.
169 Ibid., p. 44.
170 Firths' management invested in *Carpet Annual*. The archive at Bankfield Museum, gathered from skips outside the factory at closure, contained several issues published during this fraught decade.

171 *The Carpet Annual*, 1971. Firth Carpets Archive, Bankfield Museum, Box 4.5, ref. 2005.86, p. 33.
172 Ibid., p. 45.
173 'World Survey', The Carpet Annual, 1981, p. 25. The Museum of Carpet Archive, Kidderminster.
174 Ibid., p. 46.
175 Ibid.
176 *The Carpet Annual*, 1981, p. 15. The Museum of Carpet Archive, Kidderminster.
177 Ibid.
178 J. Tomlinson, *The Politics of Decline: Understanding Post-war Britain* (Abingdon: Routledge, 2000); D. Edgerton, *The Rise and Fall of the British Nation: A Twentieth Century History* (London: Allen Lane/ Penguin, 2018).
179 See for example Cowie, *Capital Moves*.
180 C. M. Law, 'Employment and Industrial Structure', in J. Obelvich and P. Catterall (eds), *Understanding Post-war British Society* (London: Routledge, 1994), p. 86.
181 Bryson and Ronayne, 'Manufacturing Carpets and Technical Textiles', p. 472.
182 A. Rugman and A. Verbeke, 'Edith Penrose's Contribution to the Resource-Based View of Strategic Management', *Strategic Management Journal*, 23 (2002), 769–780, p. 771.
183 'The Present Position and the Next Three Years', P. A. Management Consultants Limited, Company Strategy Division, November 1968. West Yorkshire Archive, Calderdale, WYC:1538/1/4.
184 Ibid., p. 2.
185 R. Martin and P. Sunley, 'Path Dependency and Regional Economic Evolution', *Journal of Economic Geography*, 6 (2006), 395–437.
186 Letter re: the Acquisition of Plasticisers and Allied companies', 14 May 1976, p. 1. West Yorkshire Archive, ref. WYC: 1538/6/4.
187 Ibid.
188 H. I. Ansoff ,'Towards a Strategic Theory of the Firm', *Economies et Societes,* 2:3 (1968).
189 'Wilton By Firth' brochure, 1976. Firth Carpets Archive, Bankfield Museum, Box B.4.8, uncatalogued.
190 Firth Carpets Ltd, Manager's Report, 1982. Firth Carpets Archive, Bankfield Museum, Box B.5, ref. 2005.106.7.
191 French *Cabana* advertisement leaflet 'par les specialites du tapis', Firth Carpets Archive, Bankfield Museum, Box B.4.8, ref. 2005.133.2.
192 'Adonis' advertising leaflet. Firth Carpets Archive, Bankfield Museum, Box.4.8, ref. 2005.16. These twins featured in a number of advertisements of the day.

193 Firth Carpets Limited, 'How We Did in 1975', Employees Report, July 1976, West Yorkshire Archive, ref. WYC: 1538/6/1.
194 Readicut International Limited, 'Chairman's Report to all Employees', year to 31 March, 1977, West Yorkshire Archive, ref. WYC: 1538/6/3.
195 Copies of the magazines were loaned to me by the people of the study.
196 R. Marchand, *Creating the Corporate Soul: The Rise of Public Relations and Corporate Imagery in American Big Business* (California: University of California Press, 1998), pp. 15–17.
197 D. E. Nye, *Image Worlds: Corporate Identities at General Electric, 1890–1930* (Cambridge, MA: The MIT Press, 1985), p. 85.
198 Ibid., p. 90.
199 E. Brown, *The Corporate Eye: Photography and the Rationalization of American Commercial Culture, 1884–1929* (Baltimore, MD: Johns Hopkins University Press, 2005), p.14.
200 Ibid., p. 4.
201 Ibid., p. 143.
202 Halifax Central Library, Firths and Bailiff Bridge file.
203 'First Half on Target', *Trim Lines*, Autumn 1985.
204 'Weaving', ibid.
205 'Car Carpets All Time High with RECORD SALES', *Trim Lines*, Spring 1987.
206 'Congratulations! Firth is Tops for Quality', *Trim Lines*, Summer 1989.
207 'Welcome on the Mat for "Textile Bonding"', *Trim Lines*, Autumn 1985.
208 'Firth is Best in Europe', *Trim Lines*, Spring 1992.
209 'Good Housekeeping in Action', *Trim Lines*, Summer 1989.
210 'After QI and Jaguar – Target BS5750', *Trim Lines*, Summer 1989.
211 'Better Times Ahead', *Trim Lines*, Spring 1992.
212 Ibid.
213 'How would YOU Improve the Company?', ibid.
214 'Let's Look to the Future', *Tuned In*, Summer 1993.
215 'British Wool Success Again for Firth', *Tuned In*, Winter 1993/94.
216 'BT Calling ... We Have Contract', ibid.
217 '28th Jan Lives On!', *Tuned In*, Summer 1994.
218 'Up to Five Years of Contracts Secured', ibid.
219 'The Masters Collection' sample book, April 1995. Firth Carpets Archive, Bankfield Museum, Box B4.7, ref. 2005.240.
220 'Firth Furnishings Investors in People', *Trim Lines*, Spring 1993.
221 'Royal Armouries Firth Has It Covered', *Tuned In*, Summer 1996.
222 Brown, *The Corporate Eye*, p. 142.
223 Ibid., p. 149.

224 Strangleman demonstrates this in his analysis of the in-house magazine *Guinness Time*. Strangleman, *Voices of Guinness*, p. 45.
225 'Car Carpets All Time High with RECORD SALES', *Trim Lines*, Spring 1987.
226 Ibid.
227 'Next to Godliness', *Trim Lines*, Spring 1987.
228 Page 3 refers to a long-standing practice in the tabloid press in Britain of featuring a bare-breasted woman for the male consumer. The campaign *No More Page Three* successfully convinced this wing of the press to cease publishing pictures of topless models in 2019.
229 'For the Good of the People', *Trim Lines*, Summer 1989.
230 Brown, *The Corporate Eye*, p. 144.
231 Nye, *Image Worlds*, p. 84.
232 'Tufters Three', *Trim Lines*, Summer 1989.
233 'The Weavers of Firths', *Trim Lines*, Spring 1987. Thanks to Rauf Khan for pointing out that 'Allah', meaning 'God', is unlikely to be the name of the featured worker. I read this as a clumsy attempt at an ill-informed joke – which fits with the unease in tone which underpins the caption.
234 'Ian Montieth at Home 30 Fathoms Deep or a Mile and a Half High!', *Tuned In*, Summer 1993.
235 'New Chemist Joins Our In-house Laboratory', *Tuned In*, Summer 1995.
236 'London Calling', *Tuned In*, Summer 1994.
237 Nye, *Image Worlds*, p. 91.
238 'Long Service Awards – Another Happy Reunion', *Tuned In*, Winter 1993/1994.
239 'Business SpotLight: Firths Carpets', *Evening Courier*, 8 October 1998. Halifax Central Library, Firths and Bailiff Bridge file.
240 Ibid.
241 'What Went Wrong at Firths Carpets?', *Evening Courier*, 13 February 2001. Halifax Central Library, Firths and Bailiff Bridge file.
242 'Goodbye to a Landmark', *Evening Courier*, 30 December 2002. Halifax Central Library, Firths and Bailiff Bridge file.

2

Nostalgia: a response to loss

My story ...

As a child in the 1970s I lived on the edges of a small village that had formed a community devoted to making carpets. For most of the pupils at Bailiff Bridge Junior and Infants' School, Firths Mills were peopled by our parents who worked daily to produce Firths goods. The bricolage of works buildings, some blackened with Victorian soot like Clifton and North Vale Mill, or sheds such as those on Victoria Road which endlessly stretched ahead, surrounded our school. It felt secure to know that my mother worked just 500 yards away from my classroom in a building I could see from the school windows. At noon I would meet her at the gates and we would walk home for lunch. Village amenities, both reassuring and convenient, were clustered around the works and the school: there was the post office, the bakers, the chemist and the tuck shop at the start of Victoria Road which sold pear drops and Coca-Cola chews. There was something reassuring and rooted in a village life which felt as though it had longevity, with no reason to end while Firth Carpets kept making carpets.

It will always, in my memory, be a place where workers felt dignity in making what my Dad often referred to as 'first class' carpet. Most employees were enormously proud of the luxury woven ranges of Axminster and Wilton. Often elaborate in pattern and vibrantly coloured, the wool pile, standing 2.5 centimetres proud of the jute backing, gave a sensuous feeling of underfoot luxury to any room. When I graduated from university in 1987 and went home to live with my parents in Bailiff Bridge, a close friend came to visit. She drove up from Buckinghamshire while I was still at

work at another local textiles company.[1] On greeting Sarah, Dad, who was still working at Firths at that time, took the opportunity to take her on a tour of the factory. She has never forgotten what she referred to as a 'privileged insight' into Firths. She described walking into the factory as an overwhelmingly sensuous experience. The 'tremendous' sound coming from the continuous green/blue metallic frames of the looms, the distinctive and overpowering smell of carpet which cannot be manufactured – a mixture of wool, jute and engine oil; the strange visual juxtaposition of old Victorian work rooms housing high-tech machinery; and spectacular visual sights – that she'd never witnessed before – of the juddering looms weaving the processed Axminster to join an enormous roll before its journey to quality for checking. She described Dad as 'puffed up with pride': he clearly enjoyed his role as custodian of the factory. Over-enunciating loudly over the noise of the machinery he shared his knowledge of all the connecting parts of the production process. She was also struck by the sense of Dad's presence within a strong working community. The authority of his job as a quality manager meant that workers had an interest in acknowledging him – but Sarah felt it was more than that. Dad was talking and waving to staff right across the factory works – from the weavers' shed to the workers in accounts.

These were the things that had informed Dad's loss as we climbed up Birkby Lane in the car in 2003. Once filled with busy staff who made carpets that ended up everywhere from the Houses of Parliament to Marks and Spencer, there were no buildings to our left as we looked out of the car window; they had been razed to the ground. In that moment I thought back along the trajectory of Dad's working life – of busy production and the routines and social rhythms of working across teams of workers – and my mind stretched out to wonder how they felt. My feelings of nostalgia interconnected with Dad's. Did other workers feel a sense of nostalgia, about the works, the gratification of making superb carpets, the people they worked with or the way of life that Firths offered in Bailiff Bridge?

Introduction

My nostalgia and the intergenerational nostalgia transmitted to me from my parents have fuelled the motivation for writing this book.

It has allowed me to wallow in my habit of thinking back and remembering my life as a child rooted in industrial culture. Nostalgia does bring feelings of loss, but there are strange and interesting pleasures in the atmospheres and images I bring back to mind of that time and place. It reminds me of what has been taken away, but it also gives me succour. This chapter widens out to the community of Bailiff Bridge to explore why nostalgia is returned to as a practice which gives affordances to those who indulge in it. What role does it play for people as they tread a Firths' carpet fitted in their home, look at old photographs or peruse the occasional staff magazine?

Given the circumstances of the Bailiff Bridge community when I returned to the village in 2016, their lives offered fertile scope for nostalgia. Most of the ex-workers who came forward to be part of my study had left Firths during the mid to late 1990s. The community had lived through tough times: the slow precarity of job loss, closure, dereliction, demolition and ruination. And gradually new-build housing had grown up over the once-mills; the sheds that had housed looms on Victoria Road and the dye house up on Birkby Lane. Clifton Mill had been removed in 2002, leaving a churned and undeveloped tract of land – a hole where an 'iconic' works building had been. For ex-workers there was the potential for social isolation after factory closure and, as for local residents, a sense of spatial dislocation.

In her work on nostalgia, Fiona Allon argues that the speed of development brought by modernity has made our familiar landscapes 'overwhelmingly illegible'.[2] Living within such landscapes can have real effects – some people might even feel deterritorialised. How do people navigate an unreadable landscape? What strategies provide emotional solace when people at home feel a sense of unhomeliness? How do people cope with the end of their productive working lives and maintain affective relationships when the workplace and its surrounding environs where warm bodies once converged have been erased? How people use nostalgia plays a crucial role. When familiar places become disrupted beyond orientation and people's identities are decontextualised, the evocation of memories becomes hugely significant; 'a consequence may be a compensatory and nostalgic "place-building" and an attempt to affirm the meanings and memories that are perceived to be threatened and soon to be lost'.[3]

Nostalgia has received a bad press and a barrage of negative criticism,[4] attacked as a stultifying and backward-looking practice.

This book draws on writers who identify their work as belonging to 'critical nostalgia' – an approach which can be 'reclaimed as a positive site of naming and unforgetting'.[5] Using the idea of a 'cultural memoryscape' which draws on 'a multiplicity of different forms of remembering',[6] this chapter homes in on the wonderful collection of photographs that respondents donated and focuses on how ex-workers interact with these photographs using nostalgia as an affective practice.

The chapter has three parts. The first discusses the importance of photographs for portraying how work was done and for unlocking how this enables a historically specific understanding of how 'work is made by space and in turn creates work'.[7] It draws on examples of how work was configured from the 1950s–1970s to show how workers both occupied space in the factory and in the convivial setting of the clubs and 'dos' of Firths' programme of paternalism. The second discusses writers from the 'critical nostalgia' camp who argue that nostalgia offers an invaluable 'coping mechanism' for people dealing with loss while caught in the maelstrom of modernity.[8] This work matters because it argues that vernacular interactive practices of nostalgia can creatively envisage the future of work. To test out what nostalgia means and how it is used in people's everyday lived experience, the final part draws on interactive interviews[9] using photographs donated to the project. Interviews revealed powerful forms of embodied remembering.[10] Knowledgeable about contemporary neoliberal working practices, respondents used nostalgia to make suggestions for the future of the workplace in relation to three themes: spatial and bodily remembering, bittersweet memories and creative nostalgia and the future of work.

Photography, deindustrialisation and space

A possible consequence of place change is spatial anxiety: workers have the potential to feel disenfranchised by new and imposed spatial change. In terms of the research process, the walk-and-talk tours offered a rich seam for the elicitation of involuntary memories, though in the spatial absences of demolition, ex-workers often had to re-imagine the interior and exterior of mill buildings back into the air. When respondents offered their photographs over a post-tour

beverage, they were a means to show *what had been there* and I began to realise that photographs could play a crucial role in the research for this book. Photographs, the majority of which were analogue, were precious to the people of the study and I wanted to learn more about the affective role they played in enabling people to cope with loss. I chose ten of the respondents who had already attended a focus group and taken me on a walk-and-talk tour. I invited them to the same café for a conversation about nostalgia, to bring 'significant' photographs of Firths and Bailiff Bridge, while I selected photographs from the wider collection for discussion.

In what follows, a selection of photographs is chosen to think about what they tell the viewer about working life at Firths. How did work in the village take place and how was space organised in working environments? Tim Strangleman argues that photography visualises the various stages in the labour process and allows the viewer to see historical changes in how work is done.[11] The viewer gains access to what workers wore and sees inside the 'hidden' features of the quotidian corridors and spaces in which workers 'lived at work'.[12]

In Figure 2.1, for example, the viewer sees a weaver, working with a high degree of autonomy, at his loom (circa. 1965). He is dressed in overalls and the viewer can see how his body negotiates the size and height of the loom, the cards which hold the pattern of the carpet above his head, and how he used embodied knowledge to regulate and intervene in the loom's operation. Other pieces of well-worn equipment stand on the detritus of the work-room floor – the jute, yarn and other waste which characterise the making process. Smiling to camera in what looks like a publicity photograph in Figure 2.2, two menders are partnered together on the floor of the sewing department on a piece of woven carpet (circa. 1948). There is a sense of the fine motor skills involved in handling the weight and feel of the carpet, the winding of the mending yarn and technology of a simple needle and thread to 'mend' the carpet. Yet, beyond the visual, as Edensor reminds us, photographs also afford access to synaesthetic and kinaesthetic dimensions of the worker experience.[13] In Figure 2.3 the viewer gets a synaesthetic sense of how it must feel to use the body at work, to lean the weight of the body over the carpet to perform the action of 'mending' in the factory in the 1970s. This photograph shows the technological shift

128 *Threads of Labour*

Figure 2.1 Weaver working at an Axminster gripper loom, circa 1965. Reproduced with permission from John Waddington.

Figure 2.2 Two menders pose for the camera. Reproduced with permission from John Waddington.

Nostalgia: *a response to loss* 129

Figure 2.3 The whole body was used in mending, circa 1970s. Reproduced with permission from John Waddington.

in machinery for mending (in contrast to Figure 2.2) so that workers are no longer confined to the floor. Figure 2.4 (circa mid-1950s) shows women in the 'winding' department. The viewer sees the rhythm of the hands of the women and the blurred tempo of yarn being wound on to bobbins in a way which evokes sound in the process. In these visual examples, the viewer sees how worker bodies were disciplined to perform rhythmic movements with the machinery in ways which became deeply bodily sedimented, a point to which I return later. For, as Valerie Walkerdine and Luis Jimenez argue in relation to industrial tasks, the 'rhythms of the works' provided a comforting pulse to the backdrop of working life.[14]

Photographs also lend a spatial dimension to an understanding of work practices and culture. The organisation of space across the Firths factory buildings told the visitor who toured the company of the class hierarchies in the firm. In Figure 2.5 (circa 1960s), spatial expanse was used to create an official aura in Clifton House, where customers climbed the wood-panelled staircase and were welcomed

Figure 2.4 Working together in winding. Reproduced with permission from John Waddington.

at the main reception before entering the showroom. Here, the visual grammar of the photograph, which deliberately foregrounds luxurious expanse of space while confining the receptionist/personal secretary to the top right of the image, communicates the corporate power of the company. It confers too the idea that the receptionist was the effective possession of the managing director. This was in stark contrast to the closer workstations in the offices housed within Clifton Mill.

These photographs also demonstrate how spatial change operated at Firths. Strangleman's photographic essay on place and space at the Guinness Brewery at Park Royal documents the spatial changes across the factory's corporate landscape as the firm shifted to adopt neoliberal working practices. Rather than drawing on the pool of existing staff employed at the brewery, the firm contracted out

Figure 2.5 The secretary to the managing director in the reception in Clifton House. Reproduced with permission from John Waddington.

segments of its services to cut costs. Casting sight across photographs from the archive in the 1950s to the mid-2000s, he illustrates key differences in how workers inhabit space. Decline in workforce numbers (1950–2005) means there are simply fewer bodies across factory photographs; work areas which once doubled up as leisure space give way to purely workspaces as the programme of paternalism falls into decline. By the mid-2000s tasks previously done internally by Guinness staff become outsourced, for example ancillary workers take up cleaning tasks and their 'peripheral' worker status is indicated by their spatial isolation – in contrast with photographs of 'core' workers in the 1950s archive.

Similarly, spatial ideas undergird complex sociological ideas about the ecologies of work at Firths. In Figure 2.6 men and women

Figure 2.6 Sewing and mending department. Reproduced with permission from John Waddington.

work at benches and sewing machines in teams in the sewing and mending department. Workers were often clustered in pairs (see Figure 2.2) and these photographs allow us to see the complex interweaving of how 'the *social* is implicated in the *spatial* and vice-versa'.[15] Worker bodies moved together in close proximity to complete work; getting work done was a profoundly social activity which provided opportunities for workers to share the satisfactions of pride in their work and to affectively bond in the process. Moreover, Figure 2.7 shows the personalisation of workspaces – the worker's own photographs of movie stars and pin-ups decorate sections of the walls. As Hedges and Beynon argue, the sociality of workers eschews the 'total rationality' of the production line. Workers 'made space for themselves' to customise their workspaces, have a laugh, to play organised worker games, fall in love or have affairs: 'people "born to work" give something of themselves to others in factories … By being there, they – men and women of different ages, with different coloured skins – affect each other. They

Figure 2.7 Personalised workstation in the sewing and mending department. Reproduced with permission from John Waddington.

make something more of each other. Sometimes even, they obtain happiness.'[16]

Firth Carpets provided a comprehensive programme of paternalistic activities for its workers. Walkerdine argues for the 'centrality of affect' in understanding how work communities feel 'held together'.[17] Given that the affective rhythms of labour already acted to bind workers in shared civic pride of Firths' carpet production, I argue that the spatial organisation of these activities worked to further cement affective relations. Lisa Fine suggests that paternalism in the motor industry in the US was ushered in at the very moment when work shifted from being masculine, autonomous and skilled to becoming automated, numbingly repetitive and semi-skilled.[18] Paternalism acted to generate corporate loyalty; it aimed to appeal to male workers 'as men' and as the head of the family. It replaced the manliness lost through independence on the factory floor with masculine sports clubs and family days out.[19] This emphasis on the family also served to confine women into more inferior work

Figure 2.8 Bullseye at Firths Archery Club, circa 1968. Reproduced with permission from John Waddington.

roles.[20] These gendered leisure roles were amply documented through donated photographs and the in-house magazine *Tuned In*, which was published by Firths in Bailiff Bridge.[21] Importantly, the sports clubs were locally organised for worker convenience in spaces adjacent to the mills – the football field, the bowling green and the archery club (see Figure 2.8 (circa 1968)). Interestingly, this club attracted a constituency of young men and these kinds of activities were known to build teamwork skills. In Figure 2.9 (circa 1967) female workers are dressed up in costumes which represented Firths' international consumer-base for the local Brighouse Gala float. It would demonstrate the world prestige of the firm as the float moved through the adjacent town.

These photographs show 'interrelationality';[22] across the factory: the phenomenology of sharing through 'actions, movements, feelings, objects, places' which bound people together in the spatial organisation that Firths works buildings and their adjacent green spaces provided for workers.[23] Walkerdine's approach insists on the 'centrality of affect for understanding how people sharing locality might be held together'.[24] I argue that when those forms of inter-relationality broke down and disappeared; when the rhythms of work with their 'temporal sequences, spatial relations, embodied effects and their performances' ground to a halt, the sense of loss felt was profound.[25]

Figure 2.9 Firths Carpets' float for the local Brighouse Gala. Reproduced with permission from John Waddington.

Spatial anxiety – a sense of ambivalence about the future of Bailiff Bridge – went beyond the industrial architecture of the works; respondents missed the shared endeavours of work and play in the spaces work buildings provided.

Critical nostalgia

This book is drenched in nostalgia. The opening to this chapter illustrates my nostalgic daydreaming which operates like a recursive practice to which I keep returning. For even though it is melancholic, it gives me solace and seems to comfort my loss. Yet nostalgia has been virulently attacked as reactionary, myopic and even 'vulgar, demeaning, misguided … criminal, fraudulent, sinister and moribund'.[26] It is also accused of leading to a backward-facing inertia in ways which drain those indulging in its bittersweet comforts of any energy for the future. Yet more worryingly, Alistair Bonnett

argues it is popularly and problematically associated with older women as the sentimental guardians of maintaining links with families and as something 'to do with the elderly and its low intellectual status, as something vague and misty, the antithesis of rationality; as anathema to "clever folk"'.[27] This description does not fit the energetic and critically alert ageing people of this study. In what follows, I join the 'critical nostalgia' camp of writers who spurn this standpoint, through identifying ways nostalgia enables the creative means to envisage the future.

Before a more detailed consideration of how nostalgia can be rescued from its detractors, it is necessary to briefly visit Keightley and Pickering's intricately modelled concept of the 'mnemonic imagination'.[28] Key to this conception is the dual inclusion of what the authors claim was neglected: the creative role of *imagination* in active remembering and how *experience* interacts with memory. Experience offers memory flexible access across past, present and future, and affords the ability to think backwards and look forwards. Memories return as splintered pieces out of which the remembering subject uses imagination to generate a sense of coherence with which to build a life-identity. Memory's power lies in its 'mobile and formative' attributes, but its creative potential is triggered through its productive tension with imagination: 'The creative quality of these interactions has a cross-temporal resonance, with memory necessarily thinking of the future, and imagination necessarily thinking of the past'.[29]

Influenced by Svetlana Boym's notion of 'reflective nostalgia'[30] and reversing the consignment of memory to the past, Keightley and Pickering set out the workings of their concept of 'mnemonic imagination' through which 'the past attains or regains significance for the present and future and makes of remembering a creative process'.[31] With active synthesis between imagining and remembering in train, it enters a dialogue with the past by sifting through a series of dualities, for example: 'the constitution of self-hood and the commissioning of social action; the interplay between experience and expectation, memory and possibility'.[32] Examining the manoeuvre between these oppositions needs to take place if a granular understanding of how past, present and future experiences take purchase on each other is to be developed, and if practices of

remembering and the measure of the creativity involved are to be recognised. The mnemonic imagination acts as the dynamic which rebuilds and reassesses how the past, present and future sit within the 'experiential manifold' while the forces which dominate the past are continually revised so as to make way for an open future. And while memory is responsible for reassessment, imagination brings alive the resources it pulls up. Through their productive tension, mnemonic imagination transforms lived experience into experiential product, hence activating its core function – as it brings experience into creative interaction with expectation and action beyond it in the present. Keightley and Pickering also maintain that memory can only be understood when personal and collective memory are interlinked; mnemonic imagination augments the interplay of their movement 'and when necessary helps realign personal and popular memory through its inter-animation of these two dimensions of identity and experience'.[33] Re-drafting memories is an unfixed process – always in flux as experience continually searches time and space between the remembering subject within a context of intervening social changes.

Using their concept of 'mnemonic imagination', Keightley and Pickering argue that nostalgia occurs as a result of the interactive synthesis of three constituent parts: loss, longing and lack.[34] These interactions, which always take an affective shape, vary by instance, but essentially it is 'when the lack is allied with longing for what is lost that nostalgia comes into being'[35] Holding these elements together, mnemonic imagination acts to pull on nostalgia as a source of memory which is not fixated on a past or caught in a stultifying longing for it. While longing is triggered by lack in the present causing a sense of loss, what matters is the recognition that the past cannot be regained and that the present is also limited by constraint – thus the past is the yardstick through which to critique the present, hence unlocking potential for transformation in the future.[36]

While not all writers on nostalgia agree,[37] for Keightley and Pickering it is 'epoch specific': a direct consequence of the acceleration of rapid social change in Modernity where people are given insufficient time to contemplate or come to terms with their loss.[38] It is also a feeling hosted by both individuals and collective communities; indeed, the weave between private and public memory is central to nostalgia.

A direct response to displacement, it has explanatory power for understanding the feelings of Firths ex-workers as a group who no longer recognise the illegible landscape of Bailiff Bridge. Nostalgia is certainly an 'existentially and socially valuable' practice which tries to understand change in terms of reconciling memories of the past in an attempt to keep continuity with the future. In this way, as Andrea Rítívoí suggests, nostalgia encourages the remembering subject to 'differentiate and to contrast, and as such, it functions as a potent interpretative stance, a tool of comparison and analysis'.[39] But essentially, depending on how the trio of loss, longing and lack interact, it need not be seen as a paralysing force. It can be hopeful, even aspirational in terms of the future and it can be used to critically question or build counter-narratives against the political, economic or social orthodoxies that brought change in the first place.

In this chapter, I respond to Keightley and Pickering's call for empirical work to test out the contours of the mnemonic imagination for understanding nostalgia. Their book, by their own admission, takes a singular focus on declarative memory.[40] Yet in my interactive interviews, I found the photographs evoked nostalgia in relation to the bodily and sensory memories that co-working, sometimes with machinery, produced. In what follows, I examine work on how bodily movement, rhythm and temporal sequences combined to produce affective relations within the spatial settings of the work buildings.

Historian Michael McNeill opens his book, *Keeping Together in Time: Dance and Drill in Human History* with a vivid memory of his experience of performing 'Hit! Hup! Hip! Four!' military drill in 1941 as a US army officer.[41] It 'felt good' to march with his fellows, 'swaggering in conformity with prescribed military postures, conscious only of keeping step to make the next move correctly and in time'.[42] Words proved inadequate, he argues, and were never used for expressing what he recalled as 'a strange sense of swelling out, becoming bigger than life, thanks to participation in a collective ritual'.[43] These affective bodily practices, uncommitted to speech or written documents, meant that McNeill's work looked to cultural artefacts and archival sources to produce a range of transcultural and historical examples, from industrial calisthenics in Japan in the 1980s to Flemish wedding dancing in the 1500s. McNeill coins the

term 'muscular bonding' to argue that rhythmic movement, using song or chanting, performed in temporal sequences, played a crucial role in generating the social cohesion necessary for making and sustaining human communities. McNeill's work tends to universalise 'keeping together in time' across history and culture in a way which sits uncomfortably with the historically specific perspective of social research. Yet his model of work in small communities has valence for understanding how work was done and how it made disciplined, controlled industrial workers. He argues that new kinds of work were completed efficiently and that the tedium of repetitive work was endured more easily.[44] Of key insight are the positive inward and outward affective states that interpersonal working relationships produced. Prolonged exertion of muscular movement led to 'boundary loss' – where self-awareness blurs and becomes submerged in the flow, producing excitement within the self in the midst of collective activity. This in turn produces a heightened intensity of fellow-feeling which serves to sediment affective bonds among worker 'buddies'.

McNeill argues that an 'emotional residue'[45] – an enduring affective memory of keeping together in time – remains lodged in the connective tissue of the body. Similarly, lived bodily remembering of trauma-induced pain, according to Connerton, is etched into bodily practices of gesture, speech, sense and posture.[46] Walkerdine argues that 'affective practices' fuelled the binding processes which enabled 'ongoingness' within industrial communities. Using Studdert's notion of 'inter-relationality', she argues that shared 'actions, movements' in spatial settings where workers shared an atmosphere pervaded by the rhythm of work made them feel secure, alive and held together.[47] One such example from my memory was the way in which I would watch the mothers of my friends from the Stoney Lane council estate walk down to the mills to begin their evening shift. They walked, not necessarily together, but in the knowledge they were headed in the same direction to begin the teamwork they would perform together. These ideas offer explanatory power for the instantaneous flow of involuntary memories ex-workers produced as they interacted with photographs of work at Firths.

Nostalgia can be used by communities who have experienced deindustrialisation or disorientating spatial change in their locality as a *critical* practice. Jackie Clarke, for example, looks at the way

nostalgia was mobilised as a critique of neoliberal time by female workers at Moulinex in France.[48] Clarke frames her analysis in the context of changing modes of capitalist production from a paternalistic managing director in the 1930s to period of instability reliant on capital accumulation by the 1980s. Workers she interviewed felt nostalgia for the assembly line of the 1970s: they felt pride in the work produced in a 'good atmosphere' of sociability and solidarity. Shifts in economic imperatives in the 1980s meant that profit-centrism changed the atmosphere and brought a harsher production line with demands for speed and greater responsibility. When the company closed in 2002, the French media maligned its female workers as nostalgic for the paternalistic past of the company. Their voices dismissed for mourning the 'old order', they were castigated as ill-equipped for future-orientated work. For Clarke, the nostalgia felt by the women contained 'critical potential'.[49] The idea of 'progress' presented by national government and media in which closure was inevitable and a neoliberal future – the only future option – was challenged by the female workers. The women's nostalgia for Fordist production offered an alternative way of thinking about the present and future, and acted as a critique of a 'total rupture' of time. Indeed, rather than being 'paralysed' they used their validation through nostalgia of the solidarity of the past to envisage the future as a call to mobilise new forms of activism. As a result, they formed associations for workers' rights and campaigned for compensation for redundancy and health claims.

In similar vein, Alistair Bonnett draws interesting parallels between avant-garde psychogeographers of the Paris 'Situationist International' movement of the 1950s and the 'backward-looking sensibilities' of a group of older ex-residents of Newcastle.[50] Mourning for the city and the authenticity of working-class streets lies at the heart of psychogeographic writing. Writers such as Debord used their nostalgia to critique the historical flattening and homogenisation of modernised Paris. Yet, Bonnett argues, 'avant-garde situationists don't have a monopoly on critical urban nostalgia'.[51] Turning to his respondents, he argues they present 'a complex picture of continuing engagement' with their demolished and rebuilt city.[52] While he finds pain in their loss, they propel their knowledge of the past city into future-forward ideas for how planners might preserve its distinctiveness by searching their memories of the past for inspiration.

Nostalgia: a response to loss 141

I turn now to the interactional interviews with three ex-workers to show how nostalgic encounters produce critical interventions with photographs which help ex-workers to cope with loss.

Critical nostalgia and future projections

Spatial and bodily remembering

Most respondents held a spatio-geographical conception of Firths and Bailiff Bridge as one and the same: Firths gave Bailiff Bridge a *raison d'être*. Some of them had a spatial sense of the order, dimensions and networks of how Firths operated in the contours of the village. Ex-workers were asked to bring photographs that mattered to them personally, and Thomas (ex-office worker) brought a misty early morning photograph he had taken in the early 1990s of Firths' roof-tops set in the valley of Bailiff Bridge surrounded by housing.[53] His rationale for choosing this photograph was that it captured all that had made up his working life – his home on the hill he shared with his family, his walk to work and village amenities. And Jerry was knowledgeable about the class-stratified business planning of the industrial village and he and his family felt proud to still live within it. They acknowledged their memories were intergenerational: 'This brings back memories of what my father used to talk about when Sir Algernon Firth used to come down here [pointing to personal photograph] in his carriage and there was a man there and his job was to open the gates'. He told me that Holme House, a grade 2-listed building, where Algernon Firth had lived, was now partly occupied by Jerry's daughter's family. In this way, Jerry's family had managed to keep the history of Firths in the fold by caring for and contributing to the ongoing preservation of part of the holdings belonging to the Firths firm. He went on, 'he had the mill but he didn't like looking at it so he planted all those trees ... there was a huge rookery and he used to shoot them and my father would run and pick them up'. Mike Savage and Andrew Miles remind us that town planning was conceived in ways which enabled 'philanthropic' mill owners to live in the elevated geography of hills so they could survey and regulate the activities of the working class.[54] It is interesting that Jerry had a sense that the spatial contours of Bailiff Bridge had

a bearing on how the firm organised where, how and by whom work was done. Bringing his thinking to the 1950s, Jerry had a spatial sense of how locally situated workers nourished the carpet cloth: 'in those days there were these people adding value to this yarn all around that mill'. In these ways, respondents showed their sense of the spatial networks that had formed the working occupational community.

In interviews with workers from the factory floor, I was struck by the powerful forms of spatial and bodily recollection the photographs triggered, especially when workers saw photographs of workspaces containing machinery they once operated. Across the interviews, at least a quarter of the ex-workers I spoke with experienced the impulse to demonstrate the movements of how their bodies negotiated machinery or used gestures to perform their roles. There are two instances worth detailing. In a focus group dedicated to a consideration of photographs of Firths and Bailiff Bridge, I showed the group a number of images of workers operating machinery – in the setting, winding and of workers at looms. Terry's (ex-weaver) immediate response was: 'I bet I could go up – even though it's been 16 years now – I bet I could press a button and operate one of those gripper spool Axminster looms'. What the photographs triggered were corporeal memories lodged in the body of the specialist knowledges, rhythms and routines of working in the carpet factory setting. Something similar occurred when I spoke with Hilda (setter) about a photograph she showed me of herself in the setting (circa. 1962). This was an interesting interview encounter where I asked Hilda to reflect on whether analogue photographs are rare and important historical documents for showing the existence of demolished works. But again and again, Hilda resisted this line of discussion. Instead the image seemed to transport her right back to the workroom:

> LT: You're back there?
> HT: I'm back there, just in the bottom, round me frame. Your mind goes back to what was there. I can see myself walking down the shed, with two frames at the side of me and lasses working on the frame and on the creels. And then there's lifts there and then an alleyway which goes right up to the weaving part. There's what 1, 2, 3, 4, 8 – there's about 24 frames all working with two people, two friends that you know. There's a lot of work going on, a lot of noise …

In this recollection, Hilda holds intact a keen visual and three-dimensional sense of how space was configured in the shed which far surpasses the edges of the photograph she interacts with in our interview. After more than 50 years, she still has a spatial clarity of where she worked and how it connected to other essential parts of the factory: 'you're sort of stood there aren't you, watching, you know what's happening, it puts yourself in the atmosphere, you can hear – and they might be singing too while they're working'. Signified by her use of the present tense, she is hurtled back to an atmosphere of work and noise. It is as though the photograph prompts mobility around the shed so she can move and count – mimicking the counting of bobbins and yarn she performed in her role as setter. Vital to Hilda's account is the affective memory of the social bonding that working together produced: 'it reminds you of the friendship you got there, all the girls, we all knew one another, it was all first names'. But it is in her recollection of working with her sister Susan, who worked as supervisor, where working rhythms with others emerged. Hilda holds the photograph while speaking – gesturing with her hand to talk through her sense of where things were:

> There's three frames down that side. But this one, that one there was where our Susan worked and that was a bigger sized spool ... And we had laughs on a Friday. Friday afternoons after lunch we started and cleaned all the frames down and all around your work area. Our Susan would start it up – the singing. And that gave lasses and their partners the beat and we'd get our arms going cleaning all 'round the frames while we sang.

Bittersweet memories

Respondents did as Allon described: they engaged in 'compensatory and nostalgic "place-building"' as they interacted with the photographs. But none of the respondents felt the pull of what Boym calls 'restorative' nostalgia, the type she defines as wanting 'to rebuild the lost home and patch up the memory gaps'.[55] They had no interest in wanting to go back either in time or place. Gerard (ex-worker, during university holidays) felt angry that Firths had been closed: 'I'm nostalgic for the fact that it should still be there'; for him, corporate capitalism would compromise local specialist quality for the sake of global profit, but what he wanted was for Firths to still be manufacturing in the present. Thomas spoke of all the advances

that modernity had brought that he would not want to lose. He remembered being in Woolworth's café with his mother in the late 1960s and she had asked why he had chosen to eat chilli con carne, or what she had called 'foreign muck', instead of choosing traditional English food. Thomas said that going back in time to Firths would mean losing out on all the choices that living in a global economy would provide – like more interesting exotic food. It would mean going back to a workplace without computers. Instead of being able to email workers in other departments to communicate, while also keeping a handy record, 'you'd have to walk all around different departments – weaving, shipping – with different pieces of paper'. In a similar way Jerry and Sherry held a complex 'bittersweet' view of their nostalgia for Firths as they leafed through the photographs – they understood that the things they wanted back were fastened to things they would prefer to leave in the past:

> SG: No I wouldn't like to go back to living between two mills, no I wouldn't. But I do look back with great longing at the time when Bailiff Bridge was a proper village and people got together a lot more.
> JW: So you think it's selective nostalgia? You can't have them both. But go back? No thanks.

Practising nostalgia in this way necessarily involves weighing up the losses and gains over time, bringing, as Keightley and Pickering argue, 'the past into dynamic relationship with the present, opening up the possibility of critique in the movements between them'.[56]

Using nostalgia creatively: the future of work

Nostalgia is 'epoch-specific'.[57] Indeed, Boym describes it as a 'symptom of our age' and a direct consequence of modernity.[58] A cognitive and affective coping mechanism, it attempts to understand change by measuring it against the remembered past while negotiating threads of the continuing present. Capitalist modernity has no compunction about stripping the environment of social meaning in its endless search for profit, as the ravaged cities and villages of deindustrialisation illustrate. Indeed, this principle underlies economist Joseph Schumpeter's notion of 'creative destruction', the idea that capitalist progress depends on the destruction of businesses and all

that goes with them.[59] The longing that Sherry describes and the loss Gerard feels about the end of Firths are not about reconstructing the past; rather, they call into question the drivers which generated the conditions of loss in the first place. In this way, Allon argues, 'Nostalgia has the potential to be reclaimed as a positive site of un-forgetting, and of negotiating the future ahead'.[60]

In my interview with Stacey (ex-export manager) she showed me a picture taken at work by the company photographer and editor of the in-house magazine *Tuned In*. The photograph shows her dynamically walking out of the office. This began a conversation about how much of her working life in export sales was about going to different departments – the stockroom, finishing, despatch. Often her walks spanned the geography of the firm: 'I used to walk round, I used to see the shop-floor workers as well. They all took a pride in what they were doing, I don't say 100% well, big majority, over 95%'. As we looked together at Figure 2.2 Stacey noted the collaborative effort of the two workers: 'They've set two girls on there to work together at a fault, before the carpet gets sent out and they'd have worked well together wouldn't they? And they wanted to do the job, they want it to be right. And this one there with the sewing and concentrating.'

Cognisant of the criticism platform corporations such as Amazon. com face in contemporary journalism about poor working conditions, Stacey noted images she had seen in the press of workers 'on their own' being monitored by computers. Working together in teams, 'in person', was something Stacey looked back on positively about working practices at Firths. Facing fellow workers – speaking in person – was the way to get the job right. 'And I always got the job done speaking to them, you got the job done explaining it – saying to those two why it was required that afternoon. Whereas now if you read an email and you think OK, I'll get round to it sometime'. Critical of technologies which ultimately discourage interpersonal communication, Stacey used her nostalgic memories to project best working practice around communication forward into the future.

> Talking to people more, I think all now everything is just whizzing past and it's so much easier to send a text or an email and it shows you how close you were to working with people doesn't it? I mean you have to speak to people don't you?

Conclusion

I began this chapter by treading the pathways of my own nostalgic memory practices about Firth Carpets in Bailiff Bridge. They illustrate both the longing and lack, identified in Keightley and Pickering's conception of nostalgia, for and of the positives of industrial culture back in the 1970s. I am grateful too to have the shared privilege of being able to occasionally revisit my friend's account of Dad's tour around the factory in the mid-1980s. It means I can unpeel anew the sensuous memory of a dynamic, working factory – its rhythms, strange workspaces, the pungency of fresh carpet and the conviviality of worker sociability. It reminds me of Dad's tremendous pride – his stewardship of a prestigious working firm. It is the feelings of human security the portrait of industrial culture revives that feel lost: the shared school-day knowledge that our parents worked close by; the familiar buildings which made us feel enclosed; clustered amenities which made for plentiful opportunities for social interaction; and the remembered feeling of an effective and proud working Dad. This book has allowed me the latitude to indulge my daydreams with nostalgia for Firths.

But there are other ways it can be experienced. Nostalgia can physically creep up in the jolt produced by a photograph, *in situ*, like an unbidden impulse. McNeill's historical and cultural work about working together in time held startling efficacy for, as Terry and Hilda show, an image or a workstation can produce involuntary corporeal nostalgia. Powerfully embodied, it provides an energy which offers a passageway right back to the sensory atmosphere of being at work in place, evoking the movements the body makes with other workers to remember the sociality and bonding of work. But nostalgia can also be a deliberative, contemplative practice. However it is used, as Keightley and Pickering argue, the mnemonic imagination is not fixated on either longing or with the past. While Thomas looked at his hazy, romantic photograph of Bailiff Bridge, he acknowledged that going back would mean revisiting a time when an easy walk to work and going home for lunch were possible, but it would have to mean sacrificing the affordances of contemporary global lifestyle culture he would not wish to make. As Jerry understood, nostalgia contains something sweet, such as re-experiencing a sociable village with real-life sociality,

but it is fastened to the bitterness of living cheek by jowl with mill buildings, leading him to a firm conclusion: 'go back? No thanks.'

While workers used their photographs to utilise nostalgia in these ways to 'unforget' Firths, ultimately they had spent their lives since propelling forward: nobody wanted to go back in time. Importantly though, as the interview with Stacey shored up, the mnemonic imagination moves to reassess how the past, present and future sit within experience – while the act of looking back is continually revised to ensure an open, possible future. As Stacey's interview showed, nostalgia can be used critically to think about the positives of past working practices – of face-to-face teamwork and problem solving in the physical spaces of the factory - to evaluate them and draw them into work practices of the future. Nostalgia can also use the past as a yardstick to critically measure the circumstances which lead to transformation in the first place.

This chapter has considered the adequacy of nostalgia for understanding how people cope with the loss of the works. The next considers the adequacy of nostalgia as a practice for those who remain in a transformed place.

Notes

1 Skopos Fabrics, Earlsheaton in Dewsbury.
2 F. Allon, 'Nostalgia Unbound: Illegibility and the Synthetic Excess of Place', *Continuum: Journal of Media & Cultural Studies*, 14:3 (2000), 275-287, p. 276. doi: 10.1080/713657730.
3 The term 'place-building' comes from P. Cohen 'In Visible Cities: Urban Regeneration and Place-Building in the Era of Multicultural Capitalism *Communal/Plural*, 7:1 (1999). in Allon, 'Nostalgia Unbound', p. 276.
4 J. Frow, *Time and Commodity Culture* (Oxford: Oxford University Press, 1997).
5 Allon, 'Nostalgia Unbound', p. 278.
6 P. Basu, 'Memoryscapes and Multi-sited Methods', in E. Keightley and M. Pickering (eds), *Research Methods for Memory Studies* (Edinburgh: Edinburgh University Press, 2013), p. 116.
7 T. Strangleman, 'Picturing Work in an Industrial Landscape: Visualising Labour, Place and Space', *Sociological Research Online*, 17:2 (2012), 1–13, p. 5.

8. E. Keightley and M. Pickering, *The Mnemonic Imagination: Remembering as Creative Practice* (Basingstoke: Palgrave Macmillan, 2012); A. Bonnett, 'Walking through Memory: Critical Nostalgia and the City' in T. Richardson (ed.), *Walking Inside Out: Contemporary British Psychogeography* (Lanham, MD: Rowman and Littlefield International Ltd), pp. 75–89.
9. I conducted 10 interviews with the respondents I had taken on walk-and-talk tours.
10. P. Connerton, *The Spirit of Mourning: History, Memory and the Body* (Cambridge: Cambridge University Press, 2011).
11. Strangleman, 'Picturing Work in an Industrial Landscape'.
12. N. Hedges and H. Beynon, *Born to Work: Images of Factory Life* (London: Pluto Press, 1982), p. 68.
13. T. Edensor, *Industrial Ruins: Space, Aesthetics and Modernity* (Oxford: Berg, 2005).
14. V. Walkerdine and L. Jimenez, *Gender, Work and Community after De-industrialisation: A Psychosocial Approach to Affect* (Basingstoke: Palgrave Macmillan, 2010), p 4.
15. Strangleman, 'Picturing Work in an Industrial Landscape', p. 4.
16. Hedges and Beynon, *Born to Work*, p. 75.
17. V. Walkerdine, 'Communal Beingness and Affect: An Exploration of Trauma in an Ex-industrial Community', *Body and Society*, 16:1 (2010), 91–116, p. 95.
18. L. M. Fine, '"Our Big Factory": Masculinity and Paternalism at the Reo Motor Car Company of Lansing, Michigan', *Labour History*, 34:2–3 (1993), 274–291.
19. Lisa M. Fine argues that in the twentieth century rationalisation processes of welfare capitalism decentred 'manliness'. Previously associated with the dignity of skilled work, it was dislodged by the de-valuing of skill, prohibited trade union activity and the erosion of working-class cultural practices such as drinking. This made the skilled craftsman's 'moral imperative of a manly being an anachronism'. Fine, ibid., pp. 279–280.
20. H. Bradley, 'Change and Continuity in History and Sociology: The Case of Industrial Paternalism', in S. Kendrick et al. (eds) *Interpreting the Past, Understanding the Present* (Basingstoke: The Macmillan Press Ltd, 1990).
21. As outlined in Chapter 1, Part II, *Tuned In* ran in the years 1992–1997.
22. Walkerdine, 'Communal Beingness and Affect', p. 19.
23. Walkerdine and Jimenez, *Gender, Work and Community after De-industrialisation*, p. 55.
24. Ibid.

25 Ibid.
26 D. Lowenthal, 'Nostalgia Tells It Like It Wasn't', in C. Shaw and M. Chase (eds), *The Imagined Past: History and Nostalgia* (Manchester: Manchester University Press, 1989), pp. 18–32, 27.
27 A. Bonnett, *The Geography of Nostalgia: Global and Local Perspectives on Modernity and Loss* (London: Routledge, 2016), p. 15.
28 Keigthley and Pickering, *The Mnemonic Imagination*, p. 7.
29 Ibid.
30 S. Boym, *The Future of Nostalgia* (New York: Basic Books, 2002).
31 Keigthley and Pickering, *The Mnemonic Imagination*, p. 13.
32 Ibid., p. 7.
33 Ibid., p. 9.
34 Ibid., p.117.
35 Ibid.
36 Ibid., p. 118.
37 See Bonnett, *The Geography of Nostalgia*, for a discussion of different positions on nostalgia.
38 Keightley and Pickering, *The Mnemonic Imagination*, p. 115.
39 A. D. Rítívoí, *Yesterday's Self: Nostalgia and the Immigrant Identity* (Lanham, MD: Rowman and Littlefield Publishers, 2002), p. 32.
40 This type of memory is defined as the remembering of everyday experiences, information and happenings from mundane lived experience.
41 M. McNeill, *Keeping Together in Time: Dance and Drill in Human History* (Cambridge, MA: Harvard University Press, 1994), p. 1.
42 Ibid., p. 2.
43 Ibid.
44 Ibid. For example, a peach grower in the US in 1901 who paid singers to keep time for female packers reported 30% more efficient packing and fresher fruit.
45 Ibid., p. 54.
46 Connerton, *The Spirit of Mourning*.
47 Walkerdine, 'Communal Beingness and Affect', p. 100.
48 J. Clarke, 'Closing Time: Deindustrialization and Nostalgia in Contemporary France', *History Workshop Journal*, 79:1, 107–125, http://doi.org/10.1093/hwj/dbu041.
49 Ibid., p. 117.
50 Bonnett, 'Walking through Memory', p. 75.
51 Ibid., p. 77.
52 Ibid., p. 78.
53 Respondents supplied photographs at different times and places: the focus groups, the café post-walk and talk, the interactive 'nostalgia' interview. They brought new and different materials each time.

54 M. Savage and A. Miles, *The Remaking of the British Working Class 1840–1940* (London: Routledge, 1994), p. 58.
55 Boym, *The Future of Nostalgia*, p. 41.
56 Keightley and Pickering, *The Mnemonic Imagination*, p. 114.
57 Ibid., p. 115.
58 Boym, *The Future of Nostalgia*, p. xvi.
59 T. K. McCraw, *Prophet of Innovation: Joseph Schumpeter and Creative Destruction* (Cambridge, MA: Harvard University Press, 2009).
60 Allon, 'Nostalgia Unbound', p. 284.

3

'History gone': community after carpet

Jerry and Sherry's story

As an eight-year-old in 1940, Sherry would pass the open doors of Firths' mill on Wyke Old Lane, the noise and smell of the looms spilling out on her way to school. Her father was a weaver at Firths but during the war was assigned to Firths' fire brigade. He was often on 'bomb watch' from the roof to protect the mill, and she could wave to him from the playground. The windows at home both front and back looked out to mills. She felt sandwiched by mills. There was Stotts and Bulmers; oh how she wished the mills would melt away! Everybody knew each other. The village was interconnected, in a way that felt safe, by knowledge of each other. Sherry's father had worked alongside her husband Jerry's mother. A weaver since the 1920s, she had to work because her boyfriend, like many young men from the village, had been killed in the First World War.

In the early 1940s Bailiff had hubs of everyday 'doings' where people converged. The village was dominated by the size of Firth Carpets – it had an enormous landmass. The 'Co-op', comprising three busy shops and Irvin Rushworth's sales kiosk, referred to by locals as 'the hut', on Victoria Road, hummed as workers bought sweets and cigarettes. Frenetically busy like 'Blackpool promenade', reminders of industrial production like the carts containing rolls of carpet would continually trundle from one shed to the next. Smoking workers gathered in large groups at the bridge over the beck.

Jerry's mother left weaving to work in the fish shop as part of the holdings his father built on Bradford Road. The optimistic 1950s were Sherry and Jerry's heyday. You could buy sweets for the bus

ride to the pictures in Brighouse and 'there was work for everybody'. Greatly impressed by the Festival of Britain, where Sherry was enthused by modern design, they bought a carpet square surrounded by an oil cloth. But it was not until 1970, influenced by a trip to Sweden, that they bought a 'superb' wall-to-wall Axminster, still carpeting the floor of the Bailiff Bridge home they left in 2019. For them, the village community began to crumble in the late 1960s when Readicut took over. When houses started to appear on Victoria Road in the 1990s they understood this as an influx of newcomers. Almost 80 years on from Sherry's walk past the oily, wool aroma of the noisy weaving sheds, the couple 'don't know anyone in Bailiff Bridge now'.

Introduction

Far from the common conception that nostalgia is a stultifying, backward-facing force, nostalgic interactions with photographs can produce ways of coming to terms with the loss of Firths in hopeful and aspirational ways, especially in terms of the positive work practices that workers felt retained their relevance for today. But while photographs, consumed and curated in the homes of respondents, might assuage loss in the mnemonic imagination of ex-workers, this chapter turns to the experience of *being* in Bailiff Bridge. On a walk in the village, or drive through to surrounding towns and villages, what does the atmosphere and space feel like for those once familiar with its sense of place? While Clifton House, which once housed the showroom and company directors, and North Vale Mill remain, most works buildings, like the sheds on Victoria Road, have been pulled down and built over with new residential housing.[1] The sense of how difficult navigating the village felt after demolition hit me during an uphill drive with Dad past the demolished mill site in 2003. The atmosphere in the enclosure of the car was heavy; I could feel his sadness. For anybody who lived in the village when I was a child in the 1970s, the village itself is radically changed, its industrial architectural past largely erased. Pale-bricked new housing replaces the old works such as the dye house up Birkby Lane and the Victorian soot-drenched brick of Clifton Mill. Arguably, its topography has been transformed into what Fiona Allon would call

'History gone': community after carpet 153

an 'illegible landscape'.² Perhaps most significantly, in place of Clifton Mill a large tract of fenced-off undeveloped land remained at the central crossroads for over 20 years. Local residents lived alongside the shifting ecology of the uneven rubble that characterised this churned-up space. Unruly weeds surged and died back with the seasons and out-of-date advertising hoardings faced out to the passing public. As historian Aaron Andrews argues, the physical decay of a demolished landscape like the hole at the heart of Bailiff Bridge was not merely a reflection but rather an agent of economic decline.³

This chapter focuses on the tours I took with ex-workers and local residents as we walked the altered streets, spaces and skyline in 2017, the year after I began my research (see Figure 3.1). The focus groups I ran before the tours found nostalgic memories of Firths as a paternalistic, vertically integrated employer operating as a thriving entity. The firm was described by one respondent as a place which yielded a 'smashing way of life' because of its social clubs and events. This chapter traverses two themes: the first, *buildings*

Figure 3.1 Looking across demolition to new-build housing on a walk-and-talk tour. Author's photograph.

and community, asks what happened to the people of Bailiff Bridge as a community in the years since the large operational factory closed its doors. What are the subjective consequences for the affective ties that hold together an ex-industrial community? In what ways does the erasure of buildings impact on community? The second, *place, identity, home*, turns to how ageing ex-workers cope at the end of their productive working lives and maintain healthy, affective relationships when the workplace and its surrounding environs, where people once converged, have been erased. Interested in examining responses to architectural, spatial and sensuous change, it investigates the importance of works buildings to ageing inhabitants' sense of place-belonging and asks what this means for identity, especially in later stages of the life course. If buildings, particularly in the case of company towns and villages, play a psychic role in 'holding' place communities together, how do people navigate through a village so spatially altered? Can a barely recognisable landscape still be called home?

The works and community

Place-based communities found in old industrial towns and villages operate affectively in highly specific ways. In her work on trauma, Valerie Walkerdine uses psychoanalytic theories of affect and the idea of a 'containing skin' to explain the shift from a working steelworks in South Wales which felt alive to an ex-industrial community, after closure of the works in 2002 where the skin is broken, symbolising insecurity and death.[4] Drawing on Esther Bick's work,[5] she argues for the importance of psychic holding in parent/child relations and suggests the idea of a containing skin can be extended for thinking about wider group community relations after the steelworks are shut down. If psychic holding fails, the child feels a sense of falling apart and, to deal with the anxiety, tries to seek an object that enables it to feel held. Given that community groups do not have a body, they must imagine one. The fantasy of a body provides a structure and a nostalgic dream of symbiosis between its members. The steelworks community provided the dream of such a community, with 'the works as a central object'.[6] Drawing on the work of David Studdert,[7] Walkerdine argues that, historically, small

communities which develop around a workplace, often through migration, form what she terms 'communal being-ness'. Local histories of these types of communities reveal that living with adversity, poor working conditions and fluctuations in global demand held people in tight containment in ways which enabled them to feel humanly secure. The experience of rupture brought anxieties about destruction to the fore. While this work is abstract and metaphorical, it offers explanatory power for thinking about the ensuing difficulties, especially for ageing ex-workers in Bailiff Bridge, whose physical networks are more tightly reliant on community in place.

Critiquing previous sociological writing on communities,[8] Walkerdine argues that existing studies downplay the importance of emotional ties which make communities organised around work 'tight-knit'. In the analysis of her psycho-social interviews she combines 'communal-beingness' with David Studdert's notion of 'interrelationality' – or experiential, 'actions, movements, feelings, objects, places and inter-subjective bonds' which tie people together.[9] Of special interest are the arguments about space and what Margaret Wetherell calls affective 'patterns in process'.[10] Steeltown's planning,[11] which consisted of small, terraced houses, facilitated 'affective relations between inhabitants'.[12] Close houses, gardens and low fences meant people could 'natter', so that the 'community of affect' was held together, making possible 'particular ways of being together'.[13] Likely, sharing space also meant that at times people disagreed and bitterly fell out and had to work through their differences. But the physical geography of the town contributed to the 'on-goingness' of affective practices, of being 'held' together through common spaces and the emotional sharing of talking over fences. In similar vein, historical work on life in post-war Glasgow tenement buildings counters the idea that high-rise tenements encouraged community disintegration. Lynn Abrams et al. show that while flatted accommodation enabled tenants to guard their privacy, the confined spatial proximity encouraged positive experiences of 'intimacy, familiarity and mutuality of neighbourly relations' and forms of voluntary everyday exchange in relation to the gendered work of childcare, for example.[14]

I want to take seriously work on buildings and their holding capacity because the corollary of this work suggests that when the spatial contours of an industrial village disappear, people no longer

feel 'held together'. Later, this chapter turns to how people cope with the physical changes to the village, such as the open spaces produced by demolition.

Deindustrialisation: consequences for communities

A number of writers have focused on the consequences of deindustrialisation for communities. Sherry Lee Linkon's phrase, 'the half-life of de-industrialization', asks how communities experience and deal with the weight of the deindustrialised past in the present.[15] Whether it be the pain passed down generations or the legacies of ruined works buildings, the focus of studies in deindustrialisation has been on how the norms embedded in industrial life become 'dis-embedded'[16] in the transition to new social and spatial relations and as new forms of work are taken up. I want to take a moment to consider two examples – one from Russia, the other based here in Britain – to consider the strategies people use to try to come to terms with the consequences of deindustrialisation. It is rarely, as Sherry Lee Linkon argues, simply a question of 'getting over' the body blow of economic restructuring.

Jeremy Morris uses immersive fieldwork to explore community life in the deindustrialised Russian 'monotown' of Izluchino.[17] The town has 'old, borrowed and new': defunct, renovated and recent (usually foreign owned) buildings. Denigrated by the intellectual elite as a block on Russian modernisation, towns like Izluchino, and their working-class populations, are regarded as politically and socially backward. Yet such towns make up a fifth of Russia's landmass and they produce 30% of the country's GDP. Afflicted with poverty, the landscape of the town is run down. Yet Morris finds that people find a 'good enough' approach to living that enables the blue-collar workforce to make it habitable. Homemade DIY aquariums and illegal fuel pilfering are all part of 'making do' which enables the community to continue its 'social ties of extent, commitment and deep content'.[18]

But if Morris finds what one of his respondents called 'delight' ['*prelest*'] of the place that remains',[19] Jay Emery finds that a proud, shared history of place is inaccessible among his own deindustrialising generation in the Nottinghamshire coalfield.[20] His work is shaped by the embodied and affective dimensions of 'intergenerational

transmission'; how people continue to shape values, think, feel and relate to one another in deindustrialised spaces. Researching those born in the wake of the mining strikes of the 1980s, he finds processes of dislocation that fracture linkages between people and place. Emery sketches his childhood history within an atmosphere of proud labouring, hurt male bodies habituated through ritualised displays of mining injuries in pubs and homes. The closure of the pit in 1989 meant that this embodied history of belonging through the body could not be passed down through his generation.

Denied the 'patrilineal tradition' that mining would have enabled, one of the men he interviews finds solace in work that produces similar kinds of physical exhaustion that mining in the pit would have produced for his male forebears; another feels 'disinherited' from mining and feels alienated by a boring, low-paid job in a warehouse built over the once-colliery.[21] Emery shares his own desire to deepen an indented wound from a former labouring job so that he too can experience the injurious pain of labour before he interviews his contemporaries. In these moving exchanges, Emery traces a yearning to bear the weight and familial pain of labour and a deep desire to share his own alienation and forge belonging with men of his home community. But both men feel resentment and disdain for Emery – a university lecturer – because he can't 'share in common' alienating physical work. Denied to these young men is a way of carrying on connective community through the labouring body. Moreover, Emery traces the ways his parents' generation, are unable – as a result of the traumatic experience of the 1984–1985 Miners' Strike and attendant trade union conflict – to 'communicate useable pasts'[22] through a proud, shared narrative of industrial heritage to 'the generation that came after coal'. Without proud histories, his generation are cast adrift from 'ties that bind'. In these ways, Emery shows the fraught ways in which place and community are denied those who came 'after coal' in the Nottinghamshire coalfield, for the broken link of work and community has led to 'problematized attachments and detachments from each other and place'.[23]

Deindustrialisation takes a huge toll on communities. Processes of dis-embedding can be a source of struggle. In the case of Izluchino in Russia the continuity of work despite the demise of the main employer enables the community of blue-collar workers to stay resourceful and to make a ruined town habitable though many live

in poverty. But in the Nottinghamshire coalfields an 'affective history' of labour is blocked because the hereditary patrilineal chain of embodied affects of working together blights the continuation of community bonds.

The chapter turns now to the particularities of how Bailiff Bridge coped with dis-embedding, but before those themes are explored it takes a detour into how I managed to gain an insight into ex-worker responses to Bailiff Bridge, the loss of work and responses to the village after carpet.

Researching Bailiff Bridge

I returned as a researcher in the autumn of 2016. Most of the ex-workers I recruited for the study had left Firths Carpets during the 1990s. Some had retired and some had secured other kinds of employment: one worker had got a job demonstrating how looms worked at a local museum, another worked at Next retail and one had stayed on at Interface. Significantly, just as I would never have considered working at Firth Carpets when I reached working age in the mid-1980s, none of the children of the people I interviewed had looked for work at Firths. The community had felt the precarity of dwindling jobs, processes of closure, piece-by-piece dereliction, demolition and ruination. And gradually new-build residential housing, distinguishably aesthetically different as a result of its pale brick, began to appear over the once-mills: the sheds that had housed looms on Victoria Road and the dye house up Birkby Lane. There had been a 13-year gap since the demolition of Clifton Mill.

When I returned to Bailiff Bridge in October 2016, I featured in the 'nostalgia' pages of the local press calling for 'Stories about Firths Carpets and Bailiff Bridge'. Based on the people who got in touch, I organised a series of focus groups at Bailiff Bridge Community Centre. Out of the findings from these groups, individuals were then asked to lead me on individual walk-and-talk or 'go-along' tours[24] around the village. The mobile interviews, on which this chapter is based, used the form of 'walk and talk' tours: this enabled the capture from February to June 2016 of people's responses to spatial, architectural and sensory change. I was especially interested in 'involuntary memories' which can be produced unpredictably *in*

situ.[25] Often triggered by weather, atmosphere, touch and aroma, they can take people back. Walk-and-talk tours are an effective way to re-ignite embodied memories of familiar ways of walking and being in the place of the village.[26]

There are advantages to these tours, and it is worth comparing this way of researching people's experience with static interviews. Interviewing in a room or office requires the respondent to re-experience or recount everyday doings retrieved in the past tense from other contexts. By contrast, research done 'on the move' enables a sense of the present, of 'being there'. Being 'in place' with the people of the study enables an immediacy of response. It allows, as Lesley Murray argues, for people to produce their mobile space, 'a space that would not emerge from a static interview',[27] but comes out of the mobile encounter.

Walk-and-talk, participant-led 'go along' tours were crucial because I wanted to be present at what Ben Fincham and his associates call the 'phenomenal experience of the journeys – what they saw and felt' as well as witnessing embodied 'phenomenal reactions'[28] to altered aspects of the village. Carpiano argues that allowing people to lead the researcher along their own route is empowering and enables the respondent to both storytell and unfold their memories of everyday movements and behaviours.[29]

On the tours, people were asked to lead me and to talk about their sensory memories of work in the village and to reflect on their views about the village at the time of the tour. Tours took 25–30 minutes. I asked if I could record the tours with an audio hand-held digital device and took photographs to match respondents' verbal responses with the precise spatial context of the tour. As a result, walking interviews were ideal 'for exploring issues around people's relationship with space'.[30] This kind of research gives access to embodied analysis of how people both interact and emote *in situ* with landscapes of demolition.

Buildings and community

To glean a sense of how spatial change affected the people of Bailiff Bridge, it is necessary to sketch out what respondents told me about life in the village before closure and dereliction. This is essential because it offers an insight into the coping and relating strategies

Figure 3.2 Bailiff Bridge flood, 1968. Reproduced with permission from Bankfield Museum, Halifax, box C.2.2, ref. 2007.23.7.5.

people used when the village felt alive and operational. In the act of looking back from 2016, what is apparent in these accounts is the sense in which people felt closely bound by shared stories and experiences about life in Bailiff Bridge through workspaces, leisure events and forms of emotional sharing. 'The village felt more alive when Firths was here' (Jerry, local resident).

Most walk-and-talk tours produced stories of working life, sometimes in spaces where working buildings had once been. Weavers told of pranking or 'worker games' (Terry) which built camaraderie among male workers at the looms. Rolling a cigarette which contained highly flammable jute was one example, and these took place in the sheds on Victoria Road. People had a number of shared stories about Bailiff Bridge that came up in the focus groups and in the walk-and-talk tours: the flash flood of 1968 (see Figure 3.2), the wages robbery in Centenary Park and the Birkby Lane lorry crash in 1973.

These stories, familiar if you held a knowledge of the specificity of place, worked like social glue for the community. Ex-workers and residents drew on their social memory and became animated,

especially at the community centre meetings. Sensuous memories of life in the village served to animate it as a busy, thriving community of productive workers. People told of the 5.15pm alarm when workers 'trampled' and 'stormed' out of the mills with tremendous energy so they could get on buses, some of which were laid on by Firths, to take them home. There were aromas of wool and 'foul' smells from the dye house and of the chemicals for making foam backing. The village was noisy with what local resident Sherry called the 'clack, clack, clacking of the looms'. There were 'hotspots', places of significance which held resonance for recalling everyday lived practices and shared social rituals. 'The dams' were often referred to as places to visit. One of the weavers wanted to show me the place at the stone bridge over the beck where 'a group of blokes' took their break to 'look at the water, and watch the world go by'. As we stood there the atmosphere of the conversation took on a sense of quiet importance and I noticed David (ex-weaver) touch a particular stone on the bridge. Several respondents recalled particular atmospheres, such as the shift in class register and 'the awe when you walked through Clifton House' (Tony, ex-weaver and creeler) up the grand staircase and wood-panelled walls to get to the directors' suite of offices.

People's recollections emphasised that the village held a close sense of community. Some of this was maintained through self-sufficiency. This referred back to a time when Firth Carpets was vertically integrated. As Sherry's story at the start of this chapter recalls, her father was in Firths' fire brigade. Indeed, in the living memory of respondents, dating back in some cases to the mid-1940s, none of its workers was outsourced – it employed canteen workers, security workers and mechanics. Set in the village and close to its amenities, the Firths factory and its local environs could support family life without workers having to travel. The shops, school, pub and local housing meant that the community enjoyed an operational social infrastructure of which the factory was a part. As Thomas said, 'I hadn't got to go into Leeds or Manchester travelling. I could just roll out of bed and walk down to work.'

Many respondents told me they felt that Firths was a paternalistic employer with a 'family feel' (Tony); workers felt well paid and 'looked after'. Some of the weavers who were qualified engineers had been attracted to competitive pay at Firths. But it was more

162 *Threads of Labour*

than just the work that Firths provided which enabled people to feel that Firths was managed by 'decent people who you wanted to work for' (Thomas, office worker). Firths invested in paternalism, a management strategy, which promoted sports and leisure to foster 'teamwork' and forms of social bonding which arguably fastened workers to the corporate aims of the company.[31]

As shown in the analysis of the Firth Carpets staff magazine *Tuned In*, the company invested in a raft of sports, social and leisure activities for workers and their families. Perhaps not surprisingly, people held more photographs of workers at leisure than they did of people at work. The village had a bowling club with a green and a football field. There was an inter-departmental cricket and both tennis and an archery club (see Figure 2.8), and trips to the seaside and dinner dances – such as the well-documented 1968 Hawaiian evening, where workers were featured in the local press racing with space hoppers (see Figure 3.3). Gerald (ex-local shop owner) told me his father had run the tombola and there was an

Figure 3.3 Firths organised prestigious work events: space hoppers at the Hawaiian evening, 1960s. Reproduced with permission from John Waddington.

annual Christmas party, 'and the presents weren't rubbish', another respondent (Kathleen, ex-lab technician) who had been at the parties during the 1970s told me.

Firths was much more than just a workplace; it had a large social dimension that potentially bound people to one another in ways that made a 'way of life' in the full sense of the word. As Maureen (ex-wages office manager) told me: 'to me it was a smashing way of life – we had a good life with Firths, a really good life'. In this way, people told me accounts of love and play that had been conducted in Firths' work premises. Maureen met her husband at Firths and Terry came to Bailiff Bridge 'for a girl'. Gerald told me the story of how his mother and father met:

> He was in the mending and inspection, he's what was called a passer ... and my mother looked to see if there were any faults in them, she was a sewer. So they worked in the same department which is when they met in 1947. My Dad had been in the war and my mother, they met underneath – the carpets went under a sort of bench that's sometimes lit up or else there were skylights or things so they could see because they needed light in there to see faults. My Dad's mate who lost an eye in the war had a glass eye and the glass eye had fallen out so everybody was looking for this glass eye and so they met under the carpets.

The visitor whose last visit to Bailiff Bridge was in the 1970s would surely agree that the village has become an almost 'illegible landscape', transformed by processes of demolition. When I spoke with ex-workers and residents in 2016 they were asked to think back to life before the closure of Firths. Social historian Jon Lawrence warns that retrospective considerations of community can be rose tinted – even romantic – and the backwards glance can idealise community.[32] It is important to bear in mind that people within communities do act communally – but that individualism and autonomy in post-war Britain are amply evidenced by post-war social historians. That said, Bailiff Bridge ageing ex-workers and residents had the recursive tendency to look back to a time when one's personhood would be recognised, when one felt 'seen' – in the street, in local shops – in a physical community. Before closure, most harboured the feeling that for them Bailiff Bridge was a socially homogeneous group with

a shared purpose of making carpet which built collective strength and reciprocity.

I want to argue that labelling these sentiments 'nostalgic' is beside the point: what matters is that what people are voicing is the idea that their community is *not working* for them. Lisa MacKenzie argues that Brexit was an expression of working-class community dissatisfaction; they voted 'Leave' because they felt 'left behind' and hoped for more local investment.[33] Rather than pathologising working-class voters, Valerie Walkerdine argues for listening to the interests and concerns of different community factions in a bid to move forward.[34] In relation to Bailiff Bridge, we need to listen and take seriously the idea that people want to be seen and acknowledged in the place where they live as valid individuals who matter.

Valerie Walkerdine argues that company towns and villages build what she terms an 'affective history' – of moving, relating, surviving through poverty, precarity and economic adversity – and that rather than seeing these attempts to survive self-sufficiently as regressive we need to understand the historical specificity of these types of community. This chapter shows how the community believed that modes of 'interrelationality' bound it together through shared practices: worker camaraderie, the shared sensory experiences of a textile village, the social events through Firths' investment in paternalism and the descriptors of the firm as a 'family' co-mingled to produce powerful accounts of close-knit affective ties. In this way Walkerdine's work on communal-beingness has explanatory power: shared ways of building inter-subjective bonds made it feel operational and alive. When these forms of bonding fell apart, people missed communal closeness and felt acute loss in their absence. Self-sufficiency of the company village made it feel safe and less open to threat from outsiders.

Witnessing the fall of the mill

A strand of photographs document temporary processes of spatial change enacted by dereliction. Four of the male respondents documented the dereliction the works and surrounding village had been subjected to. One respondent had a large collection of photographs dating from the early 1990s (see Figure 3.4).

'History gone': community after carpet 165

Figure 3.4 Ex-workers documented demolition which left wide, open spaces. Photograph by Michael Halliwell. Reproduced with permission from the photographer.

Some chose to make time to witness particular aspects of demolition. During one walk-and-talk tour Tony stopped on the causeway and turned, pointing to look across the expanse of derelict space:

> I remember standing here, this is where I stood and watched them with the big wrecking ball strike – I came up here just on my own … I turned round and there was six other people that I knew behind me [laughs] so I was saying – all was saying 'what a sad day'. We all said, 'isn't this a sad affair' and nobody else, nobody said another word. They just stood with me for about three-quarters of an hour and then one after the other they just drifted off. And I thought, well this is the end of an era. Will it be good or bad for Bailliff Bridge, I don't know …

By standing in the same spot, Tony told me of the atmosphere of embodied collective silent witnessing of the erasure of once meaningful spaces.

Some were affected bodily as we encountered the empty space where Clifton Mill had been:

> LT: We're just outside the Co-op aren't we?
> Margot: Oh this is just horrendous. I know the first time I came down here – my stomach churned. I thought 'Deary me. gone' … when I was walking around with Dierdre I brought her here and the dam's gone. I said 'look it's a car park'. Oh I felt – well they filled it in, it's gone. History gone.

As I walked around the village with Margot (ex-marketing officer) she kept saying, 'history gone'. It became her mantra. Some offered their thoughts and feelings about Clifton Mill as we toured the village: 'It was the heart and soul of the village', Terry told me.

Several respondents wanted to take me to the sites where the dams were once operational. Stacey, who lived several miles away but who had worked in export referred to a particular dam a couple of times during the tour. As was the case with many of the surrounding textile mills, dams provided energy through the force of the water to operate machinery in the carpet-making process. The dams were mentioned several times across the walk-and-talk tours; they clearly held historical significance for ex-workers. This was Stacey's first visit to Bailiff Bridge in several years. But when we arrived at the site next to Clifton House the dam had been covered over and made

into a car park. The tour enabled me to witness *in situ* her discovery of a physical change to a site that held significant meaning for her:

> SW: there used to be a dam. It's probably still there – it must be still there – the one I was going to suggest going to see at the front of the offices there.
> [Later we walk through Clifton House car park. I am unaware at this point that SW is walking me to the dam]
> SW: Her mother worked in the canteen. Yes is that – oh. Oh no it's gone.
> LT: What's gone?
> SW: The dam [laughs] there used to be a – yeah this is – yeah. I used to walk if I went down to despatch and there was a – and it's all been filled in. There was – a dam – like a mill dam or whatever. There – here.
> [Later as we close the tour]
> SW: … that has really amazed me, that dam going. I suppose it was no use was it? Well it wasn't when I worked here but it was iconic … it was part of my life in previous years.

This is an emotional moment of shock at the discovery of a disappeared meaningful space. There's a breathless, staccato use of language: 'there was – a dam' and 'There – here', as she struggles to absorb its absence. These mobile tours, as Leslie Murray argues, 'allow the exploration of the emotionality of everyday life while it is taking place'. Affordances in this way of researching spatial change allow the researcher 'an appreciation of the more intricate sociality and emotionality of the journey'.[35]

The site of Clifton Mill was important to Gerald. He had been born in a house across the road, adjacent to a haberdashery shop his family owned. His parents had worked at Firths. He had been in the shop at the time when the mill was demolished, but he 'couldn't look'. As we started to cross, he suddenly turned the conversation to his dealings with the demolition men:

> LT: So we're crossing Bradford Road. So yeah – so you said all this to him, this man who was doing the demolition.
> Gerald: Yeah and I said 'can I have some of that' and he said 'Oh I'll try and save you some' and I said, 'Can you save me Clifton Mills'.
> LT: Clifton Mills, the whole thing?

> Gerald: The whole thing, the guy who sent it down and it all crashed into pieces, the Clifton Mills which is sad really because I'd have had that.
> LT: Sent it down? The title you mean? [referring to the brick bearing the company name]
> Gerald: Well – yeah the Clifton Mills was up at the – in this potwork this like orangey rust-coloured potwork and all that came down.

University educated, a property and business owner, and an ex-teacher, Gerald had worked at Firths as a student in the summer holidays. Class confident, he had dared to ask about the retrieval of remnants of industrial history. But not all respondents were in mourning. Two members of the sample were sanguine. 'Clifton Mill? It wasn't exactly pretty', Keith (ex-weaver) told me. Some understood the factory as a business and coldly looked at the idea of Firths as an entity that had to die if it no longer yielded profit. William (ex-sales executive), told me that driving past the once-mill evoked no difficult feelings.

> WE: To be absolutely honest, I have no pangs when I go past Firths. I don't feel any, think you know – 'oh what if, what if'. It was a business! It was not for the benefit of the employees, it made money for its shareholders.

The previous chapter looked at nostalgia as an emotion and a practice that can be used at home to help people to cope with loss. Ex-workers and residents used photographs as an imaginative aid which pulled back motifs of working life and buildings as they once were. These could be consumed at home or in social settings with friends and contemporaries. But what about the lived experience of living and being in the village, performing activities such as walking or driving through? What happens for ageing ex-workers whose temporal frame of social memory of place spans across six or seven decades? What happens when the company village you live in or pass by contains empty spaces – so that your memories have no built props, or shape on which to hang a sense of where you feel you belong?

These are experiences which cannot be assuaged by nostalgic looking at frozen images of times past. None of the ex-workers wanted to time travel back to a golden past of Firths as it was. Thus, I want to argue that the tenets of nostalgia are inadequate for thinking about how the people of Firths physically relate to

Bailiff Bridge in the present. In what follows, I turn to a concept used in environmental studies to expose the limits of the temporal and spatial dimensions of nostalgia. In the next section I examine a conceptual framework to help people to comprehend the pain of the present state of a village called home. Before I do, I look in more detail at how people form attachments to place; work which looks at how social memory and embodied experience of place meld together in highly social ways to bond people with place.

Place, identity, home

Place attachment, or the intense emotion evoked by our relationship with place, is especially significant for the later stages of the life course. Cathrine Degnen's work offers some helpful detail for thinking about the significance of the physical and social elements of place attachment. Drawing on participant observation in two South Yorkshire mining communities, she argues that studies on the individual experience of place attachment tend to miss its dynamic, active elements which cohere in 'collective, relational and embodied process'.[36] Moulded and felt interactively with people, objects and environmental surfaces through social memory and embodied sensory practices, place attachment can stretch across several decades in the life course. How we make bonds that fasten us to place starts with the sensory – our relationships with place occur through the felt body, through aroma, touch and sound. Place is navigated through the sensing and moving body: encountering steps, corridors, rough ground such that when bodies encounter familiar ways of manoeuvring through place these practices become habituated, living in the body like distilled matter that is to be activated repeatedly across time.

Degnen's work also emphasises that place attachment is a social process rather than something that occurs just between the individual and place.[37] Her detailed observations found it is made interpersonally, often in group gatherings through the discussion and debate of shared social memories. Place attachment is benefit laden in later life – indeed, older people often attempt to maximise attachments with place – because it enriches life quality, builds a sense of belonging and scaffolds personal identity, particularly in situations where older people feel socially disparaged.[38]

Taking Degnen's insights, I want to move to the work of Glenn Albrecht, an Australian environmental conservationist and philosopher whose work has focused on the relationship between 'sick' environments and human distress. Residing near the Hunter region in New South Wales, Albrecht witnessed the impact of open-cut mining and power station pollution and their deleterious effects on the health and identity of residents in a once-loved home environment.[39]

Albrecht argues there is a time delay between our lived experience of processes such as global development, changing ecosystems and demolition clearance and our mechanisms for understanding their impacts. Indeed, he argues that change to our natural and built environments is so accelerated that our language and conceptual models face a time lag: they no longer fit.[40] At stake is the cognitive and physical ability to cope with the loss of what geographer Yi-Fu Tuan terms 'topophilia', or a joyful and secure sense of place in people's lives.[41] Albrecht recognised he was witnessing a breakdown in the relationship between land health and psychic stability. In effect, what he saw in Hunter was a reversal of topophilia, replaced instead by chronic distress.

Implored by people in the region with cries for help, Albrecht describes sitting down with his wife at the dining table in an effort to grasp the distressed state residents experienced. Reaching for nostalgia, Albrecht found it lacking: its combination of *algia* = pain or sickness and *nostos* = desire for return home described a melancholia for people far from home.[42] But the pain felt by his residents was experienced *at home*. Moreover, as other geographers have noted, nostalgia is often pejoratively associated with its temporal associations – of harking back and longing to return to a lost time in the past. But neither would this yearning fit, for, as Albrecht notes, 'the places I was interested in were not being completely "lost", they were places being transformed'.[43] The people at Hunter were suffering from 'imposed place transition' and they had no tools or power to resist. Albrecht needed a new term to describe the sadness of the ruptured relationship between 'psychic identity' and home, the absence of comfort (solace) at home, and the powerlessness and isolation (desolation) wrought by the lack of consultation for place change.

Built from a combination of *solari* and *solacium* = solace, *solus* and *desolare* = desolation, and retaining *algia* = pain, 'Solastalgia' has 'a ghost reference' to nostalgia – but the crucial difference is

that 'a place reference is imbedded'.[44] It can be apprehended in any context where place identity is imperilled. Solastalgia parts company with nostalgia in the sense that it lacks spatial and temporal dislocation – it has no interest in the past and it is already at home. It is about loss, dislocation and the absence of solace in the present.

> It is the pain experienced when there is recognition that the place where one resides and that one loves is under immediate assault (physical desolation). It is manifest in an attack on one's sense of place, in the erosion of the sense of belonging (identity) to a particular place and a feeling of distress (psychological desolation) about its transformation. It is an intense desire for the place where one is resident to be maintained in a state that continues to give comfort or solace ... In short, solastalgia is a form of homesickness one gets when one is still at 'home'.[45]

Albrecht argues that in both natural (drought, flood, fire) or artificial (land clearance, gentrification, agribusiness, industrial demolition) contexts, the experience of witnessing or living alongside one's altered or destroyed physical environment undermines one's sense of control. If a person is unable to plant their feet in a place they call home, the result can be profoundly destabilising. It acts as an assault on both individual and communal senses of identity. As social meeting places where forms of culture are practised break down, a people's support culture melts away. There are potentially grave health consequences as a result. Drawing attention to the increased worldwide growth of 'ecosystem distress syndromes'[46] of pandemic proportions, Albrecht suggests that the concept of solastalgia requires a new vocabulary to describe its health-related problems which operate across both mental and physical registers: 'psychoterratic', which describes mental health issues, and 'somaterratic', which alludes to physical types of pain.[47] The next section demonstrates the need to engage the tenets of solastalgia to adequately understand how ageing workers responded to their changed environment in Bailiff Bridge.

Watching the loss of home

At the time of the research, there were few works buildings left.[48] In this section, I present what respondents felt were the legacies of pulled-down buildings. Dereliction opened out previously concealed ways of apprehending space which felt discomforting, bringing new

views which felt out of place, as Frank (ex-creeler) told me: 'When you come down Birkby Lane you can see Gerald's shop; it doesn't look right'. Others mentioned a changed sense of the dimensions of the village. The absence of Firths brought a 'hugeness' of open space revealed by demolition: Maureen commented: 'It was huge. And that was a shock when it all came down, how big the place was.'

For others, Bailiff Bridge seemed bigger because of the large sites of new housing. For Jerry, housing had replaced manufacturing: 'it used to be a place of production, now it's just a dormitory'. But this was not a view shared by all: some, like Stacey, liked the housing because it gave 'use' to the sites and spaces.

Ex-industrial sites generate immobility, or enforced passivity, for those who once navigated their movement using the pathways of works buildings. In the exchange below, I encourage Maureen to lead me on the walk:

LT: Where shall we go now Maureen?
MS: Well, I don't really know where to go because the places I went to they've all been knocked down haven't they? That used to be the pattern room and now it just looks sad.
LT: Is it easier to imagine when there's a gap or when there are new buildings?
MS: Well, I don't really know because my working life really was from the offices to the canteen to the mill.

Here, Maureen is literally unable to move. As we stood in the village looking at open spaces where buildings had once stood, or at houses which had replaced works buildings – 'all this was big sheds', she told me as we looked along Victoria Road – 'gone' was the term she used. The village for her was 'a big lump of nothing'. The loss of Firths 'has killed Bailiff Bridge, hasn't it?' she said.

Today the quotidian sound of traffic dominates. As Jerry said, 'It's noisy, people are just driving through, they don't even know they're driving through a specific place'. Alongside the fragmentary memories ruins afford, people juxtaposed their present views of the village community. As Sherry told me in the story that opens this chapter, there were fewer physical opportunities to meet people: 'I knew practically everybody in the village and they all knew me, but now I know very few people'. Three or four people mentioned social media, 'computers' and 'phones', as modes of communication they

observed others using, but the connective possibilities of digital and social media were rejected – seen as poor substitutes compared with the face-to-face physical encounters with other warm bodies these respondents once experienced in the works or pub. 'People are far more in their own homes now and they're on the computers with their little phones. My grandchildren are like this, they keep in touch with hundreds of people but they're not *there*' (Sherry).

Perhaps most worryingly a section of the sample ruminated about 'these people' or 'incomers', the anonymous people who are living in new housing. Where were they from? How did they make their money? Did they have any idea about the place that Bailiff Bridge had once been? As Jerry told me, 'the people who come into all these new houses and flats aren't Bailiff Bridgers'. Note this dialogue from one of the focus groups with Jerry, Sue (ex-wages clerk) and Colin (local resident):

> SR: Because Bailiff Bridge without Firths doesn't seem like a place really
> [laughs] ...
> JW: Well it's nowhere now is it?
> SR: It's nothing is it? It's just somewhere you drive through if you're going up that road.
> CR: It's all new houses now.
> SR: It's just where people live.
> CR: What sort of jobs are all these people doing who live in all these new houses?
> SR: Yeah I know. Well they're probably going to the motorway to go wherever. [pause]
> JW: It's like a person without a personality isn't it?

Fear of 'outsiders' who do not share a history of mutual support in the community presides. Worryingly, people living in Bailiff Bridge find bridging the gaps with new 'others' very difficult, as these comments show, such that these communities have the potential to be riven with division in the future. Undoubtedly, this experience is more acute for ageing residents.

Firths in Bailiff Bridge is by no means an isolated case; indeed, it offers an example of a substantial nation-wide phenomenon. Reference to the contextual factors surrounding a village like Bailiff Bridge enables a clearer understanding of why different layers of the

community find it so difficult to cohere. According to a report by the Centre for Regional, Economic and Social Research,[49] Britain's old industrial towns are inhabited by a substantial proportion of the populace at around 16.6 million people – a quarter of the UK. One of their key findings is that such towns are 'increasingly becoming dormitories for men and women who work elsewhere'.[50] When Britain's industrial towns were first formed, they developed as a consequence of local factors – in the case of the West Riding textile industry, wool, soft water and the nearby coalfields. They expanded due to their connectivity with national markets via the rail and canal networks and then internationally through empire. Today cities are locales of regional business growth orbited by surrounding towns that are expected to act 'as their satellites'. Yet this is not how older industrial towns were first conceived as independent business locales and there is scant evidence to suggest that labour markets in cities and satellite towns operate in mutually nourishing ways.[51] The economy in Britain's old industrial towns suffers acute inertia. Though not stagnant, since 2010 job creation has been lower than the national average and far slower than in regional cities. Geographically, old industrial towns now occupy two surrounding layers: those far flung and those in the 'hinterland' of the main regional cities. Indeed, 11.9 million people of the 16.6 occupy the hinterland. Both are subject to out-commuting to work, but it is heavier in the hinterlands.[52] From its location as an immediate hinterland outside Leeds as the nearest major city, these trends enable an understanding of the function of new-build housing in Bailiff Bridge to house people commuting to work. Between 2010 and 2016 out-commuting in the UK grew from 860,000 commuters to 970,000.[53] It is important to note that not all old industrial towns are the source of commuters to regional cities; commuter flows are complex. But it is safe to assert that the shortage of 'good' jobs in Bailiff Bridge incentivises workers to travel out for work to Leeds, Bradford and the other surrounding smaller cities of Halifax and Huddersfield. It is a world away from the self-sufficient 'way of life' workers at Firths experienced locally as a once carpet-making business centre in its own right.

Like many deindustrialised towns and villages in the UK, where manufacturing has been replaced by new residential building, spatial dislocation and social isolation have changed what it means to

belong. In this way, the purpose and identity of Bailiff Bridge has been significantly redefined. Local resident Jerry suggested that it had become a 'dormitory' like many other old industrial towns and villages: a place where people live so they can work elsewhere. As a consequence, the experience of being in the village for older residents is radically altered.

Conclusion

From my own experience of growing up there in the 1970s, Bailiff Bridge's inhabitants had what Valerie Walkerdine calls 'communal beingness',[54] a sense of being together, through the shared experience of living there and making carpets. Thirty years later, Dad and I took a sad and difficult journey past the demolished works. It was a drive that seemed to open a chapter of decline for Dad. While I offered empathy at the top of the hill, he cleared his throat and met me with silence. With the end of the works, and an end to the village as it had once been, came feelings of purposelessness. Around that time Dad declined surgery for his osteoarthritic hands: 'they're not working hands, anymore,' he told me; 'if they were then I could justify it' – and he closed down further discussion.

My observations of Dad's pain and sense of low self-worth 'after carpet' widened my thinking out to the experience of other ex-workers in the Firths community who had lived through the demolition of buildings their bodies once dwelt in. Did others feel these types of pain when they physically passed the once-mill? The tours I took with the people of the study were important – they allowed me granular access to how people interacted *in situ* with landscapes of ruin and demolition they live with. While living alongside ruination is a central strand in deindustrialisation literature, underplayed in the accounts is an embodied analysis of the emotions, senses and actions contained in the 'memoryscapes'[55] of the members of a community. The embodied analysis finds ways of accessing emotional and affective responses to the erosion of place.

In situations where people were physically near to demolished sites, silence filled the air – as when Dad drove up Birkby Lane, as Jerry noted as the wrecking ball took down Clifton Mill, and as I noted when people showed me their photographs of demolition in

action. Or there was a gut-wrenching physical effect at the site of demolition – Margot's 'stomach churned' when she witnessed all that had 'gone'. Spatial and sensory unease characterised some people's responses: the 'company village' no longer felt 'held' by the contours of the spatial organisation of the buildings; sensory characteristics which promote belonging to place had disappeared; and navigating the village had become impossible for some respondents – Maureen was physically immobilised by demolition.

Possibly cognisant of locales in West Yorkshire which had been worthy of preservation and regeneration, such as Salt's Mill and Dean Clough, they witnessed the dismantling of Firths' industrial heritage: *their* industrial village was not worth preservation; it was 'history gone', with no consultation. The huge apparatus of corporate social activity has been erased; all that remains are visual motifs frozen in dearly held photographs. The spatial nexus through which embodied affective ties can be held in place to continue an 'ongoingness of being' have dissipated into air. In this way, Walkerdine's psychoanalytic metaphors of affect hold efficacy for this study: losing industrial buildings which acted as a 'containing skin' surrounding people's working and leisure lives was experienced emotionally as a wounding loss which will continue to resonate for years.

Albrecht's work on solastalgia allows an understanding of the distress of ex-workers and local residents because it accounts for the bodily effects of damage to one's sense of place that cannot be expressed in language. Tempting though it is to reach for 'nostalgia' as the term to describe the feelings expressed in the walk-and-talk tours, none of my respondents wanted to time-travel back, nor did they yearn for 'home' – they were already at home in the present, but 'home' was no longer a readable landscape. 'Solastalgia' expresses the melancholia of loss, and the lack of comfort in disordered and large open space and sensory unfamiliarity in the environs of home. In their work on belonging and ageing, Vanessa May and Stewart Muir argue that 'the look, feel, sound, smell and taste of our surroundings ... create a "sense of self" through place' and that 'unwelcome sounds, sights and smells'[56] do much to usher in feelings of non-belonging for older people coming to terms with change to their local environment. Moreover, solastalgia expresses the lack of consultation, the sheer powerlessness of imposed place transition

and the lack of care for the psychic, mental and physical forms of distress experienced by ex-workers and residents.

Before the closure, residents felt that Bailiff Bridge was a socially homogeneous group with a shared purpose of making carpet which built collective strength and reciprocity. Self-sufficiency of the company village made it feel safe and less open to threat from outsiders. Carrying these memories of the 'half-life' of deindustrialisation produces what Strangleman terms 'dis-embedding' ;[57] in this study, ageing people said they struggled to relate to outsiders in the more heterogeneous contemporary village. Worryingly, Bailiff Bridge was described as a 'dormitory' rather than a 'place that makes carpets', and new housing has brought people who are perceived to lack an understanding of a village once proud to have produced fine woven carpets. Threatened by 'outsiders', these ageing respondents were not using what Robert Puttnam calls 'bridging capital' to broker relationships with newcomers.[58] They wanted the return of a physical village and saw media-rich homes which brought digital connectivity as a lack of investment in the social potential of the village. The threat of outsiders might have been associated with what they represented: globalisation, immaterial forms of labour, postmodernity, and the production and maintenance of the disappearance of locality. Ex-industrial, like countless villages and towns in Britain, the USA, Russia and beyond, Bailiff Bridge at the time of this first phase of the research harboured a festering real-life problem: social divisions which were not being addressed.

Notes

1. Clifton House and North Vale Mill are now rented-out business premises. The central office of 'Firth' has premises at Clifton House.
2. F. Allon, 'Nostalgia Unbound: Illegibility and the Synthetic Excess of Place', *Continuum: Journal of Media and Cultural Studies*, 14:3 (2000), 275–287.
3. A. Andrews, 'Dereliction, Decay and the Problem of De-industrialization in Britain, c. 1968–1977', *Urban History*, 47:2 (2020), 236–256.
4. V. Walkerdine, 'Communal Beingness and Affect: An Exploration of Trauma in an Ex-industrial Community', *Body and Society*, 16:1 (2010), 91–116, p. 95.

5 E. Bick, 'The Experience of Skin in Early Object Relations', *International Journal of Psychoanalysis*, 49 (1968), 484–486.
6 Walkerdine, 'Communal Beingness and Affect', p. 97.
7 D. Studdert, *Conceptualising Community: Beyond the State and the Individual* (Basingstoke: Palgrave, 2006).
8 Examples include M. Savage, 'Histories, Belongings, Communities', *International Journal of Social Research Methodology*, 11:2 (2008), 151–162. Savage's approach is seen as too rigid and 'mathematised' and misses how affective relations work.
9 Walkerdine, 'Communal Beingness and Affect', p. 95.
10 M. Wetherell, *Affect and Emotion: A New Social Science Understanding* (London: Sage, 2012), p. 23.
11 For ethical reasons, Walkderdine uses the pseudonym 'Steeltown' to protect the identity of the place on which her study is based.
12 Walkerdine, 'Communal Beingness and Affect', p. 99.
13 Ibid., p. 100.
14 L. Abrams, A. Kearns, B. Hazley and V. Wright, *Glasgow: High-Rise Homes, Estates and Communities in the Post-war Period* (Abingdon: Taylor and Francis, 2020), p. 99.
15 S. Lee Linkon, *The Half-Life of De-industrialization: Working-Class Writing about Economic Restructuring* (Ann Arbor, MI: University of Michigan Press, 2018).
16 T. Strangleman, 'Deindustrialisation and the Historical Sociological Imagination: Making Sense of Work and Industrial Change', *Sociology*, 51:2 (2017), 466–482, p. 476.
17 J. Morris, 'Note on the "Worthless Dowry" of Soviet Industrial Modernity: Making Working-Class Russia Habitable', *Labotorium*, 15:3 (2015), 25–48. https://doi.org/10.3389/fsoc.2020.00038.
18 Ibid., p. 44.
19 Ibid.
20 J. Emery, 'After Coal: Affective-Temporal Processes of Belonging and Alienation in the Deindustrializing Nottinghamshire Coalfield', *Frontiers in Sociology*, 5:38 (2020), 1–16.
21 Ibid., p. 7.
22 Ibid., p. 11.
23 Ibid., p. 12.
24 This way of researching community members has its roots in health studies. See R. M. Carpiano, '"Come Take a walk with Me": The "Go-Along" Interview as a Novel Method for Studying the Implications for Health and Well-Being', *Health and Place*, 15:1 (2009), 263–272.
25 T. Edensor, *Industrial Ruins: Space, Aesthetics, Materiality* (Oxford: Berg, 2005), p. 45.

26 P. Connerton, *The Spirit of Mourning: History, Memory and the Body* (Cambridge: Cambridge University Press, 2011).
27 L. Murray, 'Contextualising and Mobilising Research', in B. Fincham, M. McGuinness and L. Murray (eds), *Mobile Methodologies* (Basingstoke: Palgrave Macmillan, 2010), p. 15.
28 B. Fincham, M. McGuinness and L. Murray, 'Introduction', in Fincham, McGuinness and Murray (eds) *Mobile Methodologies*, p. 6.
29 R. M. Carpiano, '"Come Take a Walk with Me": The "Go-Along" Interview as a Novel Method for Studying the Implications for Health and Well-Being', *Health and Place*, 15:1 (2009), 263–272.
30 P. Jones, G. Bunce, J. Evans, H. Gibbs and J. Ricketts Hein, 'Exploring Space and Place with Walking Interviews', *Journal of Research Practice*, 4:2 (2008), available at: https://eric.ed.gov/?id=EJ827010 (accessed 8 February 2025).
31 L. Fine, '"Our Big Factory Family": Masculinity and Paternalism at the Reo Car Company of Lansing, Michigan', *Labor History*, 34:2–3 (1993), 274–291.
32 J. Lawrence, *Me, Me, Me? The Search for Community in Post-war England* (Oxford: Oxford University Press, 2019).
33 L. MacKenzie, 'The Class Politics of Prejudice: Brexit and the Land of no Hope and Glory', *British Journal of Sociology*, 68:S1 (2017), S265–S280.
34 V. Walkerdine, '"No One Listens to Us": Post-truth, Affect and Brexit', *Qualitative Research in Psychology*, 17 (2019), 143–158.
35 Murray, 'Contextualising and Mobilising Research', p. 10.
36 C. Degnen, 'Socialising Place Attachment: Place, Social Memory and Embodied Affordances', *Ageing and Society*, 36:8 (2016), 1645–1667, p. 1645.
37 Ibid., p. 1646.
38 Ibid., p. 1647.
39 G. Albrecht, '"Solastalgia": A New Concept in Health and Identity', *PAN: Philosophy, Activism, Nature*, 3 (2005), 44–59, p. 44.
40 G. Albrecht, 'The Age of Solastalgia', *The Conversation* (2012), available at: https://theconversation.com/the-age-of-solastalgia-8337 (accessed 8 February 2025).
41 Ibid.
42 Albrecht, '"Solastalgia"', p. 45.
43 Ibid., p. 47.
44 Ibid., p. 48.
45 Ibid.
46 Ibid., p. 53.
47 G. Albrect et al., 'Solastalgia: The Distress Caused by Environmental Change', *Australasian Psychiatry*, 15:S1 (2007), S95–S98.

48 There are two. As mentioned earlier, Clifton House, owned by Blackshaw Holdings, is rented out to small businesses, including Firth Carpets. North Vale Mill remains on Bradford Road.
49 C. Beatty and S. Fothergill, 'The Contemporary Labour Market in Britain's Older Industrial Towns', *Working Paper*, Centre for Regional, Economic and Social Research, (2018).
50 Ibid., p. 43.
51 Ibid., p. 35.
52 Ibid.
53 Ibid., p. 13.
54 A. Miles and M. Savage, *The Remaking of the British Working Class, 1840–1940* (Abingdon: Routledge, 1994).
55 P. Basu, 'Memoryscapes and Multi-sited Methods', in E. Keightley and M. Pickering (eds), *Research Methods for Memory Studies* (Edinburgh: Edinburgh University Press, 2013), pp. 115–131.
56 V. May and S. Muir, 'Everyday Belonging and Ageing: Place and Generational Change', *Sociological Research Online*, 20:1 (2015). https://doi.org/10.5153/sro.3555.
57 T. Strangleman, 'Deindustrialisation and the Historical Sociological Imagination: Making Sense of Work and Industrial Change', *Sociology*, 51:2 (2017), 466–482, p. 476.
58 R. D. Putnam, *Bowling Alone: The Collapse and Revival of American Community* (New York: Simon and Schuster, 2000).

4

Hopeful re-making and the power of art

The artist Catherine Bertola's story

Firths was always in the background of my childhood, from the carpets that decorated my family home to the factory streams and dams that became our playgrounds in summer.

Walking through Bailiff Bridge, over 35 years since living there as a child, I retraced the routes I used to frequently walk. Everything felt so overwhelmingly familiar, if smaller in scale, and yet things were also markedly different. The library closed and boarded up, the post office now a dog-grooming parlour, the large Firths factory buildings that had dominated the landscape were gone, replaced by new housing and large expanses of undeveloped overgrown wasteland.

Places are always in states of flux, buildings and businesses come and go over time, but the changes here felt stark. Maybe it was the length of time that had passed since I was last there, and not having witnessed the slow, incremental evolution that happens over time. But it also felt more than that as I walked around the perimeter of the factory, using an old aerial photograph as my guide, following the edge of the rubble-filled wasteland and around the back of garden fences that now define and enclose the area. While I navigated my way through overgrown paths, I began to think about what went on inside the buildings that existed here, what sounds and smells would once have filled the air. It struck me how the people living on the site where looms once stood would possibly have no knowledge or recollection of the history of this place, and how in turn others would still see the factory buildings so vividly in their mind's eye.

This sense of sadness was also underpinned by anger. Anger that people had lost their jobs and livelihoods. Anger that they felt they

had been undervalued and treated badly. Anger that their sense of community and belonging had been destroyed, and that after 20 years there was still a gaping hole left in the centre of the village, like an open wound.

I could feel the division and alienation the community of ex-workers felt towards those residents who have moved into the properties that now stand on the site of the former factory. One of the questions we wanted to ask through the project was: how can a sense of community be rebuilt when what had been at the heart of that community has gone?

This disconnection between how different people experience, understand and remember place became central to the project.

Introduction

While the sense of anger on behalf of ex-Firths workers is palpable in her story of return to Bailiff Bridge, the artist Catherine Bertola and I held the belief that communities like Baillif Bridge need care provision and healing opportunities to address the experience of loss resulting from deindustrialisation. Actually thinking about healing brought the realisation that some of the assumptions in medicine about recovery could equally be applied to ex-industrial locales. In medicine, recovery tends to be assumed, often post-diagnostically relegated to the patient to be independently managed after the crisis of illness. Indeed, so strong is the assumption that bodies self-heal that 'recovery', as GP Gavin Francis argues, is barely covered by the curriculum in medical training.[1] Similar assumptions are made about deindustrialised locales: as US scholar Sherry Lee Linkon argues, ex-workers in Youngstown were expected to just 'get over it' and move on.[2] Yet the practical act of marshalling the bespoke guidance of healing as an active process requires our focus, if the lingering malcontents of inequality, failing and inadequate infrastructure, and broken or cleaved communities in Britain's old industrial regions are to be tackled. What became clear in my research in 2019 is that ageing ex-workers and residents were not finding opportunities to meet, socialise or cohere with newcomers.[3]

Bailiff Bridge is like many old industrial towns: it has an older population. Moreover, 35.2% of pensioners live alone, in contrast

to 12.6% in the wider Calderdale Metropolitan District. In addition, the number drawing incapacity benefits is 0.4% higher than the UK average.[4] Set those statistics in comparison to the arrival of residents occupying new-builds – 228 new houses appeared between 2001 and 2011 – and this emerges as a dominant characteristic of the area, considering the village radius is less than one kilometre from the centre. Unlike older residents, newcomers are likely to occupy a number of different 'layers' of community – as members of leisure groups both in and outside the village, or as parents at the local school and, most significantly, as workers elsewhere. What emerged was a picture of a broken and divided community, facing different directions and living different lives. While ex-workers wanted the experience of encountering warm bodies in a physical village, sites and spaces where they could meet and engage with others were sorely lacking. In short, research I had been immersed in presented a 'real life' problem; its community was in urgent need of a strategy to suture its wounds.

Then, in July 2020, I was awarded a mid-career fellowship to spend a year from January to December 2021 to develop the collaborative plan myself and Catherine Bertola had devised to use participatory arts workshops in the community.[5] Like so many original plans, they were subject to change because our ethos was to listen and to work *with*, rather than *on*, the community.[6] And we had to work with the extraordinary circumstances that began in 2020 and continued across the early part of 2021, namely the Covid-19 pandemic and its 'stay home' policy that brought new challenges to working socially with community.

Community action: the Intertwining Threads project

A bespoke model befitting the specific circumstances in Bailiff Bridge was needed for community healing to work effectively across intergenerational boundaries. This was germane given the rapid technological shift these groups have lived through, where one half of the community makes relationships through physical encounter, while younger members often connect digitally via social media. It required a model where conduits of mutual respect are set up across the ex-worker and newcomer divide, so that knowledge of the village's

industrial past, pride in industrial labour and respect for place as it was, is exchanged on equal terms with the life and place experience of the newcomer. To work effectively, it required convivial spaces where opportunities for people to meet, converse and exchange ideas around the theme of place could be created.

Designing the artmaking workshops

Artist Catherine Bertola and I felt the need to act on what this community told us. To reach any understanding of community tension or lack of cohesion between different layers means understanding the affective history of each faction. In doing so we took the approach advocated by Les Back of 'deep listening'.[7] But this is not just about recording voices – though it is partly that; it is also working with what he calls 'a democracy of the senses' to fulfil the need to move 'between visual, aural and corporeal registers'.[8] Catherine Bertola and I wanted to respond imaginatively to the energy encased in these multivalent registers.

We wanted to design workshops which operated in a 'live' way which aimed to be 'horizontal' to promote a 'participatory process' for working 'with'. The work of Geoff Bright's experimental arts-based 'ghost labs' is germane here.[9] Theorising haunted deindustrialised spaces as pregnant with 'affective and imaginative intensities', he set up a series of 'germination chambers' to provide a space for working-class ex-mining community members to experience the cathartic emotional release of hauntings, of 'revenant energies' that can no longer be buttoned down.[10] Through playful, 'open, acceptant and non-judgmental encounters', Bright developed a method which enabled participants to articulate damage to their community.[11] He did so through collective, politically charged and unpredictable imaginative practices – tarot cards, poetry, performance of experiences, 'happenings', 'readings' of haunted objects – with the aim of moving forward such that 'something else, something different'[12] could be done.

Our workshops

Drawing on both the visual motifs of work and the potential haunting of muscle memories of carpet making, we devised two community

workshops designed to bring together ex-workers and newcomers. We had a particular interest in movement, and from my existing research with the community, through conversations, interviews and walk-and-talk tours, Catherine and I had a hunch that movement, especially hand gestures, often used to demonstrate how carpet was made, would be shared in the workshop. Thus setters, weavers, menders and office workers would likely re-enact hand gestures from their carpet-making routines and that conversation embellished with bodily knowledge could be aired in the presence of newcomers. Bright described the event-space of the ghost lab as a 'playful ragbag'.[13] Our workshop design was not as powerfully loose or experimental. But it did aspire to release haunted and embodied 'revenant energies' related to the loss of work and place. It would lay the ground open such that ex-workers could share their memories of performing work in ways that had to draw on the imagination, because they had to conjure looms and machinery absent from the workshops.

The research design for the Intertwining Threads project that artist Catherine Bertola and I produced with the Bailiff Bridge community in the summer of 2021 was partly nourished by latent forms of affective energy found in the research for this book. In what follows I mine previous chapters to examine how the motif of the textile worker body and affective and embodied feelings of nostalgia and solastalgia played a part in the design and process of our artmaking workshops.

Affective energies

The textile worker body

Catherine and I drew on historical images of the body of the carpet maker. Historically, the textile worker is relatively scarce in representations of industry. Tim Strangleman, for example, suggests that the industrial worker was 'lionized' by the 1930s Documentary Film Movement.[14] Guided by European socialist realism, it rendered 'heroic' the bodies of heavy manual labourers in coal, steel and shipbuilding. The textile (often, though not always, male) worker, often involved in machine operation such as looms or more craft-based

filigree labour which requires fine motor skills, is less historically present. It is also the case that many textile industries – from clothing[15] to carpet making – employed predominantly female workers.[16] Female machine and craft-based workers were relatively marginalised across images which lauded heavy manual work, 'entrenched with notions of masculinity'.[17] In the knowledge that deindustrialisation studies has tended to follow suit, our work was designed to answer Arthur McIvor's call to usher in more focus on the body.[18]

I found the twentieth-century carpet-making body in the archives. The presence of the body of the carpet fitter, expertly demonstrating how *Firmoda* could solve the difficulties of the visible carpet join in 1930s leisure buildings, such as cinemas. Challenging the idea that weaving was a male preserve, a female weaver was selected for the Firths 1951 Festival of Britain brochure. She stands at a Platt Bros. loom in the 'Hall of Production', her hands resting on the carpet pile as the loom emits the weave. Black and brown textile-making bodies are shown later in the twentieth century inside in-house magazine *Trim Lines* (1985–1987), where workers from India, Jamaica and Pakistan are shown operating their looms. Such images were taken from across a variety of employee roles across factory production, from weavers, creelers, setters and menders are important for historicising the importance and value of the gendered, classed and raced carpet-making body.

Catherine and I became fascinated, as we perused the cache of photographs ex-workers showed us at the start of the project, with the embodied and affective aspects of carpet factory work. Interviews with workers showed the corporeal vocabulary worker bodies enacted: hand gestures – central to the intricate work of weaving, handling yarn and specialist tools; handling weight – of the whole body as it negotiates machinery and carpet or of the texture of working with the surface of carpet; and rhythm as work was done with looms in time with colleagues. We wanted to harness and utilise the energy of this suite of well-worn worker actions encased in the photographic motifs we examined for use in this photographic project.

Corporeal nostalgia

Nostalgia helps people to cope with loss. Interviews with ex-workers demonstrated how crucial practices of nostalgia were for providing

Hopeful re-making and the power of art 187

opportunities for them to come to terms with loss of the workplace of Firths intertwined with Bailiff Bridge as a workplace village. Working without machinery in the workshops, workers drew on their 'mnemonic imagination' and drew on the creative role of imagination through remembering while using their experience and its interaction with memory. In this way, memories returned like fragments and remembering workers used imagination to generate a sense of a coherent life-identity as carpet workers.

Most striking for the purposes of the Intertwining Threads project were the instances where powerful forms of bodily remembering came into play in worker interactions with photographs. The work of historian Michael McNeill is apposite here – he looks at historical and cultural examples of how working in rhythmic synchronicity with others produces positive affects which promote powerful bonds in worker communities.[19] When Hilda looked at the photograph of herself in the setting in the mid-1960s she recounted vivid memories, some 50 years on, of the potent atmosphere of working in rhythm to shared singing.

Hilda was by no means the only worker to feel the call of latent energy which gave them the sense that they could fire up machinery and return to carpet making. These interviews showed that corporeal memories of work performances remained lodged in the tissues of the body long after the work had ceased. Later, I detail how we used worker memories in the workshop setting, where we sought to capture and use these potent forces of worker energy in the photographic project. The particular energy they carried had the potential to reach out and 'pass on' hand gestures in ways that urged potential synchronicity with newcomers – so this aspect of the research held a potential to bond with others through working rhythms.

Solastalgia

The experience of navigating Bailiff Bridge is an issue for ex-workers. Being in the village had become topographically very different for them. Blackened mill buildings and weaving sheds had given way to pale-brick new-build housing. The aroma of wet wool was replaced by traffic fumes. Inter-relational workspaces providing opportunities for sharing, which made workers and residents feel 'held', had been

smashed down. Indeed, the research revealed that the distress resulting from spatial change meant that the temporal dimension of nostalgia was inadequate – because nobody wanted to go back in time – for understanding the trauma of an unrecognised landscape. Bodies that were in place, felt out of place. Solastalgia set in because the architectural framework of a once-known village was erased, disordered, 'not right', such that home was unrecognisable.

These research findings shored up unresolved matter productive of 'revenant energies'.[20] These themes of the research were ghostly: bathed in what Avery Gordon calls a 'seething presence'[21] of the injustice that comes from a lack of consultation about one's place in history, work and home. It is to the idea of social haunting and its efficacy for the art project that this chapter now turns.

Uses of social haunting for ex-industrial communities

Avery F. Gordon's notion of 'social haunting' is a fecund idea for thinking about the harms and the potentialities of deindustrialisation. For Gordon, sociological writing has overlooked the unseen and the banished. Concerned with banishments, her book *Ghostly Matters: Haunting and the Sociological Imagination* asks that the reader question why practices of social disappearance force things to the margins.[22] We must, she argues, try to foster new ways of developing knowledge about the people, objects and ideas that our social systems seek to expel. For her, the 'forced disappearance' of the social continues to cast a shadow over the present: 'Haunting is one way in which abusive systems of power make themselves known and their impacts felt in everyday life, especially when they are supposedly over and done with'.[23] As such, forms of '"disqualified", marginalized, fugitive knowledge from below'[24] morph into 'phantoms of modernity's violence' which refuse to settle. It is the task of sociology to creatively engage the apparitions and deal responsibly with what remains.

The ghosts Gordon describes patrol houses, bodies, institutions, whole societies; what they contain is a form of 'knowing' which is fastened to both history and social effects. Hauntings can present as 'muted presences', particularly when the abusive power system continues to motor on.[25] Ghosts demand attention. Only by

apprehending what Janice Radway describes as the 'density, delicacy and propulsive force of the imagination',[26] and by being attuned to the kernels of knowledge carried in ghostly matters, can 'a new way of knowing the world' create a more just society. Gordon seeks an agile sociology that can 'hover above the ethnographic ground'[27] in ways which can attend to the affective, the socio-political and the experiential. In this way, the transformative potential of listening and conversing with ghosts can augment political change. For Gordon, haunting is distinguishable from trauma; it leaves 'something to be done'. It happens when domains become discordant: 'when something else, something different from before, seems like it must be done'.[28]

Writers in deindustrialisation studies have made fertile use of Gordon's metaphors. Geoff Bright found that Northern former coalfields blighted by economic precarity were pervaded by a '"ghosted" affective atmosphere'.[29] The closed coalfields were re-activated by a macabre festival celebrating Thatcher's funeral which acted to shift recalcitrant youth towards making intergenerational connections. The event marked a sea-change by re-instating working-class, intergenerational, relational ways of living through intense loyalty, humour and collective commitment to others. In this way the 'ghostly affective atmosphere' could no longer be suppressed – the event triggered a return to 'neoliberalism's nemesis' – a return to living relationally.[30]

In her book, *Social Haunting, Education, and the Working Class*, Katherine Simpson describes ethnographic research in a school in a Sheffield mining community against the backcloth of Thatcherite, neoliberal policies.[31] Ghosts are metaphorical containers: carrying malign features from the industrial past or resources of 'goodness' to ignite future hope. For Simpson, how ghosts haunt depends on how they are managed. Key historical events – the Miners' Strike, the battle of Orgreave – made the malign ghosts which haunt the air. Simpson argues the school acts like a 'containing skin': a post-trauma safe sanctuary. Acting as custodians of this safe space are a group of working-class proletarianised teachers. Cognisant of the history of the use of authority to quell violence in the region, they avoid authoritarian practices which 'give sustenance to ghosts … that harbour social violence and conflicts of the past'.[32] Rather, the staff enable the nurturing of the 'goodness' of ghosts. For example, Simpson found the language of trade unionism in teacher and pupil

interactions as a way to manage pupils with affectionate humour. In this way, language containing the history of the community's industrial mining past lives on intergenerationally within the security of the school.

Lars Meier investigates the haunting workers experience after closure of a steel works in the German state of Bavaria. His focus is on the haunting capacity of the material objects and structures housed in the built environment of former buildings, machinery and workstations, but he inserts the body and movement into what characterises workplace attachment; it is 'structures, rhythm and atmosphere' which are central to a 'place-related worker community'.[33] Drawing on David Seamon's concept of 'place ballet', Meier draws attention to the ways in which individual workers understand their place as 'part of an environment where such individual time–space body routines comingled with a larger dynamic of interactions between several such individual time–space and body routines'.[34] Meier's respondents are haunted by a painful nostalgia for the embodied experience of the routine of moving through buildings and working rhythmically with others with or without machinery.

Across these deindustrialised case studies negative haunting inhabits buildings, pervades the atmospheric acts as a contagion in groups of young people or clusters of workers, or lies painfully dormant in muscles that are prevented from moving again with others. Negative ghosts hang, feeding stubborn, tight feelings, emitting noxious affects and nourishing inertia. When ex-worker Maureen led her researcher on a walk-and-talk tour across Bailiff Bridge she was literally immobilised. Practically by the ruination that had smashed down common pathways through works buildings; but also by an affective tightness of the chest, an inability to move through a disordered landscape. When one of haunting's key affects merges with the affective longing of solastalgia a doubly powerful meld can take hold; both are activated by a sense of injustice because nobody had bothered to ask how the experience of deindustrialisation felt. In this way unresolved matter 'hovers over the ethnographic ground'.[35] But if ghosts are listened to and managed by positive circumstances they can also be assuaged, calmed and navigated through useful channels; once their grievances are heard and acknowledged their pregnant energies can be harnessed to become a surface with the potential to fuse with new surfaces to promote community healing.

Back to the workshops

We wanted to set our work with the Bailiff Bridge community within a history of hand gestures, from the sign language of the deaf to Indian Kathak dance, which enabled access to movement, meaning and emotion. In this way, we wanted to encourage the still latent affective history of the rhythms and movements of working together in synchronicity in carpet manufacture to be performed. Like learning a dance, the idea was that gestures would be passed on to the newcomer like a piece of choreography. Along the journey, the potential for a conversation about the factory, history of place and the skills of carpet making would open up. The workshop spaces were conceived as improvisatory; designed to allow 'ghosts to speak', they were open to non-representational haptic, aromatic and atmospheric memories.

The thick smog of Coronavirus pervaded Calderdale, as it did over much of the UK, just as our project was set to roll out. I already had access to a wide group of Firths ex-workers, but reaching the newcomers posed a challenge. At first posters around the village informed newcomer residents of our workshops. We began by placing posters about the project at various sites in Bailiff Bridge: the community centre and in local shop windows around the village. The poster offered potential participants the opportunity to learn about the industrial history of their village, to be involved in artmaking and meet new people in the process. But this strategy gave just a handful of interested but not committed enquiries.[36] After some thought, we settled at last on leafleting the hundreds of new homes that had been progressively built over the 'tufted' weaving sheds, the dye house and the works canteen. In all, we leafleted around 450 pale brick, more recently built homes. Placing older people first on the government roll-out of the vaccine in the spring of 2021 likely enabled Firths workers to feel more confident about coming forward. Certainly, workers far outnumbered newcomers. But by July 2021, we had two workshops in place.

The workshop roll-out

The first workshop was designed to kick-start the *process* of providing a shared discussion space to tease out memories of working life at

Firths. Catherine had prepared a folder of images of Firths and Bailiff Bridge to stimulate discussion.[37] Patiently, and with nodding reassurance that she was watching and listening intently, Catherine led the workshop discussion. Interestingly, workers departed almost immediately from the images folder; they already had a storehouse of memories close to the surface for recall. It did not take long before the workers gesticulated as they spoke – an obvious entry point to ask more specifically about the hand gestures of carpet making. As Catherine wrote afterwards, ex-workers: 'described their experiences of working at Firths so vividly. As they talked their ageing bodies would begin to move, recalling the actions they repeated numerous times on a daily basis, in some cases over many years.'

As part of the process, the newcomers drew on ex-worker knowledge about the former layout of Bailiff Bridge – asking for descriptions of where the mills had stood. They responded, for example, with incredulity when they learned that the length of Victoria Road – now built over with new buildings – had been entirely occupied by Victoria Mills. Cognisant that they were witnessing a re-making of community as workers swapped memories, they watched with fascination as workers began to bodily articulate carpet making using their hands and bodies.

Stimulated by the discussion from workshop 1, ex-workers found the confidence to *perform* their roles through particular movements. Workers brought photographs of the village, of Firths buildings, samples of carpet and in some cases the specialist tools they had used to enact their roles. As Catherine elaborates:

> Lynne sat in her armchair, describing the process of winding, holding invisible hanks of wool in her hands, her arms performing an elaborate *port de bras* as she moved the yarns from one arm to another before placing it in front of her on the machinery she had conjured up in her mind's eye. Meanwhile George explained in intricate detail, the process of setting up and running a loom, at one point quickly grabbing his imaginary pliers to demonstrate how he would terrifyingly thrust his hand into the moving loom to adjust an errant needle, timing it to perfection before the shuttle came flying back across the room.

Participants recognised each other and an atmosphere of friendly exchange took hold as hands gesticulated while the vocabulary of carpet making was recalled. Newcomers keen to learn about the industrial heritage of Bailiff Bridge listened and were guided through

Figure 4.1 Workshop 2: an ex-worker passes on the knowledge of tying the weaver's knot to newcomers, 2021. Author's photograph.

descriptions of the use of yarn and machinery, and through these mutual exchanges, conversations deepened. Then clusters of ex-workers began to show newcomers the process of mending and how to tie a weaver's knot – an essential first stage in the learning process of becoming a weaver at Firths (see Figure 4.1). These processes drew on practices of improvisation from both sides of the community – both found themselves in new settings with people they had never met, yet community members were able to adapt to a new conversation with a fresh set of contingencies. A professional photographer accompanied Catherine to record the fine motor skills of carpet making and document the passing on of these gestures. In this way the participants understood that their hands and their movements were the subject of photographic art (see Figure 4.2)

The Intertwining Threads series

Catherine produced a series of nine photographs which displayed individual workers' hands using the gestures of carpet making

Figure 4.2 'Passing on' is captured in photography, 2021. Author's photograph.

(Figure 4.3).[38] All nine were exhibited in the Boardroom. Significantly, one of them features an ex-worker and a newcomer passing on the skill of tying a weaver's knot – Figure 4.4 shows this piece in the middle of the photograph.

Below Catherine discusses how the project segued with her concerns as an artist and the particular reason why living hands were so central to recording the knowledge which inheres in ex-industrial worker bodies:

> As an artist I am interested in making work that gives voice to untold narratives, using archives and historic collections to excavate the past to confront persistent contemporary inequalities. Here I was faced with a history much closer to home, and a group of people whose embodied memories became a living breathing archive from which the past could be accessed in full technicolour, along with an understanding of their present relationship with place.
>
> The resulting photographs produced in collaboration with the community, sought to capture the ageing hands of the ex-workers both re-enacting the process of making and using tools and sharing

Hopeful re-making and the power of art 195

Figure 4.3 The series 'Intertwining Threads: Valuing Labour, Re-Making Community' was displayed in the Boardroom at Clifton House. Artist: Catherine Bertola. Workshop photography: Simon Warner. Exhibition photograph: Nick Singleton. Reproduced with permission from Nick Singleton Photography.

skills with new residents. The focus on people's hands felt particularly pertinent, given the project was carried out under Covid restrictions. Touch was prohibited for fear of transmission of the virus, and hands became more important in communication, helping to convey meaning while faces were obscured by masks. The focus on hands was also a way of expressing the importance of human labour within the factory, with many hands of ex-workers visibly affected through years of handling wool, some pictured holding the tools saved from their time at the factory, repeating the movements of their old profession. The compositions of the photographs drew on centuries of art history in which hands have been depicted with care, often holding valuable objects or clothing, in particular gestures to express wealth, status, emotions, piety or profession. As Ethel J. Alpenfels reminds us: 'In the creative arts, the hand speaks, and one senses the tremendous power of the hand to convey human emotions. The hands are the organs of the body which, except for the face, have been used most often in the various art forms to express human feeling'.[39]

Figure 4.4 Intertwining Threads – Angela and Rebecca, 2021, digital prints, 24 × 16". Centre: Angela (ex-winder) passes on the skill of the weaver's knot to newcomer Rebecca. Artist: Catherine Bertola. Workshop photography: Simon Warner. Exhibition photograph: Nick Singleton. Reproduced with permission from Nick Singleton Photography.

The photographs carry a sense of contemporary fashion, the use of nail polish and of adornment of the arms and hands using jewellery accrued over the life of the wearer (see Figure 4.5).[40] But the gestures which reside in the tissues of the flesh, presumably acquired before objects and decoration were added, are re-activated. In Lars Meier's work, the nostalgia he witnessed in the muscles of the workers he interviewed was tight and somehow trapped through inactivity. But here the demonstration of movement is relaxed. The use of black background and clothing forces the viewer to look solely at the hands and arms. The camera caresses the weight of the flesh on the arms, the chiaroscuro of the folds of the skin, as Catherine observed, 'visibly affected through years of handling wool' and the skilful dexterity of suggested movement. Given the aesthetic beauty of these limbs it is no wonder Rudolph Laban drew on the graceful movement of the industrial body for use in dance.[41]

Figure 4.5 Intertwining Threads – Karen, 2021, digital prints, 24 × 16".
Artist: Catherine Bertola. Workshop photography: Simon Warner.
Exhibition photograph: Nick Singleton Reproduced with permission
from Nick Singleton Photography.

But the representational strategies we used to celebrate and commemorate the labour of carpet makers also raise questions. Might there be a danger that beauty might eclipse the suffering of labour or the losses of deindustrialisation that Firths workers experienced? As Arthur McIvor argues in his work about the corrosive, traumatic dimensions of ill-health caused by deindustrialisation, there is a danger that nostalgic representations neglect the multi-faceted impacts industrial work had upon worker bodies'.[42] My earlier ethnographic research with these workers revealed industrial injuries: breathing problems from jute which hung in the air and settled on cups of tea in the weaving sheds; deafness from spending hours with noisy looms in the weaving sheds; and accidents with machinery that maimed bodies.[43] When one weaver walked into a focus group and shook my hand, I realised he had just two fingers and a thumb left after a loom accident. Office workers, thought to operate the less harmful machinery, were also at risk. When a wages clerk held up her hands in a focus group, her fingers splayed permanently outwards, from

years of repetitive work on a comptometer, the first commercially successful mechanical calculator. Writers on deindustrialisation remind us of the physical and mental harms of industrial work.[44] Cognisant of workers' physical and mental injuries, it was not our aim to sentimentalise or 'air-brush out' suffering. Following McIvor's call for researchers to 'allow people to speak for themselves', we found that, on balance, the ex-workers of the Firths' community wanted the good memories of their working life to be central in the workshops. In this way, we argue that these photographs answer Arthur McIvor's call to produce a 'sharper focus on the body'.[45] He advocates using oral testimony where workers 'bear witness' to effects on the industrial body. Our work pays homage to the affective history of those bodies. Here we use aspects of the worker body which lie outside language: non-verbal physical movement and gesture to advance research beyond voice in relation to the worker body.[46] First, as a counter to the focus in deindustrialisation studies on heavy manual work, 'entrenched with notions of masculinity', we sought to shine light on the particularities of the textile worker body. And secondly, to represent lived experience of female textile workers arguably under-represented in the field of deindustrialisation studies.

Discussion

Improvisation as process

Drawing on Elizabeth Hallam and Tim Ingold's anthropological work on creativity, I want to explore the process of the works and the workshops through the idea of improvisation.[47] Hallam and Ingold argue that quotidian social and cultural life is unscripted. Challenging modernity's conception of creativity – often the selling point of consumer products – as unique and created by an (exceptional) individual whose work marks a disjuncture with tradition, they contend that creativity inheres in the act of 'working things out' in the midst of life's contingencies. Challenging what they call the 'backwards reading of modernity' which seeks focus on *products* of innovation, Hallam and Ingold argue for collective, relational processes made in concert with the actions of others, made from the existing materials of our environments created not as a radical

Hopeful re-making and the power of art

break with tradition and convention, but as part of the existing 'onward propulsion of everyday life'.[48] Social and cultural life is 'crescent rather than created', always 'in the making', as people carry their histories and traditions from their predecessors as they propel forward in the act of carrying on.[49]

In this vein, we sought a 'horizontal' approach as collaborators facilitating the outline of the open space of the workshops. In this space participants made agile, tactical communicative decisions to open conversations with strangers who had place and community in common. In the anthropological vein Hallam and Ingold propose, our art materials were drawn from the living, quotidian, raw community: hands – drenched with ghosted energetic memories of the rhythm of work. But it must be remembered that these movements were the effect of industrial training which was a highly disciplined regime. Recollecting the processes of these gestures years later outside the original context of carpet production is an improvisatory act, but they themselves originate from within industrial capitalism. Those hands were adjusted, poised in filigree gestures and used in conversation and through movement to relate to newcomer hands. In this way, our primary focus was the fecund potential to build relationality through the workshop process. What mattered to us was the dynamic potential of the creative improvisation of 'Real people, as the living organisms they are', who 'continually create themselves and one another forging their histories and traditions as they go along'.[50] But in forging such relationships, we realise that these connections could not be thought of as wholly voluntaristic – unhooked from the context in which they were acquired within industrial capitalism. Ex-worker bodies and their attendant limbs were shaped by the power relations into which those bodies were inserted – and it would be impossible to ascertain a distinction between 'authentic' movements and the taught, habituated acts of cultural accommodation. What we invested hope in was the idea of an active, ongoing process of starting relationships that are still being grown. As Hallam and Ingold argue: "People make themselves is to say that they not only *grow* but are *grown*, in that they undergo history of development and maturation within fields of relationships established through the presence and activities of others."[51]

The 'fields of relationships' that Hallam and Ingold refer to here include coercive power relations in play during industrial production.

The 'presence of others' in the workshops might include the memory of the apprentice trained to move the body in circumscribed ways by a supervisor. As this chapter noted earlier, the labouring textile body can be marked and maimed. Or it can bear marks invisibly through habituated repetitive movement. Our workshops wanted to recall and commemorate the history of these power relations.

Non-representational dimensions

The workshops were mobile, bodily encounters which operated not just visually, but also along 'sensory, bodily and affective registers'.[52] As a first meeting, it may have introduced a soft feeling of slight vulnerability which likely made for a more porous relationship between ex-worker and newcomer.

The performance of recalling working gestures evoked scenes which were quite moving for the onlooker. Catherine's description recalls the graceful performance of Lynne's handling of yarn through movement which was witnessed, experienced and passed on to other bodies in the space of the community centre. Watching Lynne's arm movements and facial concentration meant that others could viscerally sense the embeddedness of her experience and her embodied intelligence about how carpet was made. In this way the workshops held a multisensory dimension.

It was also the case that the workshop was pervaded by a felt micropolitical power dynamic. Firths ex-workers felt valued as their lost skills were re-awakened and made front and centre in the workshops – they were telling of their experience, and this made them feel powerful in their knowledge.

In this way there was a re-appropriation of embodiment previously disciplined by work practices; here skills and knowledge – laid off by closure – are re-deployed and showcased. The respect paid by newcomers who listened and followed was also tangible. In this way an atmosphere of mutual respect was built.

Workshops and artmaking: aiding community cohesion

The workshops were about commemoration and signified a paean to the value of labour. Their aim was to build a respectful conduit

for opening up a conversation. Essentially, our central aim was to bring ex-workers and newcomers together to pass on skills of carpet making: the 'weaver's knot' became symbolic of tying the community together. But the workshops had a broader aim: I argue that a key contribution of the project was that it used artmaking as a 'horizontal' method for working with community to encourage cohesion. In practice, the workshop made space for conversations about shared ground to work for good social relationships in a village so that ex-workers would feel seen, acknowledged and their identities understood, and so newcomers could learn something of their place and put roots out to existing inhabitants.

Questions of community cohesion gained increased visibility in policy debates after violent clashes in Bradford, Burnley and Oldham between young white and Asian men in the summer of 2001. Mike Makin-Waite's work as a council worker promoting good race relations following these disturbances forms the focus of his book, *On Burnley Road*.[53] Arguing that brewing resentments in ex-industrial Burnley form the context for the rise of the British National Party and a shift to populism, he discusses the value of making space for shared ground using 'mundane encounters with difference' through a discussion of Paul Gilroy's 'convivial cosmopolitanism'.[54]

While Makin-Waite and Gilroy are concerned with supporting conversations to identify 'shared ground' across racial difference, the work we did was tied to associational cohesion. This type of cohesion, as Ben Richards argues, is about the quality of interaction between people in terms of interpersonal communication and cultural activities which promote a common sense of belonging to locality and a sense of place.[55] Yet the practice Makin-Waite advocates – that of finding routine interaction across diversity in everyday doings – helps build a sense of resilient 'capacity to live together' such that people can negotiate racial, ethnic and cultural differences. For Gilroy, what he calls 'convivial cosmopolitanism' is not just for higher-class groups endowed with cultural capital. Indeed, practising convivial relationships helps shift deep-held cynicism about the multicultural potential of Britain. Our work sought to build on this idea, especially in relation to differences across life experience of work and community across differences of age. The workshops did generate convivial conversations about the history of place, carpet making, the skill

of hands and the camaraderie of factory work, and made ex-workers regain a sense of pride.

Pitfalls of the workshops

While I have argued for the resounding benefits of this bespoke community activity for an ex-industrial 'dormitory' village, conducting the project was far from problem free. Even when I began the project back in 2016, at a stage when I was working only with Firths ex-workers, some had no interest in taking part. Working at Firths was in the past and some people wanted it to remain there. Others harboured negative feelings towards what they felt the company had become: a firm that had been forced to surrender its traditional, paternalistic values in the takeover by the multinational concern, Interface. Other writers on deindustrialisation have made similar arguments. In *One Job Town*, Steven High notes that ex-industrial community members do not always wish to participate in commemorative projects.[56] It is problematic to assume that they should or will take part.

The other issue concerned the moment we tried to get the project off the ground. Fear of Coronavirus and government lock-down during 2021 made any kind of community event unattractive. A Gov.uk report in Spring 2021 documents a moment when the country began to come out of its second lock-down at the beginning of March, but government restrictions meant 'obeying the law; staying at home; getting tested when needed; isolating when required, and following the "hands, face, space" and "letting fresh air in" guidance'.[57] The encouraged safety practices created cultures of 'staying home' that some found difficult to break even as waves of lifted restriction came into play. By July 2021, when the workshops took place, participants were likely to have based their decisions on whether to attend on the pervading 'stay at home' culture.

But the most enduring and worrying issue was that the people we were hoping to reach the most, the relative 'newcomers' who occupied the new-build housing, were reluctant to come forward. Leafleting, the predominant way we used to try to reach participants, with its promise of a £20 gift voucher, was not an effective strategy. The black-and-white leaflets advertised the chance to 'learn more about the history of your village', and promoted workshops as

places where participants would 'have the opportunity to be involved in the artwork that will commemorate the pride of carpet making at the centre of Bailiff Bridge'. The poster used black-and-white photographs of female workers in Firths' winding department in the 1940s and promised: 'safe and socially distanced workshops led by a local artist'.

But our melange of local history, industrial heritage, 'vintage' mid-century nostalgic photographs of working life and a chance to be involved in artmaking failed to enlist many newcomers. Perhaps yet more significantly, neither did the community appeal, 'Are you interested in meeting new people?' bring anything like a significant number forward. As a result, ex-workers far outnumbered newcomers in the workshops. In fact, we only managed to enlist two newcomers, a staggeringly low number.

One question might feasibly be: what was in it for the newcomers?[58] Perhaps our assumptions, that local history, being involved in art or community meet-ups would interest newcomers, were misguided. Certainly, it is possible to establish that this group were not as connected to the locality of place in the 'traditional' way that ex-workers were. We know that many of them were commuters, making their way out of the village to work. It was also likely that they were at least partially digitally connected to social networks on national and international scales. But taking these differences into account, one thing was sure: we needed an audience for the exhibition.

Further strategies for community involvement

This lack of interest within the 'newcomer' section of the community meant we had to re-think our strategy. Given that leafleting proved ineffective, what other avenues of involvement could the project tap into?

We decided to organise a suite of further activities aimed at the Bailiff Bridge community which took place at Bailiff Bridge Community Centre from mid-October to mid-November 2021 under the auspices of the Intertwining Threads project, with the same aspiration to bring different community layers together. Outside the community centre, 'Weaving Stories' was an intergenerational event where people told stories about Firths and factory life over pie and peas; at 'Weaving Families: Half-Term Halloween Craft

Activities' ex-worker volunteers helped children and parents make woven pumpkins. 'Weaving Families: Tour of Calderdale Industrial Museum' allowed volunteers, often ex-workers from the region, to demonstrate industrial machinery operation;[59] while 'Explore Firth's Archive' took place at Bankfield Museum, where the main collection is held.

These events were advertised in a leaflet but to reach both sides of the community we decided that our most effective means of reaching the newcomers was to introduce the project to local children at Bailiff Bridge Junior and Infants' School. Our idea was to stimulate interest among the children: partly through the leaflet going home in the school bag, but also by awakening interest by stimulating existing links to family members who worked at Firth Carpets.

I attended the school in the early 1970s. As an alumna, I approached the headmistress and asked if I and my research assistant could come into the school to run a classroom talk and activity. Primary school-trained in aspects of the national curriculum, our research assistant Zoe Moreton was able to work with me to organise a dialectical lesson plan.

In half-hour sessions designed to work across each year group, we began by using a commemorative stained-glass window, sited in the hallway of the school, which carried the company name 'Firths'. This became an important starting point for unearthing intrigue about the importance of place and of connection through family members – grandmothers, uncles – who had worked there.

Once pupils had been reminded of Firths, I told my own story of living in Bailiff Bridge, of attending the school and of my family working at Firths. We then used an interactive strategy by constructing a series of puzzles that pupils had to problem solve juxtaposing archive materials of the geographical transformation of the village, from a place largely dominated by Firths works, to contemporary photographs of new-build housing over the once-mills. We showed a picture of the undeveloped tract of land where Clifton Mill once stood and asked students to contrast it with images of the building in the late 1890s. We showed images of workers managing machinery: both male and female weavers at their looms; 1920s advertising from the archive featuring carpets that were once made literally yards away from where we sat in the classrooms. Finally, we shared (with permission) a poem written by an ex-worker reflecting

on the final closure of Firths. Using this melange of images and themes we were effectively laying the foundations for learning about the key tenets of deindustrialisation by asking the pupils to relate their own history of place to the transformed geography of their village. Pupils at all levels were intrigued; they shot their hands up enthusiastically and several of them mentioned family members who they had heard mention had 'worked at Firths'. We encouraged the children to take part in the suite of events and handed out the programmes – which were designed as keepsakes as much as an aide memoire of events. That day, as we were leaving the school, a mum mentioned to me as I was walking past, 'I'm hearing your life-story here, apparently your mum used to work at Firths'. This felt like evidence that we had made an impact. The hope was that the changes in the village as a result of deindustrialisation would become a talking point and that engagement would move from children through to adults.

The Intertwining Threads exhibition

The series hung in the wood-panelled Boardroom where the most important management decisions about the direction of the company would have been made, in one of the only remaining Firth Carpets Limited buildings – Clifton House. The building is now rented out to small businesses, including Firth.[60]

For ex-workers, walking from the entrance of Clifton House through the lobby to the winding staircase with its polished wooden handrail would be significant. This staircase led to the offices of the managing director, senior managers and white-collar workers; to climb these evoked the aura of a different class register. To be asked to report to the managing director's secretary, who had a desk in the spacious foyer across from the Boardroom, as creelers and weavers mentioned in the focus groups and interviews, often meant a chastisement. The entrance and stairs had radically altered: the unmistakable smell of wood polish had disappeared, there was no luxurious Wilton carpet adorning the stairs and the foyer was run down.[61] But, despite its altered state, to climb the stairs on this occasion as an act of commemoration using this space to celebrate the quotidian hand movements of carpet making transformed the meaning of the space.

Catherine Bertola and I, with a handful of enthusiastic ex-workers, most of whom had lent their hands to the workshops, curated the exhibition. It ran for a week from 12 noon to 4pm daily. In all, the exhibition received around 80 visitors, 70% of whom were ex-Firths workers, with 10% people interested in culture and local history, and the remaining 15% families who had heard of the project through the distributed programme. Having the ex-workers as curators was a huge advantage. They explained the context of the site of the exhibition, and discussed how the pieces were made and why the weaver's knot was an essential basic for working at the factory. At other moments they provided a friendly ambience – and hung around with visitors to share stories and memories as well as plans for the future.

Reception of Intertwining Threads

How the exhibition was received raised some interesting questions. The visitor's book, where people were encouraged to 'feel free to remain anonymous', brought some enlightening insights. One of the responses was clearly from an ex-worker who had taken part in and enjoyed the workshops, 'bringing back to life the old days and the sense of community in our factory'. Another ex-worker commented on the grace and beauty of the hands portrayed in the photographs which enabled the worker to positively transform their own sense of the value of their working hands: 'Shows artistically the different ways the hands work as they do their everyday jobs and brings an elegance to them ... We didn't see this as we did our jobs in the mill and this brings a new perspective'. I return to this point in the following chapter, but this response testifies to a re-visioning of the working textile body which, in the context of the project, stands distinct from the context of the relations of exploitation. Others enjoyed the use of ex-workers as curators – 'the exhibition was brought to life by George and Alan who generously shared their stories' – and another enjoyed the live backing-track of worker stories to accompany their viewing: 'interesting to hear the mill workers who had worked here in the past talking among themselves and bringing back memories'.

But in other places, comments hinted at requirements for a more functional aesthetic which offered a more literal and informative

account of how carpets were made by workers. While one response complimented the art as a 'creative idea', it also asked to see 'a video/film of the factory in action'. Further critical analysis was offered by another viewer who asked for a wider variation of roles to be included, 'of winding, weaving and finishing depts' adding, *to make it more understandable perhaps*. These comments are significant because they reveal a need to place function – the usefulness of the image – above a celebration of form. Here form – the beauty and grace of the weight of the flesh and the use of the limbs – takes precedence over an image which offers more functional information about how carpets are made. For Pierre Bourdieu, photography, as a middle-class practice, is largely class determined; for him these readings show class-inflected differences and for the working-class workers these images are less 'understandable' because they lack attention to function.[62]

Choices about how to represent complex working communities must by their nature be beset by difficulties; indeed, it is an irresolvable conundrum. Ultimately we chose to show the dynamic, nostalgic, affective drive towards celebrating the working lives of the Firths community using able-bodied ex-workers. We chose this as an incentive to pull in the new layers of the community to create a social glue, in the hope that culture, local history and geography, camaraderie, craft and photography would produce ways to generate community adherence. We chose the form of the hands and arms to represent their grace and skill, over their function. We did so because we knew that an embodied conversation through movement could happen, though in doing so, we had to leave out whole swathes of worker knowledge.

Conclusion

It is here that I want to go back to where I began, to borrow from ideas about healing in medicine at the start of this chapter. GP Gavin Francis argues that healing is an active process which requires guidance. It must pay respect to the process of healing using time and energy to build a programme of rehabilitation which includes a measured and slow pace, carried by movement and rhythm. Guidance in recovery should, where possible, 'work in concert with natural

processes'.[63] In this way, doctors, he suggests, should be conceived more like gardeners, for the stitch used to join the tissue is not in itself the healing mechanism but 'simply a trellis to guide the body in its own work of healing'.[64]

While it was beyond the scope of artist's workshops to cohere an entire community, the use of improvised movement and rhythm did provide the trellis to bring the vibrancy of ageing once-Firths workers into respectful social engagement with people previously thought of as disinterested strangers. And so together two halves of the community attended the Intertwining Threads exhibition of photographs displayed in Clifton House. In this way, the exhibition gave admission to the labouring hands of men and women to a space they had rarely – if ever – occupied, to make visible and commemorate the lost labour of carpet making in Bailiff Bridge.

Notes

1 G. Francis, '"We Need to Respect the Process of Healing": A GP on the Overlooked Art of Recovery', *The Guardian*, 4 January 2022, available at: www.theguardian.com/world/2022/jan/04/we-need-to-respect-the-process-of-healing-a-gp-on-the-overlooked-art-of-healing 4/01/2022 (accessed 9 February 2025).
2 S. Lee Linkon, *The Half-Life of De-industrialization: Working-Class Writing about Economic Restructuring* (Ann Arbor, MI: University of Michigan Press, 2018).
3 L. Taylor, 'Landscapes of Loss: Responses to Spatial Change in an Ex-industrial Textiles Community', *Sociological Research Online*, 25:1 (2019), 46–65.
4 Clifton and Bailiff Bridge MSOA profile, Local Government Report, available at: https://dataworks.calderdale.gov.uk/dataset/calderdale-msoa-demographic-profiles (accessed 16 November 2021).
5 Mid-career fellowship from the Independent Social Research Foundation, titled 'Landscapes of Loss: Re-valuing Labour, Re-making Community', was a collaborative project with Catherine Bertola. It ran from January to December 2021.
6 V. Walkerdine, 'No One Listens to Us': Post-truth, Affect and Brexit', *Qualitative Research in Psychology*, 17:1 (2020), 143–158.
7 L. Back, *The Art of Listening* (London: Bloomsbury, 2007), p. 8.
8 Ibid., p. 2.

9 G. Bright, 'Feeling, Re-imagined in Common1: Working with Social Haunting in the English Coalfields', in M. Fazio, C. Launius and T. Strangleman (eds), *Routledge International Handbook of Working-Class Studies* (Abingdon: Routledge, 2020), available at: www.taylorfrancis.com/chapters/edit/10.4324/9781315200842-22/feeling-re-imagined-common1-geoff-bright?context=ubx (accessed 28 October 2022).
10 Ibid., p. 217.
11 Ibid.
12 A. F. Gordon, *Ghostly Matters: Haunting and the Sociological Imagination* (Minneapolis, MN: University of Minnesota Press, 2008), p. xvi.
13 Bright, 'Feeling, Re-imagined in Common1', p. 219.
14 T. Strangleman, *Voices of Guinness: An Oral History of the Park Royal Brewery* (Oxford: Oxford University Press, 2020), p. 14.
15 See A. Clark, *Fighting Deindustrialisation: Scottish Women's Factory Occupations, 1981–1982* (Liverpool: Liverpool University Press, 2023), where Clark analyses the resistance through occupation of the predominantly female clothing workforce. Female activism, he argues, has been radically under-researched.
16 R. Stride, 'Women, Work and De-industrialisation: The Case of James Templeton and Company, Glasgow, c.1960–1981', *Scottish Labour History*, 5:4 (2019), 154–180, available at: www.scottishlabourhistorysociety.scot/journal/category/2108 (accessed 10 February 2025).
17 A. McIvor, 'De-industrialization Embodied: Work, Health, and Disability in the United Kingdom since the Mid-Twentieth Century', in S. High, L. Mackinnon and A. Perchard (eds), *The De-industrialized World: Confronting Ruination in Postindustrial Places* (Vancouver: UBC Press, 2019), p. 29.
18 Ibid.
19 M. McNeill, *Keeping Together in Time: Dance and Drill in Human History* (Cambridge, MA: Harvard University Press, 1994).
20 Bright, 'Feeling, Re-imagined in Common1', pp. 213–224.
21 Gordon, *Ghostly Matters*, p. 8.
22 Ibid.
23 Ibid., p. xvi.
24 Ibid., p. xviii.
25 Ibid., p. xvi.
26 J. Radway, 'Foreword', in Gordon, *Ghostly Matters*, p. viii.
27 Back, *The Art of Listening*.
28 Gordon, *Ghostly Matters*, p. xvi.
29 N. G. Bright, '"The Lady is Not Returning!": Educational Precarity and a Social Haunting in the UK Coalfields', *Ethnography and Education*, 11:2, (2016), 142–157, p. 144.

30 Ibid., p. 154.
31 K. Simpson, *Social Haunting, Education, and the Woking Class: A Critical Marxist Ethnography in a Former Mining Community* (Oxford: Routledge, 2023), p. 31.
32 Ibid., p. 92.
33 L. Meier, 'Encounters with Haunted Industrial Workplaces and Emotions of Loss: Class-Related Senses of Place within the Memories of Metalworkers', *Cultural Geographies*, 20:4 (2013), 467-483, available at: https://journals.sagepub.com/doi/epub/10.1177/1474474012469003 (accessed 9 February 2025).
34 Ibid.
35 Back, *The Art of Listening*, p. 21.
36 The poster featured historical photographs of Firths workers and offered a £20 Amazon gift voucher as a thank you. Potential participants were assured that workshops would be safe and socially distanced.
37 The folder contained a variety of photographs of work, social activities and Bailiff Bridge both pre- and post-demolition.
38 Thanks to Nick Singleton for this photograph and the ones which follow of the Intertwining Threads project exhibition.
39 E. J. Alpenfels, 'The Anthropology and Social Significance of the Human Hand', *Artificial Limbs*, 2:2 (1955), 4–21, p. 14.
40 Photography at the workshop by Simon Warner.
41 D. Matless, *Landscapes of Englishness* (London: Reaktion Books, 1998).
42 McIvor, 'De-industrialization Embodied', p. 40.
43 Taylor, 'Landscapes of Loss'.
44 See Robert Storey's work on the effects on steelworkers in Ontario: R. Storey, 'Beyond the Body Count? Injured Workers in the Aftermath of Deindustrialisation', in S. High, L. MacKinnon and A. Perchard (eds), *The De-industrialized World: Confronting Ruination in Postindustrial Places*, (Vancouver: UBC Press, 2019), pp. 46–67. See also McIvor, 'De-industrialization Embodied', where he highlights the complex detail of health issues for mine and plant: the 'demanding, dirty, demeaning work' of industrial work which also gave tremendous dignity of purpose; yet the lowering of self-esteem at the loss of work and the mental stress in feelings of purposelessness.
45 McIvor, 'De-industrialization Embodied', p. 43.
46 J. Lorimer, 'Moving Image Methodologies for More-Than-Human Geographies', *Cultural Geographies*, 17:2, 237–258.
47 E. Hallam and T. Ingold, 'Introduction', in E. Hallam and T. Ingold (eds), *Creativity and Cultural Improvisation* (London: Routledge, 2009), p. 1.
48 Ibid., p. 2.

49 Ibid., p. 7.
50 Ibid.
51 Ibid., p. 10.
52 Lorimer, 'Moving Image Methodologies', p. 242.
53 M. Makin-Waite, *On Burnley Road: Class, Race and Politics in a Northern English Town* (London: Lawrence Wishart, 2021).
54 Ibid., p. 192.
55 B. Richards, 'In debates about Britishness, it is important to distinguish between two different types of social cohesion'. LSE Blog, 28 October 2014, available at: http://blogs.lse.ac.uk/politicsandpolicy/britishness-and-social-cohesion/ (accessed 6 March 2023).
56 S. High, *One Job Town: Work, Belonging and Betrayal in Northern Ontario* (Toronto: University of Toronto Press, 2018).
57 Gov.uk 'COVID-19 Response – Spring 2021' (Summary), 22 February 2021, available at: www.gov.uk/government/publications/covid-19-response-spring-2021/covid-19-response-spring-2021 (accessed 9 May 2022).
58 Colleagues at the 'Futures of De-industrialisation' conference in Bologna in October 2022 posed interesting questions about the 'newcomers'. Alistair Kifford asked what knowledge the project had about them in terms of their socio-cultural background around class, age and so on. While I was able to access data about the village, unfortunately the funding for the project could not stretch to providing more granular data about newcomers' understanding of Bailiff Bridge as a place or about their cultural interests.
59 At the visit a volunteer fired up a mochette loom. Mochette was a type of fabric suitable for upholstery used in train carriages and aircraft. It was produced at the Flush Mills branch of Firths in Heckmondwike.
60 Our thanks to Blackshaw Holdings Limited for donating the space of the Boardroom for the duration of the project in October 2021.
61 Indeed, when ex-PA to the managing director who spent many years at the desk in the foyer was taken back to see the stairs and foyer, she was appalled at its dilapidated state.
62 P. Bourdieu, *Photography: A Middle-Brow Art* (Cambridge: Polity Press, 1996).
63 Francis, '"We Need to Respect the Process of Healing"'.
64 Ibid.

Conclusion: a journey back to Bailiff Bridge

On Easter Sunday I took an afternoon drive down Birkby Lane. A low, beautifully built dry-stone wall had replaced the cast iron railings, previously the boundary between the pavement and the undeveloped land where Clifton Mill once stood. It indexed good-quality construction work. Sure enough, as I turned my head to the right, the bright yellow and black paintwork of excavators and diggers met my gaze. There were stacks of new materials piled up on the site. 'The hole, at last, is covered in fresh new bricks and timber, the earth is being churned and levelled', I wrote in my journal that afternoon. 'After twenty-two years, something is being built over the gaping hole in the village'.

I parked up on Victoria Road, somewhere down from Bailiff Bridge Junior and Infants' School, opposite the community centre, built over where Firth Carpets' canteens used to be. I turned backwards to make my way to the old Post Office, now a dog-grooming parlour, and bumped into the manager of the community centre. Recent vandalism at the centre is the result, she told me, of discontent and contested views about what a community centre should be – a broken wall bashed in by a van and a stolen banner from an outside wall robs the building of signage. Speculation about what might be built over the once-mill had persisted for years. It was too early then to ascertain what those early foundations would become. I turned to scan the landscape of the village. For those with a longstanding knowledge of place, the evidence of transformation was clear. The beautiful church buildings, once so central to the social infrastructure of the village in the nineteenth century, had changed: Ebenezer Methodist Church (1870) had become Ebenezer House accommodating Kinetic Systems, and St Aiden's Mission Church,

now called 'The Chapel', was home to Oil Tech. The Punch Bowl Hotel pub was now Clearwell pest control, Waddingtons, the place where workers bought Firths' carpet off-cuts, was now a designer floor shop, and Costcutters had replaced the Co-op. Yet despite these shifts it was still easy to get my bearings, the rest of the village had retained its structure. The sandblasted houses on East Street looked much the same and my walk along Bradford Road took me towards North Vale Mill with its proud history of halted carpet production for the war effort during the Second World War. And I knew from parking up at the community centre that Memorial Park, donated to the people of Bailiff Bridge by T. F. Firth to commemorate those who died in the First World War, was well maintained and cared for. Turning back to the heart of the village, the shops opposite Clifton House which line Bradford Road looked contemporary and operational – a bridal shop, a dentist and, ubiquitous now on most high streets, a vape shop. Soon I was back at the crossroads. Advertising hoardings still shouted their messages from the temporary metal fences which corralled the building work on the undeveloped scrub. Blackshaw Holdings still rented out Clifton House to various concerns, such as Bridges Gym and Firth Carpets.

I pledged on the Easter walk to return to track the progress of building development. By June things had moved on. An advertisement fastened to the metal fencing announced that the housing complex 'Axminster Court' was well underway. Looking beyond the construction site, contemporary capitalism in property development, fast food and lifestyle goods (home and pets) was palpable. I turned left and drove towards the bustling McDonald's dine-in and drive-through on Bradford Road towards Brighouse. To my left through the passenger door, warehouse stores B & M and Pets at Home glided past.

Commerce brought work to the village, but the work was a world away from the standard employment contract Firth Carpets Limited had provided for its vertically integrated staff – the security, canteen workers and cleaners it had on its books up until the 1980s. How work is done and what it means has shifted since Firths closed its doors. Manufacturing of physical tangible goods has drastically waned. A host of hidden knowledge workers – social media marketers, brand analysts and customer relations staff – lie behind the physical façade of retail chains like Pets at Home using their intangible

assets of IT, data, software and AI in an increasingly dematerialised world. 'Flexible' precarious work bubbles invisibly below the surface for retail and catering employees of the village. The construction workers in hi-vis jackets and hard hats were likely subcontracted by the main developer. And, as I approach McDonald's car park, two young male gig-economy workers on push bikes with large, square Just Eat carrier packs ride past on the other side of the road. On a wage of £10.89 an hour with the requirements that the rider maintain their own bicycle and pay their own insurance with no sickness or holiday pay, it is a far cry from the benefits of the employment terms Firth Carpets offered its workers under the auspices of the social welfare state of the 1950s.[1] Union membership was at least available to staff at Firth Carpets: for the contemporary employees working in the village now, that opportunity will be unlikely.

Nonetheless, life goes on in a village that looks so radically different from the village I knew as a child. My mind ran to the interiors of the new-builds I saw before me. Bookings for the show home at Axminster Court were open at Weaver's Place. Images of the room sets boasted modern, airy, neutral aesthetics. The images excluded the floors, but the chances of spring-loaded carpet pile underfoot would be unlikely in an era of the hard floor. Elsewhere, business was ticking over in Verity's Café @ the Bridge, the fish and chip shop and the pharmacy. These signs of life were presumably frequented by new village occupants who live in the expanse of new homes that were added to the village in the early 2000s. Around 150 homes are located over the dye house to the back of the Clifton Mill site. Another 300 flats and houses are on Victoria Road over the once-weaving sheds. Yet more re-build housing is tucked away less visibly in a left hand turn past North Vale Mill.

Admittedly, the village is convenient for those commuting along A roads for work in towns such as Halifax and Huddersfield. The city of Bradford is but 5.4 miles away and the nearby M62 offers a smooth route to Leeds. Indeed, as the mills have faded out, the roadways have taken on more prominence. Traffic smog has replaced the smell of damp wool which once pervaded the air. Noticeable above anything else is that Firth Carpets Limited has disappeared almost without a trace. That is, apart from a small Brighouse Civic Trust blue plaque of 2015, hung on the wall of Clearwell pest

control. Effectively it asks the reader to summon back the ghosts of a bygone era:

> Bailiff Bridge developed around the original crossing of Clifton Beck. Here, The Punch Bowl Hotel, formerly The Bailiff Bridge Inn, used to be the focal point of the village. The world-famous carpet mills T. F. Firth founded in 1875 expanded around the crossroads, and the impressive Firth fountain stood in front of this building. Now the Brighouse Boundary Walk and the Calderdale and Bronte Ways all pass through this village.

Otherwise, the story of Firths, as far as the landscape of Bailiff Bridge is concerned, has been almost entirely erased.

Tapestry of an ex-industrial community

To reflect on the shape of what this book set out to achieve, I want to draw on the model of 'making, un-making and re-making' of social infrastructure in left-behind places described by John Tomaney et al. in their study of a small mining community in the North of England.[2] Thinking creatively for a moment, and in reference to thinking metaphorically of this book as a tapestry, it seems fitting to use their tripart model to reflect on its contribution, with particular emphasis on 're-making'. Usually a wall-hanging in an interior, positioned centrally in a room as a conversation piece, a tapestry is an ancient form of woven textile. Some, like the eleventh-century Bayeux, are storytellers. The story this book tells could be a tapestry triptych woven from intricate threads in a colour palette from vibrant to drab.

The making of Firths in Bailiff Bridge

The first panel would unfold the 'making' of T. F. Firth and Sons as a carpet-manufacturing centre which from the mid-nineteenth century gave the village its *raison d'être*. Men and women workers gave their labour, but a repeat pattern from the beginning of Firths this book foregrounds was the importance of women's cheap labour, which was business critical to the economic prosperity typical of the woollen textile industries in the region. Equally, women's aesthetic

tastes were held in the mentalities of those in the chain of crafting carpet; women were the purse string holders over its consumption as a decorative interior product. The village clustered around the works and a thriving and operational social infrastructure began to accrete. The churches, school, local amenities and organisations were spaces where people could assemble, air grievances and set agendas. Guarding against rose-tinted conceptions of community, the book maintains the built structure of the mill buildings acted as pillars which allowed workers and residents to feel affectively 'held' and humanly secure. The works provided the physical space to complete tasks together in time to produce what Michael McNeill describes as an affective 'swelling out' while caught in rhythms of work where social bonds had the potential to flourish.[3] This book visualises the working bodies of those involved in the mechanised craft of making carpet as a counter to images which have dominated deindustrialisation studies of men in mining or steel – the more 'spectacular' roles in heavy manual labour. The firm established its name both nationally and internationally during the late 1800s and continued to build prestige for high-quality woven goods across the twentieth century.

These antecedents form the backcloth to my parents' stories, which interject in the narrative of post-war reconstruction. It was a moment of relative stability in British society in acknowledgement of the upheaval of war, as part of a will to make a workplace which aimed to promote a 'wider humanistic impulse in British society … to reanchor people in their place of work, to re-animate the social so they could better understand one another and what they did together'.[4] The ex-workers involved in this study were born into this context and the influence of its values on their early lives undoubtedly affected their recollections, memories and accounts of the lived experience of work and life in the village.

I opened the introduction with my mother's story with a sense of the ecology of local industrial culture in Bailiff Bridge with its promise of a good life within an operational infrastructure where opportunities for life, work and sociality were abundant. Her story was echoed in a remark decades later by an ex-worker which encapsulated what the company meant to her: 'Firths', she told me, 'gave us a smashing way of life'. Firths was a capitalist concern whose profits were derived from the exploitation of local labour

and postimperial markets, and it discriminated against women workers. But the company also afforded a solid, rooted and three-dimensional life to its workers. At least up until the 1980s, it gave its entire workforce – from the cleaners to the board of directors – a stable, permanent employment contract with decent wages (at least for male workers), with pension benefits, in full recognition of their employee rights to be union members. Given the security of work, staff enjoyed the latitude that relative permanence afforded, the chance to embed into the firm and develop an understanding of the factory, form working relationships and learn a set of valuable skills. These circumstances gave staff the required space and time to excel at the art of carpet making, and the locality and sense of place in which the craft took place mattered.

John Tomaney's notion of 'parochialism as a mode of dwelling' is germane here.[5] Living in the village necessarily produced 'a parochial outlook' which 'values the local, its culture and solidarities'.[6] In one of my interviews, for example, an ex-worker told me the backstory of the most popular wall-to-wall carpet design that Firths ever produced. As a designer who lived in the village walked to work one October morning down Wakefield Road, he looked down to see the pavement was covered by overlapping shapes of vibrantly coloured fallen leaves. That day he took this experience to the design studio. *Buckingham Leaf* became a bestseller. Tomaney defends parochialism as a vanguard of 'place attachment and belonging' and as a foil against what he calls the 'condescension of cosmopolites'.[7] *Buckingham Leaf*, it seems to me, qualifies as what he would describe as 'art of the local', with its imaginative expression of belonging and place attachment (see Figure 5.1). Fashioned out of an everyday observation, *Buckingham Leaf* sold across the world, thereby managing to 'reconcile the role of the universal and the particular in human life ... of tradition and modernity, topography and topology, home and world'.[8]

Yet Firths was interested in instilling more than just the skills required to produce textiles; it engendered the attributes and qualities required for a good life. In turn this generated an almost moral pride in being part of a community of workers who made high-quality goods. One worker made the point that most of her colleagues at Firths held up the idea of 'wanting to get it right' – not just in the pursuit of job satisfaction but as citizen-workers providing flooring for the national good. Firths inter-meshed and

Figure 5.1 Place attachment in the art of the local: *Buckingham Leaf*. Reproduced with permission from Firth Carpets Archive, Bankfield Museum, Halifax, Box B.4.8, ref. 2005.130.21.

contributed to the social infrastructure of the village through its investment in a comprehensive programme of paternalism which meant access to a raft of team sports and their grounds – from archery, football and tennis to membership of the village bowling green and beyond. There were day trips to London or the seaside, dinner dances and 'dos' at local entertainment venues. While it can be argued that paternalism was a management strategy designed to foster teamwork for use in the factory, its strategies made opportunities for workers to enjoy their free time in leisure pursuits and to make lasting friendships or fall in love with their sweetheart, just as my mother and stepfather did in the design studio in the early 1970s.

Village life, with its clutch of amenities and outer layer of residential housing where many workers chose to live, formed the backdrop of the 'way of life' that working at Firths provided. It was within these sets of values that workers formed their own autonomous cultural norms within the structures of the firm – the act of making their own workstations, generating shared humour, and building atmospheres of conviviality and ways of relating to each other. It was an industrial structure feeling which ex-workers re-ignited with relative ease in the focus groups held at the start of the research in 2016 and again during the art workshops at the community centre in 2021.

The un-making of Firths in Bailiff Bridge

But while my family experienced what seemed on the surface to be a thriving industrial culture in the 1970s, undergirding it was the slow decline of the carpet industry. The 'un-making' of the village, the second panel of the tapestry triptych, this time in drab colour shades, was already in train. As the introduction shows, a nexus of socio-economic and political factors conspired to motor the process of deindustrialisation: the economic recessions of the 1980s and 1990s, aggressive global competition as well as fashion tastes which ushered in laminate floor covering.

Local press files documented anxiety and concern for a company with long-standing history in the region, and employment continued to dwindle across the 1990s. The company was taken over by the

US technical flooring giant Interface in 1998 and faced closure in 2000. Closure meant that around 500 workers lost their jobs, the pride and purpose of making carpets, and the sociality of work. Dereliction and demolition followed in the village in the early 2000s, bringing the denigration of local high street amenities juxtaposed with areas of land denuded of the once-mills.

It was through this landscape of loss that my stepfather and I took a drive through the village and up Birkby Lane in 2003. As a passenger, it was there that I could feel how weighed down he felt by affective displacement. It was the double shock of the closure of Firths, and the decline of the pub, the shops and the areas that had built the community in the first place. Half a decade later, the financial crash of 2008 and the swingeing austerity measures meted out to old industrial Britain must have felt doubly unfair on the community. This tranche of factors led to the feeling in Bailiff Bridge of being 'left behind'. It marked the end of the good way of life and the start of the radical diminution of social infrastructure in Bailiff Bridge. The village joined left-behind places all over Britain where the loss of social infrastructure 'is felt disproportionately,'[9] which led to the policy measures expressed in the government's *Levelling Up* White Paper.

When I returned to the village in 2016 to begin ethnographic research with the community, I found that ex-workers used nostalgia to assuage multiple loss. While nostalgia has been vilified as a practice, recent work suggests it carries a tranche of psychological benefits: it can uplift self-esteem, generate warm affective feelings and mitigate against the dread of mortality, which is especially germane for the ageing ex-workers of the study.[10] While it is argued that the importance of place attachment 'has had comparatively little influence on the debate about LBPs',[11] the ethnographic use of walk-and-talk tours unlocked granular experiential detail of trauma in a left-behind place ravaged by demolition. Ageing ex-workers experienced feelings of the *unheimlich* as they navigated the village, which for them had altered beyond recognition. Nostalgia was an inadequate concept for understanding the spatial change that came with the demolition of the works and the erosion of the high street and local services. Solastalgia, the idea that residents felt homesick at home, held more valence for some residents. These feelings were compounded by a latent sense of anger towards 'non Bailiff Bridgers'; 'newcomers'

who had moved into the new-builds were perceived as indifferent, disinterested and uncaring.

Attempted re-making of community in Bailiff Bridge

The (re-) making of SI is almost always an exercise in radical hope.[12]

The final panel of the tapestry would articulate how Intertwining Threads offered a creative model to start a conversation between two halves of a community about living together in an ex-industrial locale. It was about the act of re-making in a bid to restore belonging to ex-workers by healing the hurt of not being seen or acknowledged in a village that once felt affectively connected. It aimed to bring social benefits and the potential to encourage newcomers to think more about their place by increasing their knowledge of Bailiff Bridge. It hoped to provide a catalyst for social opportunities for older ex-workers and relative newcomers to find some common ground.[13] As this book has established, there are health benefits and pleasures which inhere in the social for older and younger residents. But it failed as a community cohesion project. Arts-based workshops about the particularities of Bailiff Bridge's industrial heritage as a once-proud producer of carpet ended up as a series of one-sided events. There were plenty of ex-workers, but almost nobody from the new-builds. Why, then, did it fail?

Newcomers could be forgiven for having scant knowledge of Bailiff Bridge's industrial past. There are few, if any, visible traces of the former Firth Carpets Limited as a manufacturing company in the village today. None of the mills used by the company has been granted listed status. Clifton House is rented to private businesses. The visitor who climbs the stairs on their way to Bridges Gym or a dancing class in Clifton House may pass the small gold plaque about the company on the landing, but few of those living in the new-builds would have reason to notice it or pay it heed. When the research team leafleted the village for participants for the project in 2021, shopkeepers were asked if they knew what the scrubland had been. Nobody asked knew the answer. All that remains is street name signage with decontextualised allusions: 'Tufted Fold', 'Axminster Drive' and 'Weaver's Croft' which give only a vague indication that the area was once associated with carpets. The historical significance

of the mills is itself commoditised as 'heritage' in these street names to sell new property. Local tourist information only adds weight to the argument that Firths has been virtually erased. The West Yorkshire Textiles Heritage Trail leaflet maps 33 points of interest: astonishingly it makes no mention of Firth Carpets Limited. But then, to visit the village would be to find almost nothing to see or experience in terms of textile history. In this way, our leafleting messages could well have proven almost meaningless to newcomers we tried to reach for the project. Why would they seek involvement without a firmer sense of what the place they lived in had once been?

It is pertinent to ask and unpack some further questions about the layers of community I have described as facing different directions and living different lives. The lack of involvement from newcomers in the project compounded the perception they were uncaring. As for the newcomers themselves, it was difficult to reach them. As we wandered through the new-builds passing around leaflets in the early summer months of 2021, sometimes conversing with people outside their properties, there was a sense of impatience when I tried to engage conversations about the project.[14]

Considered historically these two constituencies hold very different values. The ex-workers, some of them born in the 1940s, experienced industrial capitalism under the managerial and technological infrastructure of Fordism. It was an era of powerful centralised governmental administration with control over industrial and financial investment. Broadcast media and communication networks, the railway system and telephone networks held central sway over population flows across expansive geographical areas. Cultural, ideational and experiential values were expressed across shared menus and cultures. Work in manufacturing was regulated and characterised by worker assembly lines, fixed and scheduled working hours, and gendered divisions of labour which governed personal and social lives. People could reasonably expect access to public services.[15] The constituency in Bailiff Bridge had literally been engaged in 'flooring Fordism'.

These values shifted in the post-Fordist moment of the late 1960s which brought 'flexible specialisation' in which industries were forced to chase niche markets. Large industrial concerns were too cumbersome to respond quickly, and smaller supplier networks, employing people on short-term contracts, emerged to meet finite

fluctuations in consumer tastes. In turn, work communities once stabilised in common by shared work and leisure schedules began to disaggregate into more detached micro-networks as the retail and service industries eclipsed the manufacturing economy. This ushered in an era of 'postmodernity', characterised by cultural fragmentation. In its wake came a decline in the authority of institutions alongside a proliferation of lifestyle choices and an increase in personalised forms of freedom.[16] These are the foundational historical bases from which the two consecutive layers of Bailiff Bridge perhaps need to be understood.

Plugging into the post-Fordist moment of fragmentation, the early 1980s brought an intensification of neoliberal governance, bringing with it a particular set of human values – centrally, the freedom of the competitive and relatively isolated individual as the cornerstone of human agency. This presents a potential problem for thinking, creating and acting as part of groups. Neoliberal thinking, as Jeremy Gilbert asserts, treats

> all creativity agency and potential rationality as properties of individuals rather than of groups, which are in turn understood only as fetters on the freedom and mobility of individuals. They enforce market relations in every conceivable social sphere, promoting an atomised, fragmented and commodified culture within which it becomes difficult even to imagine belonging to a group on any scale which is capable of getting things done.[17]

Gilbert goes on to argue that neoliberal values of the sovereignty of the individual are 'promoted in classically ideological fashion' across all areas of social life and within the polity as though it were 'common sense'.[18] This pervasive set of values which has gripped the UK for the last 40 years is apposite for reaching some kind of understanding as to why this younger, professional group of newcomers might shy away from activities with no obvious individual gain or future projected value. As one scholar remarked to me after I presented a conference paper in which I reported the lack of take-up by newcomers in the project: 'What was in it for them?'[19]

There are likely other differences between these groups in relation to work cultures, which might deepen an understanding of the lack of interest. The newcomers are unlikely to work predominantly in manufacturing industries – which have now, on the whole, migrated

to South-east Asia. More feasibly, they might work in the knowledge economy producing intangible goods; they might manage information flows or work in specialised communications using 'immaterial labour'.[20] Or they might be employed in service or retail work which relies on the skills and competencies of emotional or affective labour. They may work flexibly and they are unlikely to work in the immediate locality of the village. This may also mean they have a reduced interest in valuing or investing in the local – which would include having scant, if any, interest in the industrial history of the buildings or the workers employed by Firth Carpets. Indeed, it is likely that newcomers use online sociality through social media, enabling them to be part of communities not just within their local environs but out to far-flung locales on a global scale.

What Bailiff Bridge presents, then, is a community with different values shaped as a consequence of the historical circumstances from which they emerged. What we proposed depended on the mistaken presumption that the people of Bailiff Bridge had elements of a shared identity – at least in terms of place. Another possibility is that our project was about a series of time-based events that were relatively ephemeral. Had we been able to co-opt a particular space in the village where events could stretch over a longer time span, in which relationships have the space to organically grow, things might have worked out differently. One cannot generalise about other 'dormitory villages' across old industrial Britain based on this study of the specificities of Bailiff Bridge, but it would come as no surprise if similar kinds of locales face similar types of difficulties.[21]

Turning back to the ex-workers, what did emerge was a sense that the loss of paternalistic capitalism meant the loss of a self-sufficient village and a tightly bound community. These were the effects of a Fordist mode of production that Thatcherite neoliberalism dismantled in the 1980s. But this book argues there is another way of seeing the workers' appropriation of the places and 'structures of feeling' to which paternalism gives rise. As a community they carved out a set of relatively autonomous ways of being together from within that system of exploitation. There was a sense of 'surplus': of knowledge and experience capable of building connections with each other that could not be kept captive within capitalism. Thinking back to the workshops – workers re-appropriated modes of embodiment

originally shaped by the workplace and re-deployed them outside that context to display the knowledge of making carpet rendered 'redundant' by the closure of Firth Carpets Limited. In that sense, one could interpret the shared experience of loss as a resistant reaction to the way capitalism constructs worlds only to smash them down.

So where lies hope? This book argues that work on deindustrialised locales with children in schools holds a wealth of potential. There is a body of work about school and university partnerships which demonstrates the clear benefits of how research in higher education can be used in classroom settings.[22] The previous chapter discussed how I gave a dialectical session with every class at the local junior and infants school in Bailiff Bridge in 2021. It aimed to gauge the levels of intrigue that children between the ages of 5 and 11 would demonstrate in response to archival materials showing Firths' carpets, and buildings and machinery in which they had been made. These were juxtaposed with images of the radically changed village in 2021. Children stood up in their seats, their hands thrown high with enthusiasm as they identified the disappearance of Firth Carpets and the changed geography of the village. And announcing my connection with place, as ex-pupil, as part of a family who had worked at the factory, they were given a welcome context in which some of them could say that their grandparents had worked there too. In this way, the school acted as the custodian of a space in which a proudful industrial history of textiles could be nurtured. Crucially, it was a space where the benefits and harms of deindustrialisation could be critically interrogated using creative teaching methods.

The experience offered a clear sense that imaginative work across a range of topics – the use of ex-industrial sites, archival resources, ex-worker testimony or the ghosts of industry past (objects, buildings, people) could offer a suite of fantastic resources for teaching in history, English language, geography and PSHE.[23] It could activate intergenerational involvement as ex-workers co-produce the creative work in classroom activities. While it would be immensely challenging to intervene across what is arguably a rigid national curriculum,[24] teaching the effects of deindustrialisation could extend work, for example, on the industrial revolution to sharpen the connection between the past and experience of communities in the present. It could also offer the space for something that the Intertwining Threads

project struggled to transmit: a set of empathetic feelings from the children about deindustrialised communities which pervaded the atmosphere in each classroom. For as the story of decline unfolded, I could sense a genuine attempt to understand how it all must have felt for the people who had lived before them in Bailiff Bridge. If we could begin with the idea that there are shared affective connections through histories of work, place and families, then we can begin to ignite young minds with a sense of collective engagement. This might be a foundational space from which to rebuild capacities, interests and feelings in common. It might even mean a return, in some small way, to working together to get things done.

Notes

1. J. Woodcock and M. Graham, *The Gig Economy: A Critical Introduction* (Oxford: Polity, 2019), p. 11.
2. J. Tomaney et al., 'Social Infrastructure and "Left-Behind Places"', *Regional Studies*, (2023). doi: 1080/00343404.2023.2224828.
3. M. McNeill, *Keeping Together in Time: Dance and Drill in Human History* (Cambridge, MA: Harvard University Press, 1994), p. 2.
4. T. Strangleman, *Voices of Guinness: An Oral History of the Park Royal Brewery* (Oxford: Oxford University Press, 2020), p. 169.
5. J. Tomaney, 'Parochialism: A Defence', *Progress in Human Geography*, 37:5 (2012). https://doi.org/10.1177/0309132512471235.
6. Ibid.
7. Ibid.
8. Ibid.
9. Tomaney et al., 'Social Infrastructure'.
10. M. Voss, J. Arndt, C. Routledge, C. Sedikides, and T. Wildschut, 'Nostalgia as a Resource for the Self', *Self and Identity*, 11 (2012), 273–284.
11. Tomaney et al., 'Social Infrastructure'.
12. Ibid.
13. A short film about the project Intertwining Threads made by Nick Singleton offers a useful visualisation of the site of Bailiff Bridge and aspects of the project. It can be accessed on the Independent Social Research Foundation (ISRF) website at: www.isrf.org/2022/04/08/video-intertwining-threads/.
14. I recognise that leafleting, perceived as 'junk mail', can produce this reaction.

15 J. Gilbert and A. Williams provide a helpful account of Fordism in *Hegemony Now: How Big Tech and Wall Street Won the World (and How We Win it Back)* (London: Verso, 2022), pp. 89–92.
16 M. Featherstone, *Consumer Culture and Postmodernism* (London: Sage, 1991).
17 J. Gilbert, *Common Ground: Democracy and Collectivity in an Age of Individualism* (Northampton: Pluto Press, 2014), pp. viii–ix.
18 Ibid., p. 30.
19 This was the question posed by Gilda Zazzara at the 'Futures of Deindustrialisation' conference hosted at the University of Bologna, Summer 2022.
20 'Immaterial labour' is associated with the work of Maurizio Lazzarato.
21 A number of studies highlight the difficulties for deindustrialised communities with the arrival of 'newcomers'. For example, J. Lawrence's re-reading of Yvette Taylor's (2012) work *From the Coalface to the Car Park? The Intersection of Class and Gender in Women's Lives in the North East, 2007–2009*. Jon Lawrence, *Me, Me, Me? The Search for Community in Post-war England* (Oxford: Oxford University Press, 2019).
22 See for example, T. Dobson and L. Stephenson, 'Primary Pupils' Creative Writing: Enacting Identities in a Community of Writers', *Literacy*, 51:3 (2017), 162–168.
23 PSHE stands for 'personal, social, health and economic' education. It is a subject which teaches the skills and knowledge required to keep children healthy and safe and to prepare them for life and employment.
24 Questions are being posed around how far the national curriculum allows any scope for children to exercise their own agency in relation to their education. See for example Y. Manyukhina, 'Children's Agency in the National Curriculum for England: A Critical Discourse Analysis', *Education 3–13*, 50:4 (2022), 506–520.

Index

Page numbers in **bold** refer to figures

Abrams, Lynn 155
absence, sense of 172
Ackroyd, Michael 88–89
Ackroyd, William 23, 61
Acrilan 69
advertising 22, 57, **58**, 60, **61**, 64, 65, 66, 68, 75, 76, 77, 81, 85, 91, **94**
affective history 35, 164
affective pain 10
affective ties 4, 36
affluence 67–68
aims 19–21
Albrecht, Glenn 36, 170–171, 176–177
alienation 157, 182
Allon, Fiona 125, 143, 145, 152–153
Alpenfels, Ethel J. 195
Alwyn 75
Amazon 145
Andrews, Aaron **153**
Ansoff, H. I. 90
apprenticeships 43
Architectural Review 63–64, **65**, **66**
archive collections 29–32
Attfield, Judy 69–70
austerity years, the 15
Axminster 1, 24, **26**, 50, 51, 52, 68, 90, 124, 152
Axminster Court 213, 214

Back, Les 184
Bailiff Bridge 2–3, **3**, 9, 13, **14**, 15, 35–36, 123–124, 125, 155, 158, 177, 181–182
 buildings and community 159–164, **160**, **162**
 contextual factors 174
 deindustrialisation 82, 219–221
 demographics 182–183
 expansion 24
 experience of being in 152–153
 flood, 1968 160, **160**
 loss of sense of place 171–175
 making 215–217, 219
 re-making 221–226
 researching 158–159
 site purchase 22
 spatial anxiety 135
 spatio-geographical conception of 141–143
 transformation 212–215
 un-making 219–221
Bailiff Bridge Junior and Infants' School 13–14, 204–205, 225
Bankfield Museum 30, **30**–32, 204
Barnett, Corelli 67, 84
Barry, Gerald 71
Bartlett, Neville 23, 49, 50, 52, 53
Beatty, Christine 15, 18
Bentley, Phyllis 23
Bertola, Catherine 19–21, 36, 39n58, 181–182, 183, 184,

Index

185, 186, 192, 194–195, 196, 200, 206
Beynon, H. 132
Bick, Esther 154
Birkby Lane 10, 12, 124, 212, 220
Blackwood, Morton and Sons Ltd (BMK) 43
Blair, Tony 84
Bluestone, Barry 82
Bonnett, Alistair 135–136, 140
Bourdieu, Pierre 207
Boym, S. 143, 144
Breward, Chris 48
Brexit Referendum, 2016 15–16, 164
Bright, Geoff 184, 185, 189
British Airport Operators 101
British Carpet Centre 85
British Carpet Exhibition, 1948 74–75
British Telecom, contract 101
British Wool Marketing Board 101
Brown, Elspeth 97, 102, 104
Bryson, John R. 86–88
Buckingham 91
Buckingham Leaf 91, 217, **218**
buildings and community, walk-and-talk tours 159–164, **160**, **162**

Cabana 91, **93**
Calderdale 21–22
Canada 53, 86
capacity building 19
capital flight 35
Carpet Annual 46, 68–70, 84–85, 119n170
Carpet Manufacturer's Association 23, 70
Carpet Review 68–69
Carpets, Rugs, Linos and Floorcoverings 56
Carpiano, R. M. 159
Centre for Regional, Economic and Social Research 174
Chenille 50

children and childhood 2–3, 5, 9–10, 12–13, 158, 225–226
Christmas parties 10
cinemas 63, **65**
citizen-workers 217
civic buildings 49
Clarke, Jackie 83, 139–140
Clifton House 21, 24, 79, 152, 161, 205, 207–208, 213, 221
Clifton Mill 3, 12, **13**, 51, 56–57, **58**, 61, 105, 153
 demolition 27, 36, 108, **109**, 158, 164, **165**, 166–169, 175
coalfields and coal workers 8–9, 156–157, 158, 189
Colin (local resident) 172–173
commemoration 14–15, 221–223
'communal-beingness' 155, 164, 175
community
 feeling of 2, 103, 111
 importance of 107–108
 place-based 154–156
 walk-and-talk tours 161–164, **162**
community cohesion 200–202
community involvement, further strategies 203–207
company village life 4
competition 8, 51
competitive resources 88
Conekin, Becky E. 71, 72
consumer spending 67–68
consumption, circuit of 47
containing skin 154
contested space 13–14
corporeal nostalgia 186–187
cost-reducing strategies 50
Council of Industrial Design (COID) 73, 74
Covid-19 pandemic 202
creative destruction 144–145
creativity 198–200
critical nostalgia 126, 135–145

Crossley and Sons, John 51, 52, 54, 70
cultural expectations 5
cultural memoryscape 126
cultures of meaning 12
Cyril Lord 70

David (ex-weaver) 161
Dean Clough 51
declarative memory 138
declinism 35, 86
deep listening 20, 184
Degnen, Cathrine 169
deindustrialisation 35, 79, 110, 219–221
 conceptualisation 14–15, 81–83, 112n23
 consequences for communities 156–158
 ill-health caused 197–198
 literature 5, 176
 in the UK carpet industry 83–88
 Victorian period 50
deindustrialisation studies 7, 8, 186, 189
Department for Levelling Up, Housing and Communities 18, 19
dereliction 171–172
design clerks 2
deterritorialisation 125
dignity 123
dis-embedding 158, 177
disillusionment 15
displacement 138
domestic economy 68
domestic ideal, the 62, 78
domestic ideology 55
domesticity, cult of 48
dormitory towns 174–175

ecologies of work 131–132, **132**
economic circumstances 5
ecosystem distress syndromes 169–171

Edensor, T. 28, 127
Edgerton, David 86
Ella (aunt) 1
embodiment, re-appropriation of 200
Emery, Jay 156–157
emotional residue 139
emotional responses 175
emotional ties, importance of 155
employee relations 95–96, 98–99, 102, 107–108, 133–134, **134, 135**
European Common Market 87
Evening Courier 11, 108
evolutionary economics 86–88
exports 51–54, 60, **61**, 98

Federation of British Carpet Manufacturers 23
female experience 33, 34
Festival of Britain 24, 71–74, **72, 73**, 75, 78, 151, 186
Fielden, Mark 101
Fincham, Ben 159
Fine, Lisa 133
Finlayson, Alan 16
Firmoda 63–64, **65**, 186
Firth, Gary 54
Firth, Thomas Freeman 23
Firth, Willans & Co 51
Firth, Willans and Company 22–23, 51
Firth Carpets Archives 8–9, 51
Firth Carpets Limited 1–5, **4**, 63
 absence of 172–173, 212–215, 221–222
 Bailiff Bridge **25, 26**
 brand revived, 2009 38n19
 branding 8
 closure 205
 development 7–8
 focus on 5–6
 making 215–217, **218**, 219
 mechanisation 50
 spatial reach 56–57, 59–61, 80

Index

spatio-geographical conception of 141–143
status 7, 16, 29–30, 78–79, 81, 118n144
un-making 219–221
Firth Carpets Limited, history and development 22–24, 27, 34–35, 77–79
 1930s 54–57, **58**, 59–64, **59**, **61**, **65**, **66**, **67**, 77
 1950s 67–75, **72**, **73**, **76**, 77, **77**, 78
 1966-1970s 80–81, 110
 1970s-1980s 81–91, **90**, **92**, **93**, **94**, 95–99, **100**, 101–108, **106**, 110–111
 closure 9, 11–12, 108, **109**, 110
 decline 10, 10–12, 219–221
 deindustrialisation 86–88, 110
 exports 51–54
 Interface takeover 108, 110
 origins 9, 45–46
 Readicut takeover 38n19, 88, 89–90, 95–96, 96
 Victorian period 45–46, 47–54, 77, 78
 see also T. F. Firth and Sons Ltd, history of the company
Flush Mills 9, 56–57, **58**, 105
focus groups 27, 32, 40n76
Fothergill, Steve 15, 18
France 83, 111n9, 140
Francis, Gavin 182, 207–208
Frank (ex-creeler) 172
Furnishing Trades Organiser 8
Furnishings from Britain 75
Futures of De-industrialisation conference 211n58

gender 5, 9
gendered labour 6, 30, 34, 78
general election, 2017 16
geographical context 21–24, **25**, **26**, 27
Gerald (ex-local shop owner) 162–163, 163

Gerard (ex-worker) 143, 145, 167–168
ghost labs 184, 185
ghosts 188–190
Gilbert, Jeremy 223
Gilroy, Paul 201
Glasgow 83, 155
global financial crisis, 2008 15, 17, 220
global neoliberal capitalism 14–15
globalisation 16
Glucksmann, M. 47, 68
Goodacres Carpets 44
Gordon, Avery F. 188, 188–189
Great Depression, the 55–56
Great Exhibition of the Industry of all Nations 47–48, 52, 111n9
Guinness Time 103
Gunn, Simon 49

Halifax 11, 23, 50
Hallam, Elizabeth 198–200
Hargreaves, John 11
Harrison, Bennett 82
Hattersley, Roy 11
haunted spaces 184, 185
haunting 188–190
healing 181, 207–208
Hebden Bridge 6
Heckmondwike Manufacturing Co. Ltd 43
Hedges, Nick 5, 64, 132
High, Steven 202
Hilda (setter) 142–143, 146, 187
Hobsbawm, Eric 49, 56
Hockney, David 12, 23
Hoggart, Richard 5
home ownership 7, 55, 62, 85
household economy 7
housing 19, 62

Ideal Home exhibition 62
identity 9–10, 14, 22, 224
illegible landscape 152
ill-health 14, 197–198

Index

immigrant workers 9, 105, **106**
immobility 172
importance, sense of 4
imposed place transition 36
improvisation 198–200
industrial identity 9–10, 14
industrial injuries 197–198
industrial life, ecology of 3–5
industrial policy 83–84
industrial surveys, 1930s 57, 59–60, 60–61
industrial towns, old 174–175
Ingold, Tim 198–200
Institute for Community Studies 19
Interface 10, 38n19, 108, 110, 202
intergenerational hurt 10
intergenerational nostalgia 124–125
intergenerational transmission 157
International Contract Services 101
International Wool Secretariat 69
interrelationality 134–135, 139, 164
Intertwining Threads project 36, 183–184, 207–208, 221, 225–226
 affective energy 185, 185–188
 aims 187, 201
 and community cohesion 200–202
 discussion 198–207
 exhibition 21, 205–207, 208
 film 226n13
 further strategies 203–207
 improvisation as process 198–200
 non-representational dimensions 200
 photograph series 193–198, **194, 195, 196, 197**
 pitfalls 202–203
 Weaving Stories 203–205

workshop design 184, 185
workshop roll-out 191–193, **193**
workshops 184–185, 191
'Investing in People' award 102
involuntary memories 158–159
Izluchino 156, 157–158

Jacobs, Bertram 30, 63
James Templeton 83
Jerry (ex-creeler and local resident) 35–36, 141–142, 144, 146–147, 150–151, 172, 172–173, 175
Jevons, W. S. 51, 52
Jimenez, Luis 35, 129
Journal of Commerce 60, **61**
Joyce, Patrick 22

Kathleen (ex-lab technician) 163
Keightley, E. 144, 146
Keith (ex-weaver) 168
Kosset Carpets 44, 91

Laban, Rudolph 196
labour market 15
Lancashire Industrial Development Council 59
Langhamer, Clare 63, 75
Lawrence, Diane 53–54
Lawrence, Jon 163
Lawson, Christopher 52, 53, 82–83
lay-offs 11
Leeds 5, 49
left behind places 17
leisure 63, 67
Levelling Up strategy 17–19, 36, 220
Linehan, Denis 57, 59
Linkon, Sherry Lee 14, 156, 182
living standards 17
London Showroom 57, 59, **59**
loom cards **31**
looms 30, 46, 50, 71, **72**, 101, 124, 127, **128**, 211n59

Index

loss, sense of 18, 145
Lynne (workshop participant) 200

McIvor, Arthur 186, 197, 198
McKenna, Hugh 69
MacKenzie, Lisa 164
McKinsey Global Institute Report 80
McNeill, Michael 138–139, 187, 215–217
Mah, Alice 82
Majima, Shinobu 67, 69
Major, John 11, 101
making, un-making and re-making model 215–217, **217**, 219–226
Makin-Waite, Mike 201
male workers, emphasis on 5, 7
management and management culture 34, 89
Manager's Report, August 1982 91, **92**
manufacturing employment, decline in 10–11
Marchetti, Thomas 7
Margot (ex-marketing officer) 166, 176
marketing strategy 59, 60
marriage 44–45
Masters of Art 101
Matless, David 67
Maureen (ex-wages office manager) 163, 172, 176
May, Vanessa 176
meaningful space, disappearance of 167
mechanisation 50
media narratives 18
Meier, Lars 190, 196
Melbourne, David 101, 108
memory 137, 138, 141, 143, 158–159, 160–161
memoryscapes 175
Miles, Andrew 141
mill remnants 22, 22–23

mnemonic imagination 35, 136–138, 146, 152, 187
Moreton, Zoe 204
Morris, Jeremy 156
Muir, Stewart 176
Murray, Lesley 159
muscular bonding 139

National Union of Dyers, Bleachers and Textile Workers (NUBTW) 9
negative haunting 190
Newcastle 60, 140
newcomers 14, 18, 20, 152, 177, 182–183, 185, 187, 191, 192–193, **193**, 200, 201, 202–203, 204, 211n58, 220–221, 221–222, 223–224
North–South divide 17, 55, 56, 57
nostalgia 35, 36, 123–124, 124–126, 146–147, 168–169, 220
 bittersweet memories 143–144
 constituent parts 137
 coping mechanism 126
 corporeal 186–187
 creative use 144–145
 critical 126, 135–145
 explanatory power 138
 interactions with photographs 126–127, **128**, 129–135, **129**, **130**, **131**, **132**, **133**, **134**, **135**, 152, 187
 photographs 138, 141–143, 146–147
 restorative 143
 spatial and bodily remembering 141–143
 temporal dimension 188
Nye, David 97, 104–105, 108

Offer, Avner 67
oil prices 85
old industrial Britain 15
oral history 9

P. A. Management Consultants, 'The Present Position and the Next Three Years' report 88–89, 95
Parker, Rozsika 78
parochialism 217, **218**
Parr, Martin 6–7
Partington, Angela 75
passive neglect 83
passivity, enforced 172
paternalism 3, 4, 9, 14, 29, 107, 111, 133–134, **134**, **135**, 161–163, **162**, 219
patriarchal management structure 23, 78
Pearson, Robin 22
personal stories 45
photographs 28–29, 30, 97, 102–103, 105
 nostalgia 126–127, **128**, 129–135, **129**, **130**, **131**, **132**, **133**, **134**, **135**, 138, 141–143, 146–147, 152, 187
Pickering, M. 136–138, 144, 146
place, sense of 21, 169–175
place attachment 169
place-based communities 154–156
place-building 143–144
political alienation 16
population explosion 49
poverty 14
precarity 27, 102, 158
pregnancy 1, 5
Price, L. 9
pride 4, 14, 57, 146
privatisation 16–17
production 47, 61, 68, 87
product-market portfolio 90–91, **90**
psychogeographers 140
Public Accounts Committee 18
Pugh, Martin 61–62
purposelessness, sense of 175
Puttnam, Robert 177

Radway, Janice 189
railways 49–50
Readicut International group 38n19, 88, 89–90, 95–96, 96
recessions 10, 11, 15
redundancies 83
regeneration 15, 176
regional inequality 17
remembering 138, 139, 187
research method 27–32
residential building 173, 175
revenant energies 188
rhythms of the works 129, **129**
Richards, Ben 201
Richards, Jeffery 63
Rítívoí, Andrea 138
Ronayne, Megan 86–88
Rooney, Michael 38n19
Royal Armouries 102
ruination 14

sales 52
Savage, Mike 67, 68, 69, 70–71, 74, 141
Seabrook, Jeremy 5
Seamon, David 190
seating upholstery 49–50
Second World War 24
self-sufficiency 161
service sector 11, 14
sex-segregated work 46
shared purpose 164
Shephard, Gillian 102
Sherry (local resident) 35–36, 144, 145, 150–151, 161, 172–173
shipping 60, **61**
Simpson, Katherine 189
Singleton, Nick 226n13
Situationist International movement 140
social cohesion 4, 139
social haunting 188–190
social isolation 173, 174
social memory 160–161, 168
social mobility 70

social programme 4
Socialist Realism 64
socio-political circumstances 15
'solastalgia' 170–171, 176–177, 187–188
spatial anxiety 135
spatial change 130–131, 159–164, 188
spatial dislocation 173, 174
Stacey (ex-export manager) 145, 147, 166–167, 172
staff magazines 96–108, **100**, 105, 110–111, 134, 145, 162, **162**, 186
standards of living 45–46, 48, 84
Stanton, Cathy 15
Steedman, Carolyn 5, 31–32
steelworkers 5
Strangleman, Tim 55, 64, 67, 102–103, 127, **129**, 130–131, 177, 185
Streat, Raymond 59
Stride, Rory 83
strikes and strike activity 8–9
Studdert, David 139, 154–155, 155
Styles, John 48, 52
Sue (ex-wages clerk) 172–173
Sugg-Ryan, Deborah 75, 77
summer work 10
Sunday Referee 61

T. F. Firth and Sons Ltd, history of the company 51, 54, 56–57, 59–61
see also Firth Carpets Limited
Tapestry 50, 51, 52
tapestry, wall 215, 219, 221
Taylor, Jim 2, 3, 10, 10–12, 43–44, 46, 123, 124, 146, 175
Taylor, Lisa 175
 biological father 38n29
 birth 1
 childhood 2–3, 12–13, 14
 mother 34

nostalgia 123–124, 124–125
personal investment 12–14
summer work 10
Taylor, Nancie 1–2, 3–5, **4**, 28, 44–45, 46–47, 78, 216
technology change 83
Teesside 16
temporal frame 168
Terry (ex-weaver) 146, 160, 163, 166
textile worker body 185–186
Thatcher, Margaret 83, 84, 189
Thomas (ex-office worker) 141, 143–144, 146, 161
Tomaney, John 215, 217
Tomlinson, Jim 82, 86
Tony (ex-weaver and creeler) 161, 166
topophilia 170
Tosh, John 48
trade unionism 8–9, 96, 188–190
Transport and General Workers Union 108
Travel and Industrial Development Association 59
Trim Lines 96–98, 98–99, **100**, 101, 101–105, **105**, 106, 110–111, 186
Tuan, Yi-Fu 170
tufted carpet 69–70, 85–86, 101, 105, **106**, 116n114, 116n118
Tuned In 29, 96–98, 101–103, 105–106, 110–111, 134, 145, 161

undeveloped land 153, **153**
unemployment 10–11, 14, 15, 56, 62, 86
unforgetting 147
United States of America 51, 52, 53, 54, 55, 69–71, 70, 82, 86, 97, 98, 133

Victoria Mill 56–57, **58**, 105
Victoria Print Works 24

Victoria Road 24, 27, 151, 158, 172, 192, 212
visual sources 28–29

Waddingtons the drapers 2
wages, gender differences 6
walk-and-talk tours 27–28, 36, 40n78, 153–154, **153**, 158–159, 175–176, 220
 buildings and community 159–164, **160**, **162**
 demolition of Clifton Mill 164, **165**, 166–169
Walkerdine, Valerie 35, 129, 134–135, 139, 154–155, 164, 175, 176
Warner, Simon 21
weaving 6
Weiner, Martin 84
welfare capitalism 97
welfare reforms, 2010 15
welfare state 15, 67, 84
West Yorkshire Combined Authority 18–19
West Yorkshire, regeneration 176

Wetherell, Margaret 155
Whalley, Christine J. 11
William (ex-sales executive) 168
Wilton Carpet **33**, 90–91, **90**
women
 centrality of 34, 46–47, 95
 craft skills 78
 as decision makers 47, 62
 staff magazine profiles 103–104
 status 133–134
 worker profiles 107
 workforce 50, 61, 62
work
 evisceration of 14
 meaning of 29
 stigma of loss 11
work portrait 101–106, **105**
worker body, the 64, **66**, 67
worker roles 5–7, 30, 34
working practice 145, 147
workshops 19–21

York 49
Yorkshire Institute of Economic Affairs 60–61

EU authorised representative for GPSR:
Easy Access System Europe, Mustamäe tee 50,
10621 Tallinn, Estonia
gpsr.requests@easproject.com